AFRICA
THROUGH THE EYES OF WOMEN ARTISTS

by Betty LaDuke
Preface by Elizabeth Catlett

Africa World Press, Inc.

P.O. Box 1892 Trenton, New Jersey 08607 (609) 771-1666

Cover: *Ubi Girl from the Tai Region,* by Lois Mailou Jones, from the Boston Museum of Fine Arts collection.

Book design by Mary Jo Heidrick

Typography by IMPAC Publications

Library of Congress Catalog Card Number: 91-72496

ISBN: 0-86543-198-1 Cloth
ISBN: 0-86543-199-0 Paper

Africa World Press, Inc.
P.O. Box 1892
Trenton, New Jersey 08607

*Dedicated
to the artists*
**June Beer,
Inji Efflatoun,**
and
Edna Manley,
*from Nicaragua,
Egypt, and
Jamaica*

*Who remain
with us in spirit*

Acknowledgments

Africa Through the Eyes of Women Artists is a project I have lived and loved for the past four years and will continue to grow from—always. Foremost, I acknowledge: the women artists of Africa and the African diaspora whose creative spirit and willingness to share of their lives and art allowed this book to happen; the numerous friends and colleagues in the United States, Latin America, and Africa who guided me on the arduous but exciting adventure of discovering and learning; and my family for their consistent encouragement.

Special appreciation is extended to Lois Wright who managed to type from my handwriting, Mary Burgess who retyped, Chela Tapp who not only reviewed each chapter as it emerged but along with Florence Schneider generously proof-read everything.

Many of the chapters which compose this book have previously appeared, in part, as articles in the following books and journals: *Woman's Art Journal; The Bulletin of the Caucus on Social Theory and Art Education, National Art Education Association; Sage; Art and Artists; Heresies; Sweet Reason; City Lights Review; Kalliope; In Unison; Art Papers; Art Education; KSOR Guide to the Arts; Women of Power; National Women Studies Journal;* and *Calyx.*

The following photographs were taken by others or loaned from collections: Figures 1-11, 1-12 and 1-13 photographed by Douglas Campbell Smith; figures 9-1 and 9-4 photographed by Oliver Sepulchre; figures 11-2 and 11-6 photographed by Rob Jaffe; figure 12-1 photograph courtesy of Lois Mailou Jones; figures 12-2 and 12-5 courtesy of Museum of Fine Arts, Boston; figure 12-9 photo courtesy Johnson Publishing Company; figures 13-1, 13-2, 13-3, 13-4, 13-5 and 13-7 photographed by Maria La Yacona; and figure 14-1 photographed by Margaret Randall.

Table of Contents

Elizabeth Catlett

SOME YEARS AGO, on a visit to China, I had a very fulfilling experience in the northern village of Aladi, in Kirin Province. I was awakened from our after lunch nap and taken to meet the village painter. He showed me his work, which at that time consisted of paintings for the many houses being built. Each painting was on a rectangular pane of glass, brick size, and represented a beautiful, flowering, sunny landscape. Each was to replace a brick in a new house, so that when the cold, grey winter came, the light would shine through, and there would be this small window with spring and summer looking in.

I will always remember the feeling of kinship there, for I also create for my people, though less directly. Betty LaDuke has seemingly had innumerable similar encounters. This book is full of the creative experiences of such different women artists from Africa and other areas of the African diaspora. A few of them have had the help of a father or a son but all of them have had to confront and overcome tremendous critical problems in order to live as artists and to continue producing.

In the criticism of my artwork I have had to deal with bias as a black, as a woman, and for social and political reasons. Reading about these lives here presented, helps me to realize once again, that I am not alone. They seem to be almost my sisters. The Third World is still producing a rich, incomparable culture that cannot be ignored. We can feel ourselves a part of this greater international activity that creates art for our people, art that is a part of our lives, art that is a necessity for us.

But this culture of the Third World, of the African diaspora, should be a necessity for all, for it gives us a richer, broader life experience. This book can stimulate us to learn more, as well as serve us as an introduction to this culture. Felicitations to Betty LaDuke!

Elizabeth Catlett
Cuernavaca, Morelos, México
August 1990

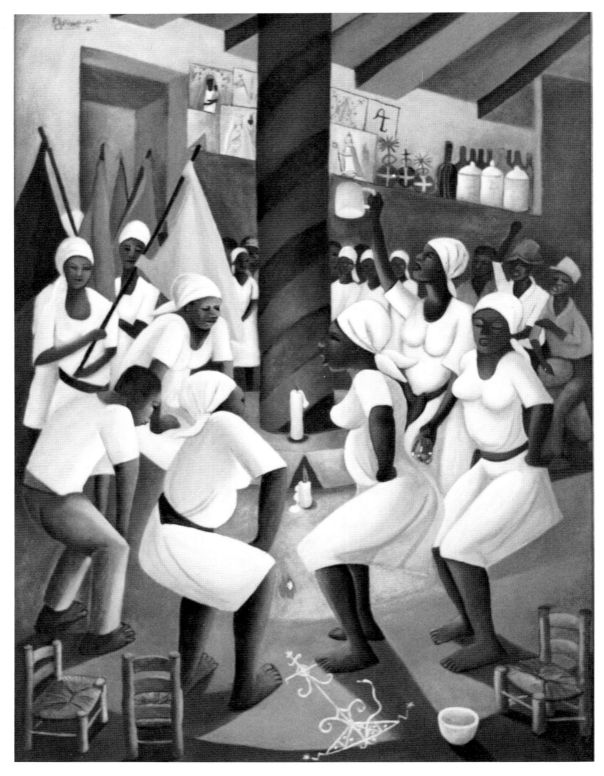

Fig. 1-1 Rosemarie Deruisseau, *Voodoo Dance,* oil, 32x48", 1980

Introduction
Africa Between
Myth and Reality

FOR MOST WESTERNERS, African art forms have remained in a frozen time warm limited to the infamous masks which inspired the development of cubism in early twentieth century Europe. African art, however, has continued to evolve in response to social needs. The art expression of the twelve women artists interviewed and featured in *Africa Through the Eyes of Women Artists* contains a variety of images and themes that reveal multifaceted roles within contemporary African society. The relevancy of each artist's contribution in the traditional media of fiber or ceramics or as modern painters, sculptors and printmakers extends beyond national boundaries. Their art is composed of intimate and universal themes that touch upon all our lives and expand our vision of humanity.

My interactions with these artists proved to be a unique introduction to a complex continent. Their diverse cultural heritages, socio-economic positions, and aesthetic expressions broadened my understanding of and appreciation for some of the vital strands forming the patterns of African reality, past and present.

My interest in Africa evolved while researching my first book, *Companeras: Women, Art and Social Change in Latin America*, published in 1985.[1] In addition to interviewing the artists of indigenous, mestizo, and Hispanic descent, I became acquainted with Latin American folk and professional artists of the African diaspora in Haiti, Cuba, Grenada, and Brazil. They had resisted total assimilation into the imposed colonial cultures of France, Spain, England, and Portugal, so that they were able to maintain a link with Africa over 300 years of the diaspora. This link was frequently manifested in rituals and art related to voodoo, santeria or candomble, transformations of their West African spiritual beliefs, now integrated with Christianity. For example, in their diverse figurative styles, Haitian painters Rosemarie Deruisseau, Louisiane St. Fleurant, and Marilene Villedrouin interpret their Afro-Latino cultural experiences in *Voodoo Dance* (Fig. 1-1), *Bourgeois Woman in Her Garden* (Fig. 1-2), and *Celestial Mermaid* (Fig. 1-3). Intrigued by these images, I continued my research of the diaspora link in Latin America and the United States before resolving to visit Africa.

Africa Through the Eyes of Women Artists, therefore, includes interviews with Louis Mailou Jones, Edna Manley, and June Beer, from the United States, Jamaica, and Nicaragua. Jones, a Professor of Art at Howard University for forty-seven years, trav-

Fig. 1-2 Louisiane St. Fleurant, *Bourgeois Woman in Her Garden,* acrylic, 36x48",
1983.

eled widely, and created multimedia paintings that forge links with four continents, North America, Europe, Latin America, and Africa. One of her best known paintings is *Mob Victim*, about a Southern lynching. Manley's sculptures portray black pride and dignity as in the monumental form of *Negro Aroused*. Her sculptures were pivotal to the consciousness-raising of black Jamaicans struggling for freedom from British colonial rule. Beer was the first artist to portray images of the black community in Nicaragua's isolated Atlantic Coast region. She is also known for having painted General Augusto Sandino, the heroic symbol of Nicaragua's revolution, as *Black Sandino*.

My four consecutive years of African travel and research began in 1986, with the help of Professor Wangbojie, a colleague from the International Society for Education Through the Arts. He facilitated my meeting three extraordinary artists, Princess Elizabeth Olowu, Nike Davis, then known as Nike Twins Seven Seven, and Susan Wenger, of European heritage.

The twelve artists interviewed from six African nations in *The Evolving Continuum* and from three diaspora countries in *Artists of the Diaspora* have experienced much cross-cultural interchange as many have traveled outside their national boundaries to the West, or conversely from the West to Africa. Exposed to Western aesthetics, these artists have stylistically chosen to remain figurative in order to be understood by a broad segment of their community. This sense of personal responsibility and the need to project positive self-images is a conscious aesthetic choice of all the artists interviewed. Afro-American historian Samella Lewis is a proponent of art which informs and educates:

> Black artists today can do much to strengthen their role in society. ... They must be cognizant of their obligations and responsibilities to their communities. Since a lack of adequate knowledge of the past is frequently an obstacle to the present, a primary obligation of Black artists is to understand and use, whenever possible, remembrances of the African cultural heritage. A second obligation is to understand the power of art and the use of that power to inform and educate.[2]

Fig. 1-3 Marilene Villedrouin, *Celestial Mermaid*, oil, 60x74", 1983.

In contrast to Lewis' definition, which Patricia Failing characterizes as outmoded and linked with the civil rights era of the 1960s and 1970s, Failing notes "the futility of generalizing about black art" and that some artists "would prefer to broaden the term black art until it becomes meaningless."[3] In Africa, however, while many modern artists work in a wide range of styles, figurative imagery remains a significant component of their aesthetics.

In Nigeria, Olowu, the daughter of the Benin oba or king, was able to cast aside centuries of taboos to become a bronze sculptor. Her life-size figure *Acada* (or *Bookworm*) portrays a young girl intensely reading a book, which is a new role model for Nigerian women. Nike Davies' large batik paintings evolved from a traditional folk craft to become dynamic personal interpretations of Yoruba village life festivities and mythology, such as *The Virgin and the Calabash*.

In North Africa, Egypt, and Morocco, I sought out the

painters Inji Efflatoun and Chaibia after learning of them from Masuz Afaf, Egypt's former cultural attache to the United States, and Elizabeth Fernea, a professor of Middle Eastern Studies at the University of Texas in Austin. Efflatuon's early paintings portray Egyptian Moslem women's limited rights in marriage and divorce, as in *Fourth Wife* and *Go, Go, You Are Divorced Now*. From 1959 to 1964 she documented the prison conditions experienced during incarceration for her art, feminist and political activities. In Morocco, Chaibia, a self-taught painter, interprets images of Berber women and folk traditions recalled from childhood memories as in *Women of Fez*.

Correspondence with the art teacher Elsbeth Court from Kenya, a member of the International Society for Education Through the Arts, led me to Theresa Musoke in East Africa. Musoke is inspired by Kenya's vast reserves of wildlife, the animals' rhythmic and cyclical movements in harmony with nature. I found that she equates her interpretation of this experience with the human need for freedom. In contrast to her popular animal imagery, she has also developed a series on the theme of family planning, emphasizing the need for young people to assume social responsibility.

I met Anta Germaine Gaye and Pama Sinatoa in Senegal and Mali in West Africa. Gaye, an art school graduate, uses the medium of fixe, or painting on glass, to create innovative portraits of the urban upper-class, as in her series *The Women of Senegal*. In contrast, Sinatoa, who lives in a rural area, paints with a black solution mixed with soil, a traditional means for creating geometric fabric designs for garments. Instead, Sinatoa creates large repeat-pattern "mud paintings" which portray village women's subsistence activities that include pounding millet, carrying water or wood, and planting or harvesting crops.

Susan Wenger and Sue Williamson are both Europeans who are long time residents of Africa. Each interprets African life from divergent social and political perspectives. Susan Wenger's major work, dedicated to the Yoruba fertility goddess Osun, is an extensive collaborative shrine project located in a tropical forest grove.

Williamson focuses on the injustices of South Africa's apartheid system. I did not go to Capetown, but interviewed Williamson during her 1986 visit to New York City, while participating in the Women's Caucus for Art Conference. Having previously seen her exhibit *A Few South Africans*, which has toured the United States, I was impressed with her photo-silk screen technique for documenting the lives of black and white women who have heroically resisted apartheid.

Even this small sampling of artists lends itself to brief cross-cultural comparisons of women's portrayal of women, mainstream recognition, and Afro-aesthetics. In reviewing the artists' variety of images, I was especially impressed by their representation of positive feminine role-models. Some of these ancient and contemporary images are:

• *biological*: birth giver, physical and spiritual nurturer of children (*Zero Hour* by Elizabeth Olowu, *Ghetto Mother*, Edna Manley);

• *economic*: agricultural worker, craft production and marketing. In Africa "sixty to eighty percent of all the agricultural

Fig. 1-4 Betty LaDuke, *Market*, ink drawing, 11x14", 1989 (top).

Fig. 1-5 Betty LaDuke, *Market*, ink drawing, 11x14", 1989 (bottom).

work, fifty percent of all the animal husbandry, and one hundred percent of the food processing" is performed by women[4] (*Market Day*, Theresa Musoke; *Marketing*, June Beer);

• *cultural*: as healer, goddess, and revered older woman assuring cultural continuity (*Osun*, Susan Wenger and *Ancestor*, Edna Manley);

• *political*: resisting oppression, participating in nationalist struggles, demanding more equality in marriage and divorce laws (*We Shall Not Forget*, Efflatoun and *Biafra War*, Elizabeth Olowu);

• *intellectual*: leaders and political activists, achieving professional careers (*A Few South Africans*, Sue Williamson and *Acada*, Elizabeth Olowu).

The significance of African women artists' portrayal of strong, assertive images of women can be better appreciated in historical context:

Colonialism directly and brutally weakened the African women's economic position. It also imposed a culture of subjugation through Christianity, which saw women as moral inferiors; and racism, which proclaimed that black people were inferior. It suppressed African history and claimed that African culture did not exist. In fact, the colonialists deliberately set about to try and change African culture. This included ... the notion that African hair and skin were not beautiful and that African woman must change in order to be acceptable to the white people. But African culture lived on.[5]

Has the art produced by women of African heritage received recognition within the national and international mainstream? In the United States, Afro-American women artists have experienced multiple exclusions: first, from the mainstream of the white male power structure, which is "the center of activity in the contemporary art world";[6] second, from the women's art movement; and third, from the means of recognition available to black male artists. The U.S. women's art movement has been very active since 1970, but the omission of black women artists from the feminist mainstream is confirmed by Thalia Gouma-Peterson and Patricia Mathews in their 1987 article, "Feminist Critique of Art History":

Feminist art history has come dangerously close to creating its own canon of white female artists (primarily painters), a canon that is almost as restrictive and exclusionary as its male counterpart.[7]

Discrimination comes from many sources as articulated by the Afro-American painters, Faith Ringgold and Lois Mailou Jones. Ringgold says, "My big problem is being a woman. Even Black art galleries have refused to show my work."[8]

Jones has won prizes in competitive museum exhibits for her paintings, but in the 1950s, because of overt racial discrimination, was refused entry in the front doors when she went to collect her awards. She continues to exhibit in shows which feature black artists, but her goal is to be known as an American painter.

Fig. 1-6 Betty LaDuke, *Pounding Millet*, ink drawing, 11x14", 1989 (top).

Fig. 1-7 Betty LaDuke, *Carrying Firewood*, ink drawing, 11x14", 1989 (bottom).

In defining the significance of the mainstream, Randy Rosen clarifies what it means for women artists to be excluded, whether it is from the white mainstream, the women's art movement, or African American male-dominated galleries.

> The mainstream serves as a filtering mechanism—identifying, legitimizing and propagating certain styles, world views and interests. As the distillation of the values that a particular generation holds most significant, the mainstream also reflects which constituencies have a voice in shaping society's choices and actions. Being part of the mainstream, therefore, involves not only individual achievement but social power.[9]

Artists June Beer from Nicaragua and Edna Manley from Jamaica experienced the issue of recognition from different historical and political positions. African culture in Nicaragua, constituting an isolated minority, has evolved within a dominant indigenous and Hispanic culture. Only since the Nicaraguans' recent revolution and establishment of a cultural ministry in 1980 has the government begun to value the diversity of its population and their cultural contributions.[10][11][12] In recent years, Beer has received national and international recognition but even more remarkable was her tenacious creative persistence when there was little or no support.

Manley and her husband Norman, Jamaica's first prime minister, were instrumental in nurturing the roots of what has become an impressive and vital contemporary art movement. They supported the establishment of the Jamaica Institute of Art and the National Art Gallery. Manley's monumental sculptures, an extraordinary legacy, are now in the National Art Gallery's permanent collection, but she has never had a major exhibit of her work in the United States.

In Africa, Elizabeth Olowu is the first female professor of sculpture at Benin University, and the first female owner of a bronze foundry. Though Nigeria has art galleries, corporate collections, and a National Theatre and Art Museum, at present Olowu has not received significant recognition from these sources. In contrast, Nike Davies is a commercially successful fabric artist of batik paintings and wearable fashions. She frequently exhibits and has workshops in Europe and the United States. Similarly, in Morocco, Chaibia rose from the obscurity of her position as a household servant to receive national and international fame. She was first recognized by French museum directors and critics and now regularly exhibits in Europe, Morocco, and the United States.

Concerning the issue of feminine aesthetics in the United States, Freida High Tesfagiorgis distinguishes Afro-femcentrism from feminist art. She considers Afro-femcentrism as "the unique focus on and presentation of Black females."[13] She notes the differences between black and white feminist artists, in racial depiction and perspective.

Most important in the portrayal of women in the ideology of Afro-femcentrism is the reaffirmation of her involved,

Fig. 1-8 Betty LaDuke, *Zebras*, ink drawing, 11x14", 1989 (top).

Fig. 1-9 Betty LaDuke, *Giraffes*, ink drawing, 11x14", 1989 (bottom).

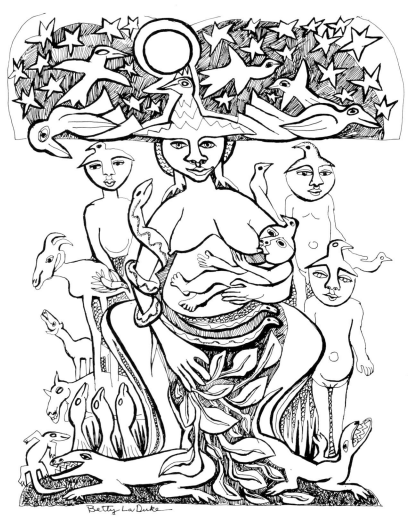

Fig. 1-10 Betty LaDuke, *Africa: Senufo Spirit Mother*, ink drawing, 11x14", 1989.

thinking personage, rather than the demystification of the feminine body and the response to sexism which often occurs in Feminist Art. Afro-femcentrist and feminist motifs differ. The preoccupation with vaginal forms, for example, is nonexistent in the former but the idea of recording her story, of celebrating women's culture, of addressing women's issues and of presenting self-defined images are factors which to some degree unify Afro-femcentrism and feminism.[14]

In further distinguishing between art produced by black men and women, Tesfagiorgis says: "Afro-femcentrism in Black Art is the black female perspective which insightfully enlarges and activates images of black women, celebrating heroines and documenting her story."[15]

Is there a consensus among African American and African

art scholars concerning aesthetics, and the role of art in society? While Tesfagiorgis defines specific aesthetic qualities common to many artists of African heritage, Samella Lewis, Dele Jegede, and Solomon Irein Wangbojie each view this issue of style and content from distinct positions. Tesfagiorgis believes:

> there is a consensus among African art historians that certain elements predominate in Black Art and that those peculiarities manifest in bright or bold colors, expressive poly-rhythmic shapes and spatial relationships and variable tactile qualities.[16]

These aesthetic qualities are not mentioned by Dele Jegede in his article "Contemporary African Art," in which he argues that "contemporary Africa produces more modern art than traditional," and that artists are now trained in formal art colleges, workshops, or experimental schools. In Nigeria, Jegede refers to the style of *Synthesis* as a means by which artists "assimilate some features from Nigeria's past, while using contemporary media as modes of expression." Jegede concludes, however, "contemporary African art has become, like modern art everywhere, an art that has a life of its own."[17]

In contrast to Jegede, Lewis believes black artists do have an obligation to the community and should:

> employ symbols common to Black lives. Art by African Americans should reflect a continuum of aesthetic principles derived from Africa, maintained during slavery, and emergent today.[18]

In the United States, Latin America, and more recently Africa, many women have gained access to modern art training and are making significant contributions to the development of African "cultural sensibility." Solomon Irein Wangbojie is concerned, however, about the danger of artists

> rushing headlong into the embrace of a monoculture ... as the world becomes a melting pot in which the smaller cultures can be swallowed. ... In other words, such people will have lost their identity, and with it their opportunity to make the kind of contribution that only their own culture would have made to the overall well-being of mankind (humankind).[19]

Wangbojie argues that

> although (African) artistic expression appears to have lost its cultural identity, there is still something left in the form of *cultural sensibility*. It seems as if that habitual way of looking at, and responding to, the world which is peculiar to any particular culture has remained relatively untouched by the wind of conformity now sweeping the world.[20]

My observations in Chapter Two focus primarily on ceramics,

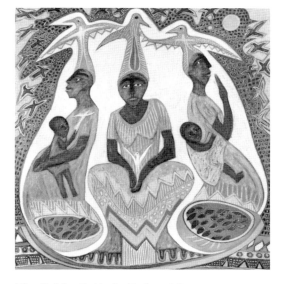

Fig. 1-11 Betty LaDuke, *Africa: Birdwomen Carriers of the Dream*, acrylic, 68x72", 1986. Photograph: Douglas Campbell Smith.

Fig. 1-12 Betty LaDuke, *Africa Water Carriers,* etching, 18x24",
1987. Photograph: Douglas Campbell Smith.

Fig. 1-13 Betty LaDuke, *Africa
Headwrappers,* etching, 18x24", 1987.
Photograph: Douglas Campbell Smith.

which fulfill significant utilitarian, ceremonial, and economic
needs. My first consideration here was to bridge the gap between
artisan and artist, craft and art. Wangbojie realizes the impor-
tance of craft production:

> At their best, these crafts reveal not only the ancient
> artistic skills cultivated in their culture, but also the
> ideas which have persistently engaged the attention of
> the people, and the peculiar motifs and symbols they
> have selected, in order to express those ideas inspired by
> their inherited culture.[21]

Among traditional artists, technical skills are passed down
through the generations from mother to daughter. The form and
function of their work has evolved to serve specific family and
community utilitarian, ritual, and ceremonial needs. In contrast,
most modern artists receive their art training in workshops or

universities, while some are self-taught. Since modern art, created as personal expression, does not serve a specific community need, the artist's economic survival is difficult! It is within this precarious framework that modern African women artists are emerging. They are the focus of *Africa Through the Eyes of Women Artists*. I was intrigued by their unique feminist perspective and contribution to contemporary African art in many cases as artists-activists.

In this brief comparison of select African woman's art from three continents it becomes evident that their imagery confirms their ethnic identity and feminine and cultural sensibilities. They contribute to our global vision, archetypal images of black and Arabic women's strengths, achievements, and active involvement within the process of social change. Indeed, African women artists deserve greater visibility. Their images of dignity need to be seen not as an isolated phenomena "with a life of its own" but in relationship to society and human values. They inspire us by their resistance to the "wind of conformity."

After four intense visits to Africa, I realized that my travels were also a personal spirit journey. Like a serpent shedding skin, I had cast aside routine responsibilities to experience and respond to an extraordinarily different world view. In just a brief period, I was left deeply touched in long-lasting ways. These feelings received visible expression in the paintings and prints later produced in my home studio. I refer to this series of images, created between 1986 and 1990, as *Africa Between Myth and Reality*. Through these images I share some of the magical moments that lingered long after my research and travels to inspire my own art. I was also inspired by the emotional content of the work of specific women artists in the context of their culture and environment.

Visual impressions which formed the basis of many of these paintings and prints were first recorded in a sketchbook. Everywhere I was made more welcome with my sketchbook than camera as I journeyed by train, bus, *bashee*, bushtaxi, donkey cart and a pirogue along the Niger River, or walked between villages. I then became more sensitive to diverse geographical terrains ranging from tropical forest to desert, and lifestyles such as the nomadic Fulani and Masai with their animal herds, in contrast to the Yoruba and Senufo farmers dwelling in towns and villages. With rapid pen strokes I sketched daily life activities from marketing (Fig. 1-4, Fig. 1-5) to the weeding and pounding of millet (Fig. 1-6). I was continually amazed by women's strength and endurance as I recorded their endless processions with babies on their backs, and firewood, produce or pots of water upon their heads (Fig. 1-7). I enjoyed noting the differences between the movement of young boys herding goats in contrast to the time-worn expressions of village elders.

I also had the opportunity to draw the massive kaleidoscopic movement of wildebeest, antelope and zebra (Fig. 1-8 and Fig. 1-9 migrating across Kenya's continental rift. Sometimes a traditional sculptural form, a mask or a spirit figure, became a catalyst for a drawing such as *Senufo Spirit Mother* (Fig. 1-10).

At the end of each journey when I returned to my Ashland, Oregon, studio, I developed my impressions on large canvases

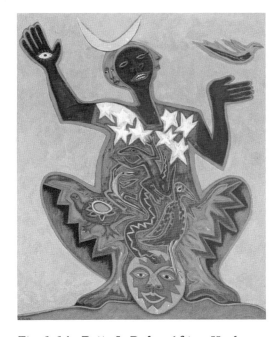

Fig. 1-14 Betty LaDuke, *Africa: Healer*, acrylic, 54x68", 1989.

Notes

1. Betty LaDuke, *Companeras: Women, Art and Social Change in Latin America* (San Francisco: City Lights Publishers, 1985), p. 126.
2. Samella Lewis, *Art: African American* (New York: Harcourt Brace Javanovich, Inc., 1978), p. 4.
3. Patricia Failing, "Black Artist Today, A Case of Exclusion," *Art News* (New York), March 1989, p. 124.
4. "Putting In Two-thirds of the Work," *San Francisco Sunday Examiner and Chronicle*, July 13, 1980, Scene, p. 2.
5. Amandina Lihemba, "East African Woman," in *Focus on African Women* (London: Africa Centre and Akina Mama wa Afrika, March 1986), p. 37.
6. Randy Rosen, "Moving into the Mainstream," *Making Their Mark*, Randy Rosen and Catherine C. Brawer, Eds. (New York: Abbeville Press Publishers, 1989), p. 7.
7. Thalia Gouma-Peterson and Patricia Mathews, "The Feminist Critique of Art History," *The Art Bulletin* (New York: College Art Association of America, Sept. 1987), p. 327.
8. Pat Wilcox, "Being Woman Is Black Feminist Artist's Problem," *The Chattanooga Times*, Sept. 8, 1974.
9. Rosen, p. 7.
10. Betty LaDuke, "Six Nicaraguan Painters, Revolutionary Commitment and Individuality," *Art and Artists* (New York, July 1983), pp. 10-13.
11. Betty LaDuke, "Four Nicaraguan Painters: Revolutionary Commitment and Individuality," *Northwest Review* (University of Oregon, Eugene, OR), Vol. XXI, Nos. 2 & 3, 1983, pp. 104-125.
12. Betty LaDuke, "Nicaragua, The Painter-Peasants of Solentiname," *San Jose Studies* (San Jose State University, San Jose, CA), Vol. 9, No. 3, Fall 1983, pp. 30-79.
13. Freida High Tesfagiorgis, "Afro-femcentrism and its Fruition in the Art of Elizabeth Catlett and Faith Ringgold," *Sage* (Atlanta, GA: Spelman College), Vol. IV, No. 1, Spring 1987, p. 27.
14. *Ibid.*, p. 26.
15. *Ibid.*, p. 29.
16. *Ibid.*, p. 26.
17. Dele Jegede, "Contemporary African Art," *Art Papers* (Atlanta, GA).
18. Lewis, p. 4.
19. Solomon Irein Wangbojie, "Cultural Identity and Realisation Through the Arts: Problems, Possibilities and Projections," *Journal of Art and Design Education*, Vol. 5, Nos. 1 and 2, 1986, p. 28.
20. *Ibid.*
21. *Ibid.*
22. Benjamin Horowitz, *Images of Dignity: Charles White* (Ritchie Press, 1967), p. 121.
23. Keorapetse Kogsitsile, "Culture and Resistance in South Africa," *The Black Scholar*, July/August, 1986, p. 30.

with acrylic paints or metal plates for etchings. The challenge was to convert the essence of my sketched experiences into universal and archetypal images. I wanted these images to reflect local traditions as well as encompass our shared dreams and aspirations.

I risk criticism researching African women artists and creating images about Africa from the perspective of a white outsider who has only casually traveled the surface of this vast continent. My multicultural interests began, however, during an early formative period of my life as my first art teachers were the prominent African American artists Elizabeth Catlett (a former student of Lois Mailou Jones) and Charles White. They imparted values about life and art exemplified in their drawings, paintings, and sculptures that I built upon in subsequent years. *Images of Dignity*[22] best describes their work, a reflection of black people's struggles and aspirations in universal and heroic proportions, partially influenced by the Mexican muralists.

I followed them to Mexico in 1953 for my third year of college. I then painted and worked for over three years in Mexico, including one year with the isolated Otomi Indians, teaching English and painting murals in their schools. This deep-rooted apprenticeship has continued to spark my self-confidence to be with and understand the ways of people for whom Western technology and modes of living and dreaming are not primary.

African women, between myth and reality, dominated my own imagery: as mothers bringing forth, sustaining and nurturing all life forms; cultural guardians and healers; mythical goddesses; and sexual beings. These themes are exemplified in the following selected paintings and prints.

Africa Bird Women, Carriers of the Dream (Fig. 1-11) are the Yoruba market vendors who sit long hours with their children and baskets of chilies, fruits, vegetables or kola nuts. When their long, colorful head wrappers unwind, they transform into birds, or guardian spirits, that become the carriers of their dreams.

Africa Water Carriers (Fig. 1-12) honors the women who appear like goddesses, as they walk long distances each day to carry water for all their families' needs.

Africa Head Wrappers (Fig. 1-13) unwind to reveal scenes of village life and women's love dreams.

Africa: Healer (Fig. 1-14) honors those ancient prophets and seers who have studied the cosmic pathway and know the power of nature to heal the sick and protect the innocent from evil.

These images are my praise songs to Africa. They are both serious and playful, and confirm the pathway first inspired by my African American art teachers, White and Catlett, almost half a century ago. African poet Keorapetse Kogsitsile confirms our pathway:

> Love, even the love between a man and a woman, parent and child, friend and friend, is a unifying factor in the wholeness we seek. ... Life is itself the major creative activity. And what is truly creative in art is a reflection and an affirmation of life in moving images.[23]

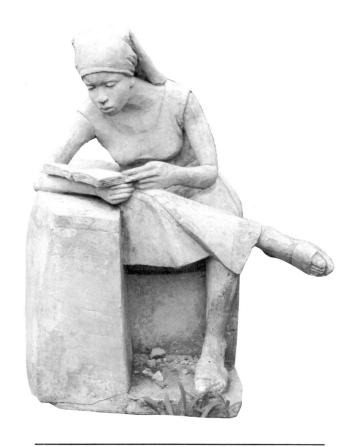

The Evolving Continuum

Traditional African Women Artists

AFRICAN WOMEN continue to take pride in their contributions as skilled artisans providing for the utilitarian, sacred and ceremonial needs of their families and communities. In the historical documentation of African art, however, women's achievements were frequently overlooked or underestimated. The transformation of the ordinary into the extraordinary, such as mud and plant fiber into functional and aesthetically beautiful ceramic forms and textiles are among the ancient arts along with basketry, gourd carving, jewelry and leather craft that are still practiced by women and remain critical to contemporary African culture.

The quantity and quality of pottery in the village environment are impressive in Nigeria, Mali, and the Ivory Coast, and provide excellent examples of woman's vital contributions. These forms vary from tall, sturdy water storage pots to ornately designed ritual vessels for ceremonial use (Figs. 2-1 and 2-2). Pottery has great symbolic importance when linked to rites of passage, goddess worship and folklore. These themes are an incredible resource for modern artists, both African and western. Many western artists are now turning to the less industrialized nations where art is still rooted in rites of passage and a reverence for nature to explore and incorporate these universal and archetypal motifs. It is useful, therefore, to briefly review traditional African women's art, focusing on pottery, in order to consider some of the issues of mutual concern to women artists in general and the benefits gained from an interchange between traditional and modern artists.

Currently many African studies scholars are challenging the limitations of some fieldwork. For example Marla Berns in her 1989 article "Ceramic Arts in Africa" believes the neglect of women potters is

> due to an obsession with smithing that the social and ritual implications of pottery-making have been largely ignored. This points to important issues of gender and technology, and our Western preoccupation with a men-iron-smithing paradigm over one exploring a women-clay-potting. ... More attention should be paid to the female potter in West African ethnography because the process of pottery-making serves as a rich model for the ways societies handle change.[1]

J.R.O. Ojo from the University of Ife, Nigeria, is among a

Fig. 2-1 *Utilitarian Pottery for Sale,* Cote D'Ivoire, 1989.

growing number of scholars confirming Bern's view. In his 1979 paper on "The Position of Women in Yoruba Traditional Society" Ojo admits:

> If my knowledge about women's roles is sketchy, it is because "females have been overlooked in the ethnographic literature." ... There is a tendency not to pursue in any detail the roles played by women unless such roles are particularly prominent.[2]

From George Eaton Simpson's edited writings of Melville J. Herskovitz, it is easy to see why women's creative endeavors have been omitted from serious study. In Herskovitz's 1930 essay on "The Art of Dahomey," brass-casting and sculpture are discussed in detail and only one paragraph is devoted to pottery production. The reason for this neglect by Herskovitz and others is due to the view that

> wood carving still affords the primary artistic outlet for the Dohomean populace, and it is only the male portion of the populace to whom is granted this opportunity for self-expression.[3]

However, the sculptor's self-expression also conforms to patron needs, and many are women. Anita Glaze points out in her intensive study of Senufo art and culture, "From the literature one would conclude that Senufo art is essentially a man's world,"[4] but Glaze answers us otherwise. This is due to the fact that

> Senufo women, to a far greater degree than men, assume roles as ritual mediators between humankind and the supernatural world of spirits and deities, and several major categories of sculpture, ornament, and masquerade derive their intrinsic meaning from this role. For this reason it is especially fitting to begin an analysis of the contexts of meaning for Senufo art by examining women's sphere.[5]

Perhaps it is due to Western scholarly obliviousness to the balancing subtleties of African male-female relationships and women's prestigious role especially as an elder or cultural guardian that has led to broader neglect. Other scholarly comments such as: "female power as power to determine the lot of future generations,"[6] and "Women in Yoruba rituals do not play such dominant roles, but the roles they play are indispensable to the rituals"[7] offer insights from an African perspective.

The categorical distinction between art for self expression in contrast to utilitarian craft production is of European origin, and is considered "a handicap" by Maude Wahlman in her book *Contemporary African Arts*. In Africa, a pottery-maker, weaver or basketmaker is "regarded as an artist no less than is the sculptor ... all art is created for a function, for social, political, religious, historical or economic reasons."[8]

These factors all converge during an important ritual, ceremony, or festival in which ritual pottery is of significance along

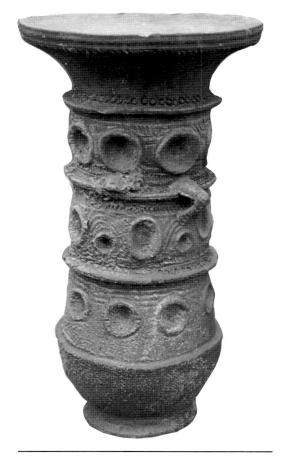

Fig. 2-2 *Ritual Pottery*, height 24 inches, Nigeria, 1987.

with the use of special woven textiles or decorated garments, music, dance, and drama—all equally valued and necessary for the success of the event. This contrasts with the Western world, according to Robert Farris Thompson, which has "evolved the frame, the pedestal and the stage as artificial isolating devices that make the individuality of art absolute,"[9] and exemplifies the contrast between artisans who are part of a communal tradition and the isolation of modern artists.

Traditional Women Potters

In traditional pottery production I found many similarities among the Dogon of Bankaas, Mali, the Yoruba of Impetumudo, Nigeria, the Fulani near Kano, Nigeria, and the Senufo in Katiola, the Ivory Coast. In village compounds several generations of women contribute collectively to pottery production, ranging from the mining and processing of the clay to the forming, trimming and firing of pots (Figs. 2-3, 2-4, 2-5). It takes many years to perfect pottery skills. This skill level is usually attained after marriage when a woman has worked for several years on her own. Delayed professional maturity is preferable as a social regulator to assure that the economic benefits gained from pottery sales will be contributed to the feeding and clothing of the family, rather than encouraging economic freedom or independence.

In one Dogon family compound in Bankaas, Mali, all five women, the wives of two brothers, produced pottery, and each specialized in forms ranging from huge water storage vessels to small clay stoves, and a variety of bowls for food and medicinal preparation. Occasionally they received commissions for ritual pottery.

Their compound contains a series of mud and thatch rooms built around a courtyard where each woman had one room for herself and her children. In this typical polygamous household consisting of two brothers (one had three wives, the other two) and their nineteen children, there was plenty of mutual support. Husbands were metal forgers. It is typical throughout West Africa that blacksmiths marry women potters. The men had their shop apart, where they produced farm implements and brass jewelry. The women made pottery as an extension of domestic activities, in the shade of a room designated as their studio, while the pounding, grinding, and processing of the clay (assisted by their female children) took place in the courtyard (Fig. 2-6). This was where the finished pottery was also set out to dry.

The basic construction method for large and small pots is through the addition of soft, pliable clay coils to a flat, round base which is set in a dish so that it can be rotated by hand. Coils are added to raise the pottery walls. Wood, stone, and gourd-scraping and polishing tools are used for blending and smoothing each layer of coils.

Raphael Ibigbami, professor of ceramics at the University of Ife in Nigeria, examines in depth the complex role of the woman potter in Yoruba society:

She is not only an artisan but an employer of labor, an artist and a worshipper. She is a "miner" when digging

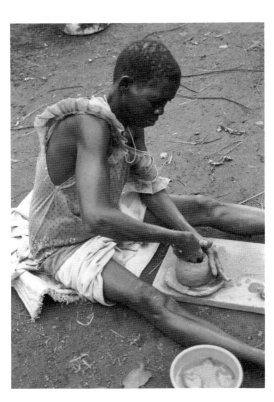

Fig. 2-3 *Senufo Village Potter,* Cote D'Ivoire, 1989.

clay, a craftsman when making pots, an artist when decorating pots, a "scientist" when mixing clay, drying, firing and hot-bathing pots, and a trader when buying and selling wares. She is a worshipper when she placates the goddess of pottery to protect herself and her work while accomplishing these scientific, artistic and economic activities.[10]

Though in each region pottery needs are similar, there are deep-rooted stylistic variations due to the family-based apprenticeship system. The student usually begins at about age four and is a relation of the potter—a daughter, a sister, or a cousin.

The pottery functions vary widely, and in addition to water storage and food preparation include dye vats, concoction pots for the preparation of herbs and medicines, burial pots and pots for ritual use at home altars or community shrines. Even a broken pottery fragment, or *agbagba*, is utilized as a child's missile for killing lizards, rats or small birds; a receptacle for transporting offerings of meat, eggs, oil or salt to a shrine to placate a deity; for the carrying of embers to ignite firewood; and even for burying the placenta. This intimate rite of passage is described by Ibigbami:

> At birth the placenta is packed neatly into a moderately sized *agbagba*, covered with another *agbagba* and buried ritually. The father digs the hole while the mother kneels down and lowers the parcel into the hole with prayers to the gods. The hole is filled with soil. It is taboo for a person to know where his placenta was buried as it is believed that such knowledge can lead to instant death.[11]

In her essay, "Women in the Arts," Lisa Aronson emphasizes the social status and substantial economic earnings that women potters can receive, which has also led to their protective strategies to "impose rigid boundaries and controls to protect profession and the processes with which it is associated."[12] Aronson also discusses the strict taboos enforced during the firing process:

> It is taboo for menstruating, pregnant or uninitiated women to approach the area. Sacrifices are made before firing to ensure that the ancestors will not interfere in a harmful way.[13]

Stylistic changes in the pottery occur as potters respond to demands of the growing urbanized upper class and to the increase of tourism. In Katiola, the Ivory Coast, there is a tremendous variety of decorative and figurative pottery that ranges from palm-sized ashtrays in the form of fish and birds to ornate casserole dishes and tall vases for flowers (Fig. 2-7, 2-8, 2-9). The women potters have also organized a ceramic cooperative with a permanent location for the display and sale of their work. This cooperative has afforded them greater visibility beyond the local weekly market, as well as the opportunity to fulfill special commissions from government dignitaries, both

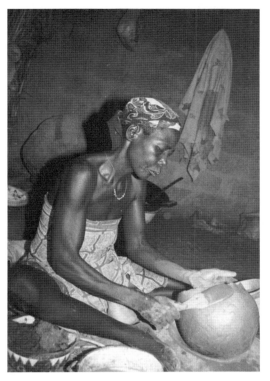

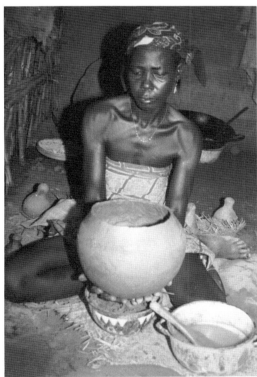

Fig. 2-4 *Fulani Village Potter, Adding Clay Coils,* Nigeria, 1987.

Fig. 2-5 *Fulani Village Potter with Finished Pot, Nigeria, 1987.*

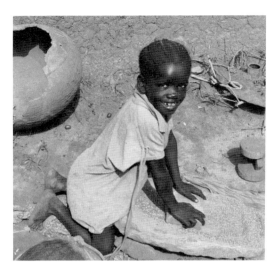

Fig. 2-6 *Dogon Child Grinding Pottery Fragments,* Nigeria, 1987.

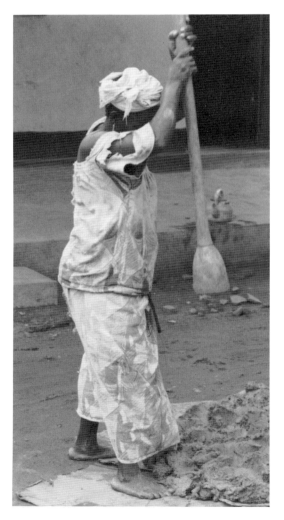

Fig. 2-7 *Pounding Clay,* Cote D'Ivoire, 1989.

national and international.

In his article on "Contemporary African Art," Dele Jegede from Nigeria points out some of the historical and negative features of cultural interchange. He discusses "the trinity of the C's: Christianity, Commerce and Civilization" and the role of missionaries who "attacked traditional arts which they perceived as the soul of traditional religion." He cites the destructive impact due to the importation of Western manufactured goods, and considers Western education as "the single most important weapon that guaranteed change" and "a threat to continuity and tradition."[14]

Jegede contrasts the training of the traditional artist through a family apprenticeship with the workshop or university training of the modern artist. He offers an example of a successful workshop established in Abuja, Nigeria, by Michael Cardew and notes that "he succeeded in harnessing the dormant artistic talents of the women potters in the Abuja area whose style is typified by the exquisite glazed pots of Madam Ladi Kwali."[15]

As potters receive recognition for their individual designs and innovations, it seems certain that more will be encouraged to try. Their efforts are also linked with patronage and access to a non-local market. Another traditional potter, Abafan Abaton, a Yoruba woman, received recognition from Thompson for her ritual pottery related to the goddess Eyinle. It is still rare, however, that a traditional potter is known by name.

By the mid-1980s, Professors Ibigbami and Ojo had established an impressive link between traditional village artisans and the University of Ife's art students in the ceramic and art education programs. Though the university's well-equipped modern ceramics facility contains pottery wheels, gas and electric kilns, these professors arranged field trips to the village of Ipetumodu where male and female students could observe the hand construction and firing methods of Yoruba women potters. Some student apprenticeships were also established with individual women so that their techniques along with rituals of respect for many facets of pottery production would be better understood and appreciated. As a result of this interaction, many personal and social barriers were overcome. Many of the ceramic sculptures produced by the students were very impressive due to their imaginative use of personal and mythological symbols stimulated by the access to the Ita Yemoo Pottery Museum at Ife and an excellent university collection of antiquities of ritual pottery.

The ability of traditional potters to inspire students can extend as far as the United States. At Texas Southern Christian University in Houston, a dynamic group of students' African inspired figurative pottery forms was on display in 1976. These "self portraits," according to Jim Biggers, the art department chairperson, were inspired by the students' awareness of African ritual pottery. Not only had Biggers been to Africa, resulting in a book of magnificent drawings, *Ananse, the Web of Life in Africa,*[16] but so had every member of the art department, including Carol Sims, the ceramics instructor. This cross-cultural exchange served as a source for confirming the artists' roots as African-Americans.

As the enrollment of women students and art faculty on the university level continues to increase both in the United States

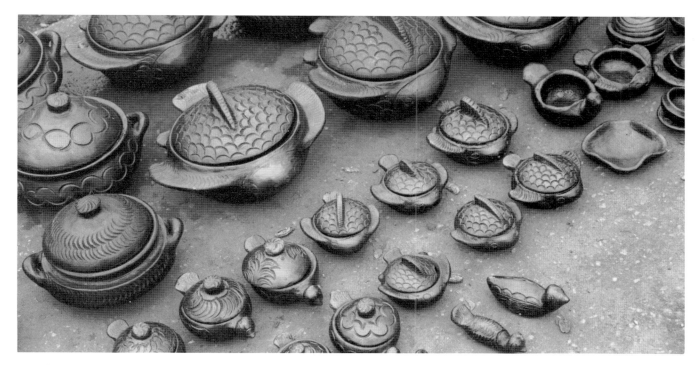

Fig. 2-8 *Ashtrays and Casseroles,* Cote D'Ivoire, 1989.

and in Africa, along with a growing feminist consciousness, this will be reflected in the art that is produced. For example, an Afro-femcentrist perspective is integral to the ceramic sculptural forms of Camille Billops, a professor at Rutgers University. Estela Lauter, in *Feminist Archetypal Theory,* describes Billops' *The Mother,* a ceramic chair and a symbol of mythic transformation in the form of a woman's body, as "full of small paradoxes: it is frightening in its suggestion of death, its stark contrasts, its emptiness. Yet it is inviting; it is a chair, maybe even a magical chair ... it allows us to respond to her from the inside, however forbidding or perplexing her exterior may be."[17]

In *Women as Mythmakers* Lauter says: "This is a stunning chair, an assertion of power not altogether benign or controllable." In Lauter's discussion of "women's vision of the place in human nature" she relates this vision as emerging "naturally from the female experience of the human body in the world—that is, from the experience of the person as having permeable boundaries." She also notes that "mythic thinking is a continuing process and not a stage that human beings passed through thousands of years ago when the dominant religions of the world were formed."[18]

As Western women and artists turn to goddess symbols and images for a reaffirmation of personal and ecological values emphasizing the need for living in harmony with the environment, the ancient goddess images and their presence in contemporary third world cultures become rich sources for investigation. A study of African women's ritual pottery and their use in ceremonies to honor various river deities such as Osun, Otin and Erinle is especially rewarding. Ibigbami notes: "The potter is looked upon with

Notes

1. Marla C. Berns, "Ceramic Arts in Africa," *African Arts*, Vol. XXII, no. 2, Feb. 1989, p. 36.
2. J. R. O. Ojo, "The Position of Women in Yoruba Traditional Society," Department of History, University of Ife, Nigeria, Seminar Papers, 1978-79, p. 131.
3. George Eaton Simpson, "The Art of Dahomey," in *Melville J. Herskovits, Leaders of Modern Anthropology* (New York: Columbia University Press, 1973), p. 111.
4. Anita Glaze, "Woman Power and Art in a Senufo Village," *African Arts*, Vol. VIII, No. 3, Spring 1975, African Studies Center, UCLA, p. 26.
5. *Ibid.*, p. 27.
6. J. R. O. Ojo, "The Position of Women in Yoruba Traditional Society," Department of History, University of Ife, Nigeria, Seminar Papers, 1978-79, p. 134.
7. *Ibid.*, p. 134.
8. Maude Wahlman, *Contemporary African Arts* (Chicago: Field Museum of Natural History, 1974), p. 10.
9. Robert Farris Thompson, "Abatan: A master Potter of the Egbado Yoruba," *Tradition and Creativity in Tribal Art* ed. Daniel Bielbuyck (Berkeley: University of California Press, 1969), p. 181.
10. Raphael I. Ibigbami, "Some Socio-Economic Aspects of Pottery Among the Yoruba Peoples of Nigeria," *Earthenware in Asia and Africa*, ed. John Picton, School of African Studies, University of London, June 1982, p. 106.
11. *Ibid.*, p. 108.
12. Lisa Aronson, "Women in the Arts," *African Women South of the Sahara*, ed. Margaret Jean Hay and Sharon Stichter (London: Longman, 1984), p. 129.
13. *Ibid.*, p. 129.
14. Dele Jegede, "Contemporary African Art," *Art Papers*, vol. 12, no. 4, July/August 1988, P. 22.
15. *Ibid.*, P. 23.
16. John Biggers, *The Web of Life in Africa* (Austin, Tx.: University of Texas Press, 1962).
17. Estela Lauter, *Feminist Archetypal Theory* (Knoxville, Tenn.: University of Tennessee Press, 1985), pp. 56-7.
18. Estela Lauter, *Women as Mythmakers* (Bloomington, Ind.: Indiana University Press, 1984), pp. 1, 135, 140.
19. Ibigbami, op. cit., p. 106.
20. Lowry Sims, "The New Exclusion," *Art Papers*, Vol. 12, No. 4, July/August 1988.

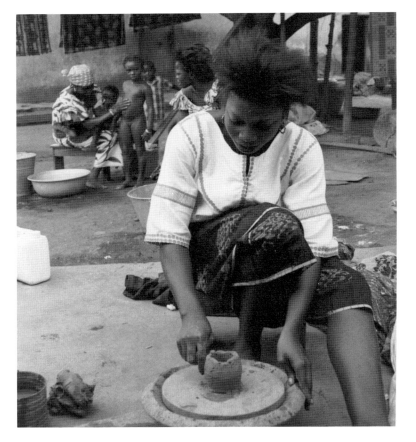

Fig. 2-9 *Senufo Potter*, Cote D'Ivoire, 1989.

special respect as she is believed capable of evoking those spirits under whose inspirations she makes her pots."[19]

There are, however, many issues to be addressed regarding social responsibility in cross-cultural exchange. For example, in the United States,

> there is no denying that the contributions of Black, Hispanic, Native Americans or Asian Americans have had an indelible influence on the flavor of American culture as a whole. But, if we continue to consume the products of these cultures while the populations within which they are engendered remain excluded, oppressed and exploited in the arenas of world and art politics, then as professionals and cultural consumers we can no longer maintain our smug self-images as social liberals, and must confront the inherent contradictions that permeate our chosen field of endeavor.[20]

From this brief overview of issues related to the contributions of traditional women artists in society, past and present, one can see the need for extending women's visibility within the mainstream. As rigid values and views of art begin to expand, we all benefit from greater accessibility to the traditional and contemporary arts of diverse cultural heritages.

Princess Elizabeth Olowu
Nigerian Sculptor

AS AFRICAN CULTURE evolves in response to changing social conditions, Princess Elizabeth Olowu's monumental sculptures offer traditional continuity as well as a refreshing contemporary and feminist perspective. Her sculptures range from symbolic ceremonial vases and portraits of the ancient gods to life-sized expressionistic images on themes of birth and death exemplified by *Zero Hour* (Fig. 3-1) and *Soldiers of the Biafra War*.

An energetic 41-year-old mother of eight, Olowu overcame ancient cultural taboos prohibiting women from sculpting in order to develop her talent. At present she is a member of the faculty of Benin University and maintains her own bronze foundry. Her mastery of bronze technology is an unusual achievement, as historically women were banned from the bronze workers' guild which at one time produced sculptures only for the *oba* or king.

Olowu's contribution to African art and Benin palace art can be better appreciated from a historical perspective. Benin, a city state within Nigeria, came to the attention of the West after the 1897 British invasion, the destruction of the palace, and the *oba*'s forced exile. Thousands of bronze portraits of the royal family, architectural plaques depicting ceremonial scenes and historical events, carved wood and ivory were all taken to England and auctioned to museums and private collections throughout Europe and the United States.

Paula Ben Amos in *The Art of Benin* tells us that in the period following the palace upheaval "the traditional impetus for artistic creation no longer existed ... art production stagnated."[1] When the British permitted the senior son of the last *oba* to return to Benin in 1914 and assume the throne, a new era of Benin art began.

The oba built a shed, later to become an arts and crafts school, in the palace courtyard so that the craftsmen could have a place to work and sell their wares. Traditional guild members were thus able to continue creating art forms for their former patrons while at the same time producing objects for a new clientele: colonial officers, tourists, and a developing Western-educated Nigerian elite.[2]

After Nigeria's independence from English colonial rule in 1960, the palace continued as "the focal point of Benin social

Fig. 3-1 Princess Elizabeth Olowu with her life-size cement sculpture, *Zero Hour,* Benin, Nigeria, 1986.

aspirations" and the center of ritual activity "aimed at the well-being and prosperity of Benin."[3] Economic and cultural expansion in the 1970s linked to Nigeria's oil production was followed by depression in the 1980s when the world market for oil fell and in turn affected government patronage and support of the arts.

One of the keys to Olowu's success is her royal lineage, as she was born in 1945, the daughter of *oba* Akenzua II.[4] He was considered an enlightened *oba* and ruled for 45 years, from 1933 until his death in 1978. Agro Benson Erhinyodavwe describes Akenzua II as "an uncommonly intelligent man who understood the dynamism of societies and tried to adjust himself quite admirably to the fast-changing times."[5]

As a young child the princess learned from her mother, a court artist and the third of the *oba*'s ten wives, to create items related to palace life and ritual needs: elaborate hair styles with coral bead decorations, fiber and fabric dying and embroidery of garments and beadwork and the weaving of mats and bags. Her mother also gave oracle consultations, and was considered by the *oba* as his *Ehi* (second nature or shadow), and a person of good luck. Special ceremonies were often performed in her honor.

The purpose of the annual cycle of palace ceremonies is their link to Benin religion and also to fortify and assist the *oba* in his work to assure balance between "the visible tangible world of everyday life (*agbon*) and the invisible spirit world (*erinmive*), inhabited by the creator god, other deities, spirits and supernatural powers."[6] It was interesting to note that the ceremonies begin with the New Yam Festival as yams are the food staple of Nigeria, and includes: rituals for the fertility of the nation, to repel evil, and to honor paternal ancestors.

Not content to follow in the queen's footsteps, the princess, the fourth of the queen's ten surviving children, preferred to observe the palace bronze casters and to form small objects in clay. She told me, "I soon realized that I couldn't do well in any other profession."

The conservative Ogun casters who feared exposing their secrets were ordered by the *oba* to allow the princess to work in their foundry. She told me, "I was overjoyed when the *oba* saw my first pieces and permitted me to continue sculpting. He also called my attention to the fact that he was not satisfied with the present level of bronze casting."

Olowu's formal education began at the same government school attended by her father, and on Sundays she accompanied him to services at the Holy Arousa Church which he founded. In 1956 at age eleven, Olowu was sent to Lagos, the capital of Nigeria, to attend Holy Child College, a secondary school, where the Reverend Mothers dedicated their lives to the "education and moral training of young women so that they may become responsible housewives and mothers."[7]

Olowu benefitted from the art and performance activities related to Christmas and the celebration of the various saints' days. Her artistic skills as a painter as well as her academic abilities were recognized. After attending the Federal Emergency Science School for two years, majoring in botany, chemistry and zoology, she began her teaching career at the Anglican Girls Grammar School in Benin in the fields of art and science. She

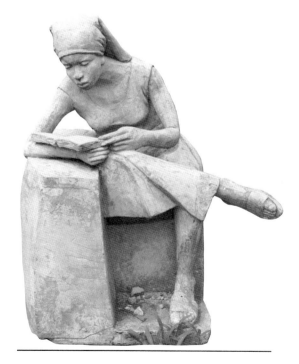

Fig. 3-2 *Acada,* life-size, cement, 1979.

taught for one year, but once again she realized her future was in the visual arts.

At this time it was unusual for a woman's personal life and professional aspirations to merge harmoniously. Marriages were usually arranged for political reasons, with daughters frequently forced to marry old chiefs. But Akenzua II gave his daughter permission, at age eighteen, to marry Babatunde Olowu, a high school friend. Olowu's first son was born in 1964, but in agreement with her husband, she continued her education while having children.

In 1966 Olowu enrolled at the University of Nigeria in the northern city of Nsukka, but her art studies were curtailed by the Biafra War of 1967-1970, a "very rough" period. Olowu was advised by her family to return to Benin which remained free from attack, and "to stay at home and take care of her two sons (the second being only a few weeks old), as the place of the woman is beside her husband and children."[8]

For the next ten years as Olowu's family grew, she resumed her teaching career at the Anglican Girls' Grammar School and organized annual student art exhibits featuring their uniquely designed calabashes, straw, fabric, bead and leather projects. When Professor Todd, the first director of Benin University's newly formed Creative Arts Department, visited Olowu's student exhibit he was impressed by her ability to motivate their individual expression. Todd then insisted that Olowu continue her own studies, and in 1976 she was among the first four students enrolled in Benin University Creative Arts Department. By that time she had six children of her own.

Extremely ambitious, Olowu admitted there were periods of stress and conflicts with her instructors, but in 1978 she was awarded the department prize for "best student," and graduated in 1979 with a Bachelor of Fine Arts degree. In exchange for her cost-free education, Olowu was obligated to participate in Nigeria's National Youth Corps Service program for one year and to teach, with minimum salary, at the federal government's Girls' College in Benin.

When Olowu returned to Benin University from 1981 to 1983 for post-graduate study, her master's thesis was "An Investigation into Benin Cire Perdue Casting Technique." Olowu became Nigeria's first female bronze caster and bronze founder and recipient of a Master of Fine Arts degree in sculpture. During this period, in addition to producing a remarkable series of monumental mixed media sculptures, she also improved bronze smelting techniques which had been performed with few modifications since the fifth century. Erhinyodavwe records,

The princess has an ardent belief that hard work is the only road to success and fame. One insatiable passion in her heart is to create and execute her ideas successfully and at such a time, the princess would toil day and night either mixing and carrying cement or fearlessly fanning, like a man, the blast of her bronze smelting furnaces.[9]

With the support of her husband, a construction and block-

Fig. 3-3 Ovbiekpo, height 8-½', granite and cement, 1979.

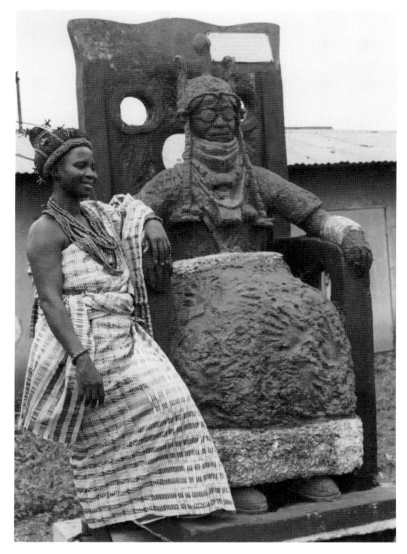

Fig. 3-4 Princess Elizabeth Olowu with *Oba Akenzua*, bronze, height 10', 1982.

molding industrialist, Olowu established her own model bronze-casting foundry utilizing an efficient gas furnace that she designed. Olowu proudly comments, "My husband supplied lots of concrete, granite and laborers to help, and in turn, he learned a lot about art from me. All my children do art in one form or another."

Since joining the faculty of Benin University in 1984 as a Fine Art Tutor for the Demonstration Secondary School, Olowu has become a significant role model for her students as both a teacher and artist. Her time is divided: mornings for teaching, and afternoons for her own studio work. Exhausted by this demanding schedule and anxious to fulfill her own professional goals, Olowu plans in the near future to teach only part-time, or if finances permit, to devote herself entirely to her own sculpture.

In 1985 Olowu received the Bendel State Award for Art and

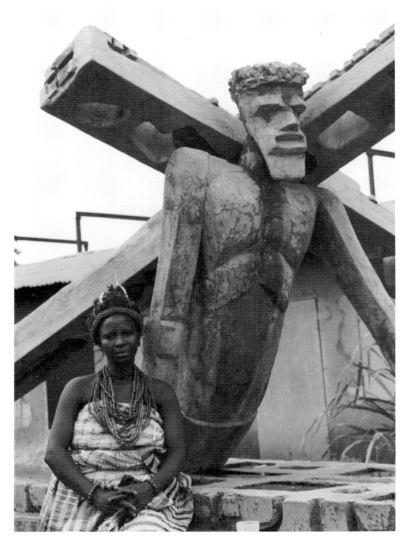

Fig. 3-5 Princess Elizabeth Olowu with *Christ*, cement, horizontal, 14', 1982.

Culture and was recognized by Women In Nigeria and the Young Women's Catholic Association for her contribution to uplifting the status of women in her country. Invited to exhibit at the International Women's Conference in Nairobi, Kenya, Olowu was prohibited from attending by the lack of government financial support. In 1989, however, Olowu did attend the Third Biennial Conference and Art Exhibition in Havana, Cuba, with two experimental banana fiber sculptural representations of Oba Akenzua II and his wife. Olowu describes the queen as a "Destiny Spirit" ... "This guardian spirit leads you through life so if you have a good Ehi you do not have much problems in life, and if you do, they are few and spaced out like your grandfather's teeth."[10]

Olowu's sculptures vary in style from realism and expressionism to geometric stylization, but Erhinyodavwe notes, "Although Princess Olowu is not against abstraction, she does

not hide her displeasure for those who hide their faults under the cloak of abstraction." ... She told him, "I believe in translating my imagination of the spiritual world into the common language that can be easily understood by the society in which I live."[11]

As Olowu continues to experiment with ancient as well as modern media and techniques, she incorporates themes related to her cultural heritage but imbues them with personal feelings and experiences. One of her earliest, realistic sculptures, from 1979, cast in white cement, is autobiographical, as it depicts a young student seated at a desk, absorbed by a book. Olowu reminisced, "I was frequently teased as a childand called *acada* or bookworm." This piece differs from most traditional representations of the female as it depicts a unique individual, integrated into modern life. *Acada* (Fig. 3-2) has been shown at many trade fairs and, until recently, *Acada* read at the entryway of Benin University's Optometry Department.

Ovbiekpo or *Young Masquerader* (Fig. 3-3, inspired by an ancient Benin legend about the romantic escapades of a young prince, symbolizes "the realm of transition where man and spirit meet."[12] This vertical granite form, over seven feet tall, contains four carved faces so that Ovbiekpo, an ancestor spirit, can look around from all directions to see the whole world.

In 1982 Olowu also explored the theme of power from emotionally and aesthetically diverse perspectives. She worked simultaneously on three images: The *Oba*, representative of the Benin monarchy; *Eshu*, the feared priest of hell; and *Christ*, bearing the weight of humanity's sins.

The *Oba* (Fig. 3-4 is a realistic life-size portrait of her father created a year after his death and the bronze inscription on the throne reads: "Oba Akenzua, 1899-1978, the first sculpture produced at the University of Benin, in 1982, by his daughter Princess Elizabeth Akenzua 'Olowu.'" This is the first nontraditional view of an *oba* in the history of Benin art.Seated upon his throne, the *oba* appears humble and diminutive as he looks out at us through his eyeglasses. The many strands of coral beads usually covering an *oba*'s neck and chin are absent and his ceremonial robe is roughly textured with a pattern composed from Olowu's own hand print. The hand in Benin culture is a symbol of an individual's success and is:

> intimately linked with an individual's destiny and the mystical aspects of the human personality are embodied in the head and the hand. ... If someone has led a successful and prosperous life he can then erect a shrine to his Hand, the representation of an individual's achievement in the worldly sense: the possession of slaves, wives and ancestors.[13]

When this nonconventional sculpture was presented to the community, Olowu recalled, "The people's response was gratifying and my work was much appreciated." She added with humor, "When I finished this piece, which is titled *The Living Dead*, I even sat on the *oba*'s lap and had my photo taken. It seemed to my friends he was still alive."

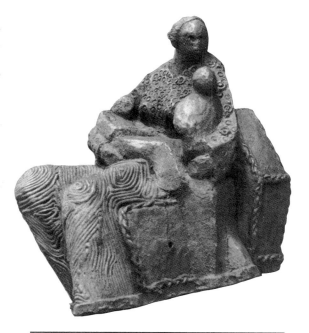

Fig. 3-6 *Mother of Many #1*, 9x12", bronze sketch, 1982.

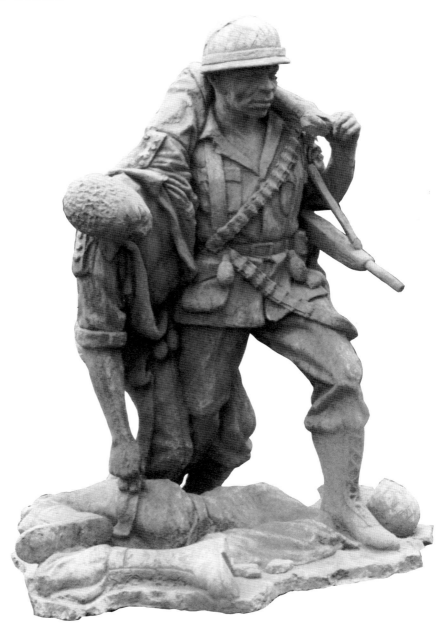

Fig. 3-7 *Biafra War*, life-size, cement, 1984.

In contrast, *Eshu Recreated* is a complex image, as Eshu's three cement carved and black painted faces represent passiveness, satisfaction, and discontent. They are imbedded within a maze of numerous buffalo horns that jut out in all directions. Olowu describes *Eshu* as a potent god of both the Benin and Yoruba peoples.

In Benin, if a child is ill and has a high temperature, people believe *Eshu*, the priest of hell, is smiling at the child who is scared. Like the devil, *Eshu* can do good, if satisfied; therefore, in every Benin household there is a shrine dedicated to *Eshu* for offerings, so that he will help fight your war for you.[14]

Olowu's unusual horizontal representation of *Christ* (Fig. 3-5) spans 14 feet. *Christ* is on his knees, bearing the weight of the cross, symbolic of humanity's sins. The design of the space between Christ's partially uplifted torso and the long, rigid form of the cross adds to the dramatic power of this piece.

Approximately 40 percent of Nigeria's population have been converted to Christianity. According to Amos, there seems to be minimum conflict between traditional and Christian celebrations as "in recent times, the number of public palace rituals has been reduced and their performance restricted to the Christmas vacation, but their meaning remains."[15]

In contrast to images of male power, Olowu began a series of diminutive 9-by-12 inch clay sketches cast in bronze on the theme of *Mother of Many* (Fig. 3-6). These tender sketches of pregnant women, or mothers and children served as preparation for her monumental *Zero Hour* (Fig. 3-1 and 3-1 detail), one of a series of six powerful, life-size images begun in 1983.

Zero Hour is an intimate interpretation of "a mother's life during labor as she hovers between life and death." This life-size image cast in warm sepia cement confronts us with its powerful expression of pain and expectancy. It also incorporates many Yoruba ritual details connected with pregnancy and spirituality. Olowu, herself pregnant while creating this sculpture, insisted on working until the last hour of her own pregnancy, as she was concerned, "I didn't want to leave my work in an unfinished stage so that it could spoil."

She also said, "In Nigeria a woman is considered a maiden until her first child is born, and women without children are pitied. Every pregnant woman must have a shrine for ritual offerings, so that god should provide good children. and there are different hair plaiting rituals for each stage of pregnancy. A woman's hair is undone just before the baby is delivered." Since pregnancy complications, such as excessive bleeding or stillbirth, are attributed to the unknown, women seek help from diviners and herbalists, and wear amulets and charms around their arms and waists for protection. A little calabash suspended from the neck can also contain medicinal herbs. Ritual sacrifices of chickens or goats are sometimes recommended for a safe delivery as well as a bathing ceremony prior to delivery with magical leaves boiled by the mother.

Olowu also explained, "When a woman is in labor, she must sit on something hard and strong against which she can push." Therefore, in *Zero Hour* the arm of the expectant mother's chair contains the design of a mortar, an elongated stone used for grinding grain or cassava. During the birth process a mortar is gently placed against the woman's thighs and spine as a symbolic gesture of strength and to help alleviate her pain.

The theme of aggression from contrasting perspectives dominated Olowu's work in 1984. The bronze life-size *Soldiers of the Biafra War* (Fig. 3-7), or *Nigeria's Civil War,* is a disturbing conclusion about aggression. With detailed realism Olowu depicts the stunned, tragic expression of two soldiers, supporting each other beside a fallen comrade. This piece is a solemn, universal commentary on the tragedy of war with no winners.

Nude Children (Fig. 3-8), a life-size sculpture of two brothers

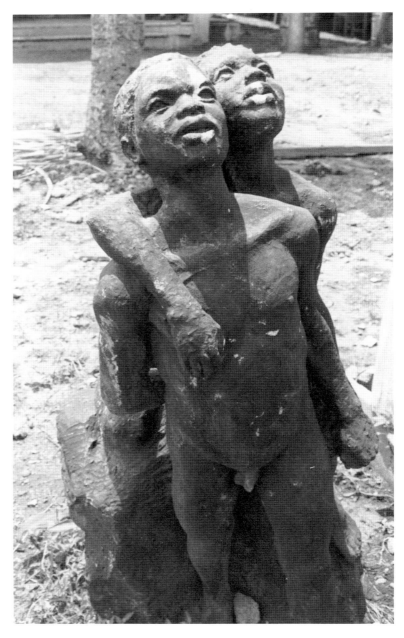

Fig. 3-8 *Nude Children*, life-size, cement, 1984.

with arms intertwined, was inspired by her own boys. When they were young she frequently had them with her while sculpting, and occasionally through their mischievous play they even caused minor damage, such as the black paint chipped from the lips of her *Nude Children*. For a long time her children served as significant sculptural themes.

Reverting once again to traditional themes, Olowu produced five ceremonial vases two and three feet tall that unfortunately remain in their original wax form, awaiting funding for bronze casting. The symbols incorporated in each vase were described by Olowu as: "the bird of disaster, or god's messenger, who pre-

dicts when something terrible is going to happen; the tiger, king of the forest a sign of royalty;and the tree of life, associated with the curative powers of herbalists, can drive away evil spirits, help women deliver safely, or make witches confess their crimes."

Although in recent years palace rituals have been curtailed, as well as the creation of ceremonial art objects, Amos, unaware of Olowu's contributions, still assures us "This hardly marks the end of Benin art. It has shown over the centuries a remarkable resilience in the face of all kinds of change, whether political, economic, social or religious."[16]

According to Erhinyodavwe's investigations, Olowu has been described as both "radical" and a "patient, understanding woman of great warmth and kindness, especially towards the less fortunate."[17] He also concludes: "There is no profession in Africa in which women are not found nowadays. But it is a matter of wonder to have a princess, who was never at anytime in need, inclined by nature towards the hard career of a sculptor."[18]

Most impressive about Olowu is that she considers her professional goals "the aim to make people appreciate my efforts" secondary to her "desire to liberate womenfolk from the shackles of men, deprivation and taboos."[19] Olowu also adds the following historical insights related to the role of Nigerian women, class and society:

> Women could not cast bronze and they had to surrender their skills and their husbands took the glory. Women were forbidden to enter some shrine houses for fear of pollution but they cooked the food eaten by the chief himself. The Oba of Benin intelligently suppressed them all and used their skills to build one of the greatest empires in Africa. The Obas of Benin were the law makers and naturally the laws were tailored to assist them in the control of the large empire.
>
> That is where my luck was. I could never have realized my talent as a bronze caster if I belonged to the ruled class, many of whom must have died with their skills undeveloped for fear of taboos. In this continent of Africa, generally the furnace, bellows and smelting pot were regarded as sacred things and women at menstrual time regarded as polluting elements. They were not allowed to touch the bronze caster for fear of causing accidents during casting. In the palace the women at such a time could not talk directly to their husband except through an interpreter.[20]

Olowu has also written about her personal battles for recognition:

> More people now request me to put down the story of my life because they are puzzled about how I have managed to succeed in a society bound in age long tradition, taboos, restrictions, expectations some of which are now outdated and retrogressive. I am certain you will be startled when I reveal to you the number of times I have locked horns with men who display some of the worst

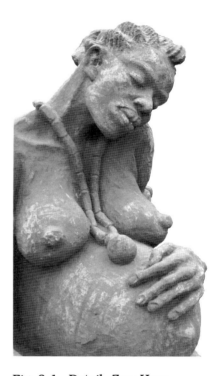

Fig. 3-1 Detail, *Zero Hour.*

Notes

1. Paula Ben-Amos, *The Art of Benin* (London: Thames and Hudson, 1980), p. 43.
2. *Ibid.*, p. 43.
3. *Ibid.*, p. 68.
4. All quotations unless otherwise cited are from my interview with Princess Elizabeth Olowu in her Benin studio in Nigeria, August 1986 and 1987.
5. Agro Benson Erhinyodavwe, *The Life and Works of Princess (Mrs.) Elizabeth Aghayemwence Olowu*, Matriculation Number 8300119, Faculty of Creative Arts, University of Benin, Benin City, Nigeria, July 1987, p. 1.
6. Ben-Amos, *op. cit.*, p. 70.
7. Erhinyodavwe, *op. cit.*, p. 11.
8. *Ibid.*, p. 21.
9. *Ibid.*, p. 26.
10. Quoted from correspondence with Olowu, July 1989.
11. Erhinyodavwe, *op. cit.*, p. 31.
12. *Ibid.*, p. 40.
13. Ben-Amos, *op. cit.*, p. 57.
14. *Ibid.*, p. 70.
15. *Ibid.*, p. 93.
16. *Ibid.*, p. 93.
17. Erhinyodavwe, *op. cit.*, p. 27.
18. *Ibid.*, p. 68.
19. *Ibid.*, p. 1
20. *Ibid.*
21. Correspondence, July 1989.

abuses to women in my country. ... I believe in fighting back in order to free myself from man-made sticky situations. ... I believe that every woman in my country should be unyielding when defending her rights.[21]

During Olowu's brief but intense period of aesthetic maturation, she has already contributed a significant personal and feminist perspective to Nigerian culture. As her talent continues to evolve and inspire others, one wonders if Olowu will receive the recognition she deserves, which previously was given only to male artists. Unfortunately, without major sponsorship, most of Olowu's bronze and cement sculptures will remain in her foundry courtyard exposed to the elements, rather than protected in the museums and honored as part of Nigeria's national heritage.

Nike Davies

Nigerian Batik Artist

THE STORY OF Nike Davies' (Fig. 4-1), formerly Nike Twins Seven Seven's, artistic development is as colorful and vibrant as her enormous batik paintings. An article that appeared in *Network Africa Magazine* described Davies as "Nigeria's leading batik artist. Her work has been heralded as an example to encourage more women to enter the art field. [Davies] works in the modern context using traditional techniques and imagery. Her efforts are directed toward preserving the Yoruba culture through contemporary art."[1]

In discussing Davies' life and art, it is impossible to omit either her cultural heritage or her former husband, Twins Seven Seven, a multitalented musician-artist. He was the first to recognize and nurture the seeds of her creativity. Twins also exposed Davies to a broader world view, including Western aesthetics and feminism, and was shocked by the emergence and evolution of the mature, independent woman who later rebelled against him. Their clash reflected both the close intertwining of their careers and a cultural collision between traditional Yoruban and Western values.[2]

Within Nigeria's total population of ninety million, where 250 dialects are spoken, the fifteen million Yorubas form one of the largest groups. At present, many Yorubas have converted to Christianity and Islam, but polygamous marriages still are common.

Davies, or Monica Ojo, was born in 1951 in the small village of Ogide. Twins Seven Seven was also born in Ogide, but they did not know each other as children. Davies' father is a farmer, also known for his drum playing and leather work. Her mother, "a tall, strong woman of remarkable beauty," died when Davies was just six years old. Her father, a Catholic, had no other wives and refused to remarry. After her mother's death, the burden of housework, especially carrying wood, cooking, and looking after her younger brother, became Davies' responsibility.

Davies learned many traditional craft skills from her grandmother, including the processing of raw cotton, and loom-weaving used for creating the traditional *oja*, or long strips of ornamental cloth for carrying babies on mothers' backs. She considered this craft just another "household chore." Davies said, "that they were punishing me. This was too much work, removing seeds from cotton" even before the spinning and weaving could begin.

During this period while attending primary school, Davies was taught the use of cassava vegetable starch resist technique

Fig. 4-1 Nike Davies, Nigeria, 1986.

for creating highly textured *adire* design patterns on cotton yard-age. This cloth, utilized for both men's and women's clothing, is then dipped into a deep, velvety blue dye solution produced from the indigo plant. The Yoruba take great pride in their appearance and still enjoy wearing brightly patterned traditional garments, rather than Western clothes (Fig. 4-2 and Fig. 4-3).

Realizing that women received meager financial rewards for their long hours of cloth production, Davies' business acumen quickly sharpened. Not only did she enjoy producing individually commissioned pieces, including embroidery and batik, but her skills also developed rapidly. Davies recalls, "The first time Anglican Catholic Missionary sisters bought my work to give as gifts, I said, 'This gives me money.' So, little by little, I did it regularly."

Davies' adventurous, restless spirit soon found new channels of expression. At sixteen, she ran away and joined Olosunta, a traveling theatre group. Eventually Davies' and Twins' paths crossed in the town of Oshogbo, where Twins, eight years her

senior, was performing with his own theatre and musical group.

When Twins first met Davies in 1968, he was impressed with her talents as a singer and dancer. He used his magnetic charm to persuade her to join his group. They married in 1970. Davies was Twins' third wife, and many more followed.

Twins' home became the source of a cottage industry. In order to contribute to their common household economy, he encouraged all his wives into one or more forms of creative production: batik paintings, sewing clothes for children and adults, and hair dressing. Davies claims each wife actually was responsible for herself and her children. And, as Davies was the most talented and receptive, Twins placed her in charge of the workshop. Davies taught four of the wives batik painting as a form of individual expression. Their combined work sold well both locally and abroad.

Twins was proud of Davies and elevated her to a superior position in his ever-expanding household. Although an honor, this position also increased the rivalry among the wives. Davies was the first wife to travel outside Nigeria with Twins.

It was apparent that Davies' initial professional opportunities to exhibit, give workshops, and travel were made possible by Twins. Also, in discussing her art career, Davies credits Twins with having taught her to draw. Within ten years, however, Davies had established her own independent, professional base, an unusual feat for a "traditional" Yoruba woman.

She looks back upon the early years of their relationship with anger. "Twins never knew I could become somebody," she says. She views polygamous matrimony as "not easy. The women are suffering. Some of the men don't want you to go out and they keep you in the compound, afraid once you go out and see life, you don't want to remain married. ... We think if we leave, we can't support ourselves."

As Davies began to develop her artistic skills and achieve recognition, her self-image changed. Davies' emotional outlet for her diverse visions and dreams became the batik technique. She could concentrate intensely, working ten or twelve hours at a time. Her batiks range in size from smaller pieces of twenty-four inches by thirty-six, to larger panels, spanning five feet by eight feet. "There is nothing static or rigid about Nike's work," commented a reviewer in *West Africa Magazine*. "It is imbued with the dynamism of her imagination."[3]

Davies' visual themes came from Yoruba history, myths, her dreams, and everyday life. "Maybe I wake up in the night, I have something in my head and I sketch it," she says. "I work on four or five smaller pieces at one time. Every one or two years I change my technique—that is why people are still buying my work."

Davies' international exposure first occurred in 1974 at a workshop at Haystack Mountain Crafts School in Maine. It was Davies' first opportunity in the United States to teach and exhibit her work. Her creative struggle has resulted in national and international fame. In a recent article, "People on the Move," in *Network Africa*, she is credited as "one of the few female artists in Nigeria Yorubaland." She is "sensitive to her obligations in maintaining and developing the African traditions through her art work. ... She is an asset in developing cross-cultural understanding."[4]

Davies' work vacillates between descriptive storytelling

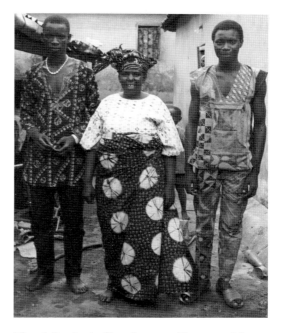

Fig. 4-2 An indigo dyer and her neighbors wearing adire patterned garments, Nigeria, 1986.

Fig. 4-3 Detail of garment pattern.

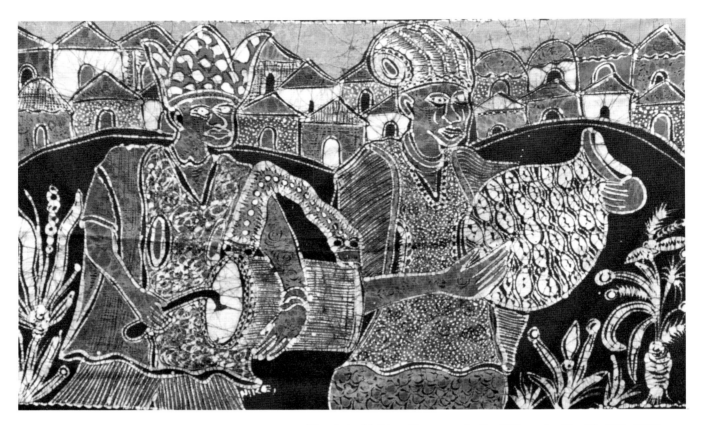

Fig. 4-4 *Talking Drummer in the Village*, batik, 48x60", 1980.

images like the *Talking Drummer in the Village* (1980, Fig. 4-4) and *Palm Wine Tapper* (1985, Fig. 4-5), to more internalized and poetic renditions such as *Virgin Carrying a Calabash on Her Head*. In *Talking Drummer*, town musicians are playing the drums which are constructed from wood and bead-covered calabashes. Drum rhythms are integral to all family or communal celebrations. Her initial drawing is first created with hot wax, which preserves the figure outline in the cloth's original color. Orange, brown, black, and blue dyes are used for filling in the textured forms of the drummers against a village background.

In *Palm Wine Tapper*, the eager tapper embraces the lean tree with hands and bare feet in order to scale heights of twenty or more feet, where he can gain access to the palm wine, tapping it and filling a gourd. Palm wine, less alcoholic than beer, is the national beverage. Therefore, the tapper skills are valued and there are many Yoruba legends concerning the interaction between the land owner, the tapper, and those overindulging in the palm wine.

The vivid linear brushwork depicting *The Shango Priest* (1984), is limited in color to indigo and white. Davies' rendition of Shango, god of thunder, is vital and alive—comparable to a Japanese sumi brush painting.

One of the most intriguing aspects of Davies' work is her expressive treatment of the human form. Her forms can be dwarfed, as in the *Virgin Carrying a Calabash on Her Head*, or

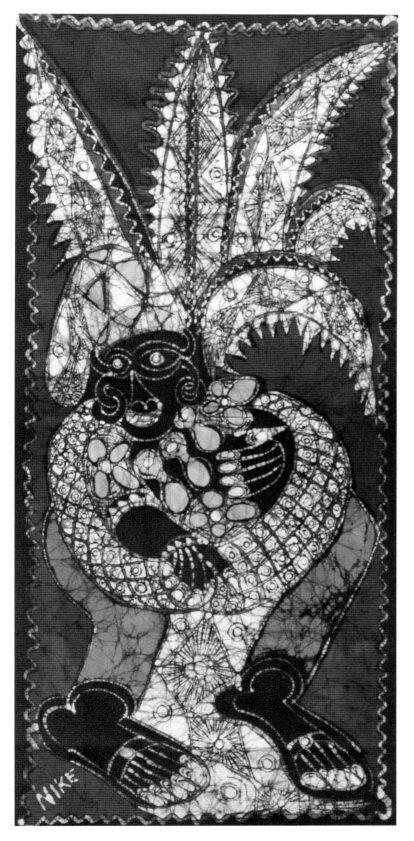

Fig. 4-5 *Palm Wine Tapper*, batik, 36x60", 1985.

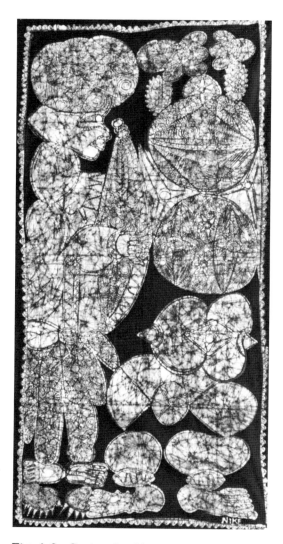

Fig. 4-6 *Seeing the Ghost with One Eye*, batik, 36x60", 1981.

elongated, like the lean hunter in *Seeing the Ghost with One Eye* (Fig. 4-6). Davies' intuitive sense of design is clearly manifested in these batiks, as her rounded, silhouetted forms in limited colors contrast strongly with their dark background. The rich, crackled batik surface treatment sometimes is augmented with designs related to *adire* patterns, as those on the virgin's calabash. Humor and surprise are reflected in her work as well, exemplified by the hunter who tries to grasp the dismembered body of the ghost, or the virgin who is truly overwhelmed by the calabash.

In another batik, *The Hunter* (1981), the image is rendered in a dominant yellow-gold against a black-bordered background. The hunter, weighted down by the deer (or the vision of the deer) upon his shoulders, smiles, while a bird looks at him from a nestled perch within his suspended bow. The mood of this gentle, charming image contrasts strongly with the *Snake and Birds* (1984, Fig. 4-7), in which we see a coiled snake striking at two roosters. Sharp, angular, zigzagged forms of the plumage, open bird beaks, and the fanged, hissing mouth of the snake are all intensified by the surrounding bright and passionate colors of red, orange, and pink.

Border patterns play an important part in most of Davies' compositions. These can vary from a thin, convoluted line to a broad, patterned edge. The overall impact of her imagery is exciting because of her intensely diverse and personal treatment of Yoruba mythology. In these particular works, the emphasis is not feminist, but cultural. Even the diminutive virgin supporting the calabash is a typical event seen at the annual osun festival; a young virgin is selected to walk with a calabash on her head from the oba's (king's) palace to the sacred Osun grove. The water contained in the calabash is not to be spilled. Osun is celebrated as the Yoruba goddess of fertility—the mother of all.

Victoria Scott, in the catalog *Oshogbo Art: Batik of Nike and Work on Paper from Oshogbo*, acknowledges Davies as Nigeria's leading female artist, whose "output is prodigious" and "imagination unfailing." Scott writes that "Nike learned the discipline required for her complex decorative patterning from her husband and from the traditional *adire* artists, but she invented new patterns to suit her own needs and the demands of her chosen media."[5]

In the early 1980s Davies divorced Twins. She moved to the town of Ede, seven miles from Oshogbo, where the oba generously gave her free land on which to build a house, for which she had carefully saved her own money. In the three years that passed, with the help of David, a man of Welsh descent and her new husband, she was able to build a house and workshop where she also raises their new baby.

When parents divorce in Yoruba society, the children legally belong to the father. Davies appealed once again to the Ede oba for custody of her children. The oba, who has jurisdiction over such matters, granted her request. Twins never accepted the custody decision, considering the oba's unusual decision to be contradictory to Yoruba custom. At present, the children rotate on weekends between both households. Internally, Twins has not accepted Davies' departure from his life.

In visiting Davies and her family in their Ede home, I

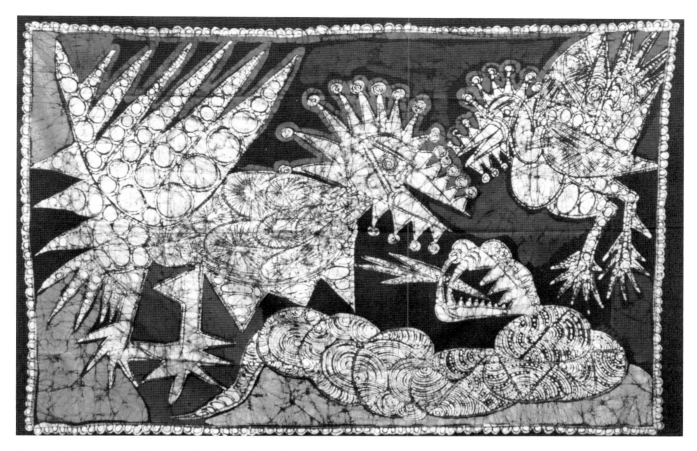

Fig. 4-7 *Snake and Birds*, batik, 36x48", 1984.

became aware that Davies' broad, warm smile and exuberant personality did not conceal the discipline she demands from herself and her children, whose ages are nine, twelve, and sixteen. Although she has full-time household help, the children are all intensely involved with chores, school work, the new baby, and art activities. Davies is particularly proud of her oldest son, Labayo Olaniyi, whom she has trained as a batik painter. He has exhibited his work with hers in the United States.

At present, Davies' new studio is under construction. Meanwhile, she works in the patio behind her house. Near the tables where she applies hot wax to cloth with a foam brush in order to create her detailed images, are large, heated vats containing various colors of dye, where the fabric is submerged and then later rinsed with cold water. As Davies works, frequently she carries her sleeping infant daughter on her back, supported by an *oja*, or traditional baby wrapper.

During the past decade, dramatic changes occurred for Davies. Davies' career blossomed and she began receiving extensive international acclaim. In 1981, she represented Nigeria at the International Arts Festival in Stuttgart, West Germany. In 1983, she held a workshop at New York's City Museum of Natural History. In 1983 and 1984, she participated in the spectacular Los Angeles County Fair, visited by over a million people.

Notes

1. "People on the Move: Nike Twins Seven Seven: A Woman Making the Most of Her Culture," *Network Africa Magazine* (Pratt Station, PO Box 81, Brooklyn, New York), n.d., p. 5.
2. Quotations from Davies and Twins unless otherwise cited are from interviews in August 1986, in Ede and Oshogbo, Nigeria, at their home studios.
3. Anita Butler, "Batiks from the Oshun," *West Africa* (Magazine), #3576, March 17, 1986, p. 72.
4. *Network Africa Magazine*, op. cit.
5. Victoria Scott, "Oshogbo Art: Batik of Nike and Work on Paper from Oshogbo," Brownagree Gallery, Commonwealth Institute, London, England, July 1985, Exhibit Catalog, p. 2.
6. Julie Kerchner, "Nike's Nigerian Batiks," *New African*, ANC Publication, May 1986, p. 64.
7. *Ibid.*

In 1985, Davies was the only woman artist from Nigeria to attend and participate in the Women's Art Exhibition in Nairobi, Kenya, during the United Nations Decade for Women Conference. In 1986, she exhibited and gave a workshop at the African Heritage Conference, Akina Mama via Afrika, held in London. Also in 1986, Davies exhibited her work at the National Gallery of Zimbabwe.

In a feature article in the May 1986 issue of *New African*, titled "Nike's Nigerian Batiks," Julie Kitchner says:

> Nigerian artist Nike respects Picasso's doctrine that "it is good for an artist to copy another artist, but not good for an artist to copy themselves." Despite her distinctly personal style there is little repetition, even down to color combinations, in her fabulous batik work, and she never reproduces her fashion designs.[6]

In referring to Davies' exhibit at the 1986 African Heritage Conference in London, Kitchner writes:

> Her designs tell tales, recorded from her unconscious in her dreams which she draws directly onto her cloth, from traditional fables or from her most recent experiences. Jazz dancers or even the movies in America have influenced her.[7]

In view of her beginnings in the shadow of a towering cultural figure, such international acclaim has a special significance for Davies. She takes great pride and inspiration from the fact that she has "become somebody" in her own right.

Susanne Wenger
Nigeria's Sacred Osun Grove

SEEING SUSANNE WENGER'S monumental sculptural images located throughout the Osun Grove in Oshogbo, Nigeria, is an unforgettable spiritual experience. The strain of her enormous life-dedication to this project is clearly visible in the lined face and tense eyes of this tall, lean woman, now in her mid-seventies.

Born in Graz, Austria, in 1915, Susanne Wenger (Fig. 5-1) came to Nigeria in 1950 with her husband, anthropologist Ulli Beier, and eventually made it her physical and spiritual home. Not only did she settle among the Yoruba, she also absorbed their religious beliefs. Wenger dedicated herself to the worship of Yoruba "orishas," or gods, and in time was accepted as a cult priestess. When he learned she was an artist, the Yoruba priest and her subsequent mentor, Ajagemo, asked her to help repair some of the ancient shrines located in a sacred grove paralleling the Osun River. Later Ajagemo and his followers encouraged her to build new shrines incorporating her personal vision.

Although in the early years she was often considered "a white priestess, a latter-day Gauguin, a degenerate artist looking for stimulation,"[1] she is now well known and respected throughout Yoruba country. Her artistic forms are "acceptable as an expression of Yoruba religion to the most traditional of Yorubas."[2] Wenger's work has become a source of inspiration for a new generation of traditional and contemporary artists now flourishing in Oshogbo. She and her assistants now receive salaries from the Commission of Museums and Monuments of the Nigerian Federal Government, and in 1987 her shrines were declared national monuments. Wenger's home and collections were also declared national monuments, with everything in the house catalogued by government employees.

The colossal, ongoing Osun Grove project, which began in the 1960s, extends over many acres and is overseen by the 10-foot tall sculpted form of the Yoruba goddess Osun—the mother of all. Osun stands astride a large river fish—one of her sacred messengers—her arms outstretched to welcome her daily visitors, mostly infertile women or those seeking health cures. Osun is also the protector goddess of the town of Oshogbo, and, according to belief, her pact with the residents is renewed annually at the Osun festival held the last week of August. Then special homage is given to Osun by the thousands who come to pray, offer sacrifices, and bathe in and drink the river water.

Wenger's dynamic, free-standing sculptural forms, especially the Iyamoopo (Figs. 5-2) and Alajere shrines are integrated into

Fig. 5-1 Susanne Wenger, Oshogbo, Oigeria, 1987, at her home.

the sacred Osun grove. They soar as high as twenty feet and like ancient banyan trees, their bases spread as much as fifty feet. Their central core is often composed of numerous restless, intertwining human forms that suggest a maze in which conflict and struggle coexist. But ultimately they evoke feelings of peace and protectiveness as a dominant figure arises from the turmoil with face turned heavenward and arms upraised.

In *The Return of the Gods: The Sacred Art of Susanne Wenger*, Beier offered insights into Wenger's creative development and the Yoruba religion that has nurtured her for the past thirty-eight years. Ironically, Beier relates that because there were no fine art schools in Wenger's native Graz, her early art studies were limited to the production of "ornamental pottery and small animals sculptures."[3] As Wenger commented: "What you think is an accident finally leads you in the right direction. After all, my shrines are now really a kind of pottery."[4]

Wenger later attended the Vienna Academy of Art for two years, where, in addition to developing her drawing skills through detailed renderings of landscape and animal forms, she learned the ancient fresco technique. She was a founding member of the Vienna Art Club and worked as an illustrator for a children's magazine. During World War II, her work became more inwardly directed; she produced a series of mythological drawings which she later transcribed into expressionistic-style paintings. As she explained: "When the bombs fell in Vienna and we were in air raid shelters, I did small drawings to make the time go faster. I have always kept paper and pencil near my bed not to forget my dreams, which are like poems. Then I did pictures from this source."[5]

She spent an intellectually stimulating year in Paris in 1949, but she soon tired of cafe debates, and when Beier offered a trip to Nigeria in 1950, Wenger was delighted. Six months after they arrived in Oshogbo, a city of approximately 720,000 in western Nigeria, Wenger fell ill and remained in bed for a year. During this long period of recovery Wenger had her first encounter with the Yoruba orishas. With recovery, a dramatic change took place in her art: she changed from painting violent expressionistic images related to European reality to a calmer, more designed approach as she interpreted Yoruba mythology. Wenger began her stylized paintings of Yoruba creation myths upon long pieces of cotton yardage using the traditional Yoruba cassava starch resist medium. Her patterns were then submerged into an indigo dye-bath. She soon substituted the cassava for the hot flowing wax of the batik process, a stronger, more flexible resist for creating her intricate, detailed images with color variations.

In 1951 when Wenger first heard Ajagemo's drums, she immediately intuited their meaning because, as Beier explains, "on the archaic level man has many symbols in common." A special relationship evolved between Ajagemo and Wenger as she gradually absorbed the Yoruba world view, learned their language, and became a worshipper of the orishas. "To Susanne Wenger," Beier continued, "art with a religious function carefully serves the same purpose as ritual, in that it can help one to overstep the boundaries between physical and metaphysical life."[6]

In the 1960s western Nigeria was "one of the most rewarding

Fig. 5-2 *Iyamoopo Shrine.*

places in the world for cultural exchange, a real melting pot of ideas, a cultural hothouse. One's very foreignness was appreciated and one was able to contribute to the life of the town."[7]

Beier was for many years chairman of the African Studies Department, University of Ife, Nigeria. After more than ten years of marriage, Wenger and Beier divorced, but they remained close friends. Shortly thereafter Wenger married a traditional Yoruba drummer with whom she shared her spiritual concerns and ritual practices. He had children with his other wives (polygamy is legal and common among the Yoruba), and Wenger "ritually adopted his eight children."

Wenger's African husband frequently accompanied her to Europe, where she had many successful exhibitions of her batik

paintings and smaller silk screen prints, all inspired by Yoruba mythology. She also presented batiks, wood and stone sculptures, and paintings by other Nigerian artists. These European exhibits, as well as art sales from the shop of her Oshogbo home (in itself a miniature museum), constituted a major source of income and support for her work at the grove. During a trip to Germany in 1981 Wenger's husband became ill; he died shortly after their return to Nigeria.

The Yorubas believe in a high god, Olodumare, and consider him an all powerful and all mighty "sky god." As Olodumare is remote, the orishas act as divine mediators. Beier claims that Westerners have difficulty understanding Yoruba religious views because "there are no fixed rules, no guidebook to god for the Yorubas. ... Each orisha is the universe looked at from another angle."[8]

The innumerable orishas are representative, according to Beier, of

certain natural forces, historical personalities, animals and the magic qualities of minerals, or even colors. To certain individuals, some of these forces are congenial, others destructive, and the art of living consists of know-

Fig. 5-3 *Gate of Arugba.*

ing who has to be in tune with what. ... The real "African science" is the accumulated knowledge in the collective consciousness of a people of how to live in tune with the non-human world.[9]

The three orishas most significant to Wenger's life and work are Osun, Obatala, and Alajire. Osun represents the water of life, which she gives to all other orishas. She ensures pregnancy, cures disease, and can fulfill wishes. Obatala is a god of understanding who accepts responsibility for failures, but is passive. Like the elephant, Obatala is the strongest and most peaceful animal of the forest. In contrast, Alajira has a restless creative spirit and is full of contradictions. Alajira is symbolized by fire, leopards, horsemen, as well as zebus, cows whose long horns symbolize suffering. The mythical meeting of these two opposing personalities, Obatala and Alajira, became the inspiration for one of Wenger's temples.

Other orishas and mythical figures represented by Wenger in the Osun shrine complex include Shango, god of thunder; Agum, the hunter; and Laro and Timehin, the founders of Oshogbo. Timehin is the great hunter, while Laro's search for water "is the constant search of man for the source and force of life, a search that has to be carried out constantly by all men and all deities at all times."[10]

The Yorubas believe that the psychic energy of the orishas is activated by the olorishas (worshippers) and their ritual activities. These include the Ose (weekly ceremony), where singing, drumming, dancing, and divination (a form of fortune telling) are performed. Some sacrifices of chickens are made during these weekly ceremonies, which serve as preparation for the annual Osun celebration. This annual event is attended by Oshogbo's entire population, the Yorubas as well as the Christians and Moslems, whom the Yoruba consider children of Osun as well.

Yoruba shrines are the sites for private as well as public ritual. Since they are dwellings for the gods, they are considered the sources of mystic power. Much of the forest that surrounds Osun grove has been converted to farmland during the last two decades. As Beier explains, because of the felling of the huge trees that housed spirits in their branches, stems, and roots, the spirits are now homeless. "Homeless forces are dangerous to mankind, as their restlessness makes man restless," Beier wrote. "The purpose of the entire work at Osun is to help the orisha to settle."[11]

In the 1960s, ten years after meeting Ajagemo, Wenger began to repair and then to recreate the destroyed shrines. She began by following old ground plans, but as she constructed the mud walls, reinforcing them with cement, the structured contours she and her assistants created became less rigid and more organically conceived. Outer surface walls and posts were embellished with relief or incised anthropomorphic images. Women elders frequently painted ritual design patterns in tones of brown, black, and white on the shrines' interior and exterior walls. According to Beier, Wenger

did not have to change in order to undertake this work.

Fig. 5-4 *Shrine Sculpture.*

Fig. 5-5 *Python Gate* (Adebisi Akanyi).

For years she had been painting symbols, had conceived art as the archaic language, had made batik pictures (and silk screen prints) or orisha myths. The building of the shrines was merely a way of extending this work into another dimension. [Her] sculptures are houses, [her] gates are trees, [her] walls are forests, [her] shrines are sculptures.[12]

One does not have to believe in Yoruba gods to feel a sense of peace and contentment when visiting the Osun Grove. It is a sanctuary, a place of refuge. Even a Western visitor senses that the shrines and sculpture fulfill their goal of creating a "community between man and spirits."[13]

The first large structure experienced when approaching the main section of the Osun Grove is the *Gate of Arugba* (Fig. 5-3). Built with mud and cement over an armature of steel and wire mesh, this wide arch of flowing abstract forms represents the curved back of a tortoise, which in this location represents the weight of the world made light by the presence of Osun. Throughout the grove and along the paths are Wenger's monumental sculptures of Shango, Obatala, Alajire, and other goddesses and gods—they seem to appear suddenly from the depths of the foliage (Fig. 5-4). Next is a long, curved wall and a gate (Fig. 5-5 and Fig. 5-6) created by Wenger's collaborator for over twenty years, Adebisi Akanyi. Topping the gate are two enor-

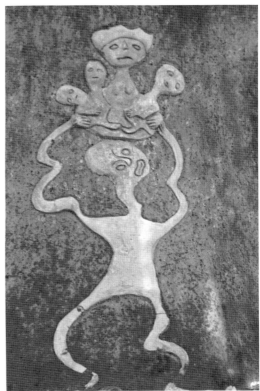

Fig. 5-6 *Python Gate* detail.

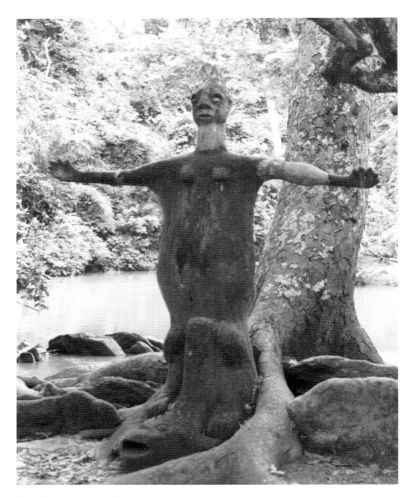

Fig. 5-7 *Osun Shrine* (Saka).

mous pythons that act as guardians of the grove, and decorating the wall are a playful array of mythical figures embossed with layers of heavy green moss.

Finally, one encounters the tall, broad form of the goddess Osun (Fig. 5-7) astride the river bank. This image of Osun, the fourth erected on this spot, was created by Saka, another of Wenger's assistants. The first Osun was destroyed by the river, the second fell when its creator violated a taboo, and the third was rejected by Wenger as not powerful enough.

In another section of the grove is an unusual house, Wenger's womblike Aiyedakun Shrine or rest house (Fig. 5-8), dedicated to the mystical reunion of Shango and Obatala. Beier considers this building Wenger's "boldest creation ... as a living house for the god."[14] One must lower one's head to enter the narrow, oval-shaped passages that lead into the inner chambers, where floors, walls, and ceilings merge into a rhythmic, all-encompassing floral form. Inside this form is a narrow, winding staircase, at the top of which is a small, secluded chamber illuminated by the soft light that filters through the cracks in the roof. Wenger dedicated this shrine to her mentor, Ajagemo, and

she often uses the building for rest and contemplation.

Wenger conceived each of the three buildings that comprise the Busanyin Shrine as a bird, with the pointed tips of the thatched roofs as bird heads (Fig. 5-9). The magnificent posts that support each roof (Fig. 5-10 and Fig. 5-11) were crafted by her assistants Lamidi Aruisa, Rabiu Adeshu, Saka, and Buraimoh Ghadamosi.

Wenger's relationship with her five artisan collaborators, none of whom follow the Yoruba religion (they are either Moslem or Christian), is most unusual. According to Wenger:

> In all my twenty-five years of commissioning work, I don't think there were three things I ordered that were useless. I tell the sculptor, "I need a piece so many feet tall," and I don't give him any restrictions, except that it should be a king or a slave, depending on the shrine location, and then to sign it.

Besides their individual projects, these artisans, trained as bricklayers and carpenters, collaborate with Wenger on the construction of her monumental forms which require extensive bamboo scaffolding to support their soaring heights. As the work progresses, it blends with the profuse vegetation of the surrounding tropical forest, evolving like a seed from simple to complex.

An amphitheater located near the Busanyin shrine is populated by a multitude of figures: drummers, hunters, an elephant rider, mothers and children, many of which, according to Beier, "represent the spirits that come from the forest, out of the earth and from the trees; deceased hunters and ancestors, not powerful enough to become orisha, but who people the forest as spirits; anonymous forces, but nevertheless spirits with whom contact is important."[15] These amphitheater images were designed and constructed by Saka and contain seats integrated with the forms so that visitors can rest and contemplate the spirits.

Along the main road are two more of Wenger's anthropomorphic gates: a tortoise, symbolic of earth, old age, and wisdom (Fig. 5-12); the other an extraordinary elephant, symbol of the god Obatala, whose arched trunk projects high over the road. A short distance beyond Obatala's trunk are two massive, freestanding shrine sculptures of Iyamoopo and Alajire, each over twenty feet in height.

According to Beier, traditional Yoruba art is naturalistic, the carving "produced by a kind of pressure from within: forehead, eyes, breast and belly all pushed outwards and the surface of the figure has the tension of a blown-up balloon."[16] The forms are rounded, unified, and quiet. Wenger's sculptural style, based on Yoruba spirit and mythology, incorporates her European, expressionist background. Her temples, shrines, and sculptures utilize complex writhing, curved and angled shapes that often soar heavenward.

The mystical, magical mood of the Osun Grove extends to Wenger's unique three-story home located a mile from the grove. Leading to the stairs and entryway is Adebisi Akanji's four-foot high mud and cement fence composed of numerous figures of acrobats, children, musicians, animals, and spirit creatures

Fig. 5-8 *Aiyedakun Shrine.*

Fig. 5-9 *Busanyin Shrine.*

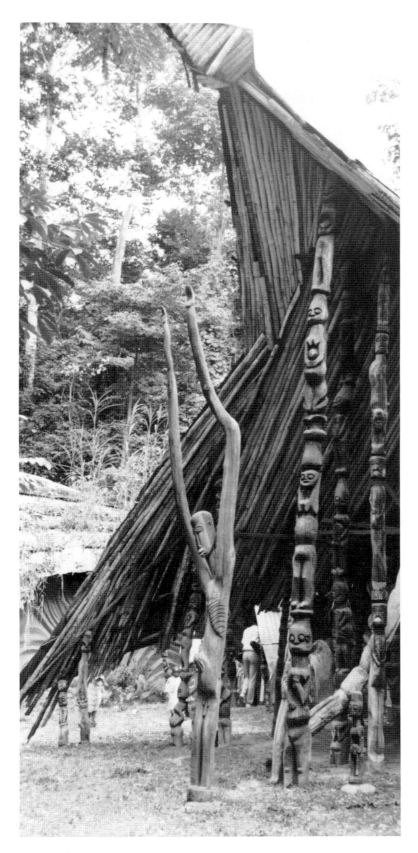

Fig. 5-10 *Busanyin Shrine.*

Fig. 5-11 *Busanyin Shrine* detail.

Fig. 5-12 *Tortoise Gate.*

(Fig. 5-13 and Fig. 5-14). The innumerable masks attached to the walls of her home and the wood and stone carvings set on the tables and floor are works Wenger commissioned form her artisan collaborators. She also surrounds herself with all kinds of rocks, shells, bones, feathers, bells drums, and objects of ritual significance. A downstairs room has been converted into a shop where batiks, carvings, jewelry, and craft objects are displayed and sold to tourists.

Wenger believes that there are two directions artists can follow: the typical development of a modern artist, asserting one's personality for individual expression; or submerging one's freedom in order to create art that functions as ritual. She has chosen the latter. She believes that if one works and lives a relaxed life, things mostly arrange themselves: "It is silly to say we live our lives. Life lives us."

Wenger is protective of the sacred grove, referring to the

Fig. 5-13 Gate at Susan Wenger's Home (Adebisi Akanyi).

encroachment of local commercial interests as the "slaughter of the gods." She feels "it is worthwhile to work a long lifetime to save a few trees and a few miles of sacred river land." Even religion, she says, is not as it was before, "when every moment was considered as sacred time. ... There has been a secularization of the sacred."

Wenger is very much involved with the Yoruba culture, where "everything is created by the spirit." She considers art to be "without meaning, without consequences, if the gods are not involved. For me God in heaven is as much an animal, a tree, or a stone." She believes human beings are but distorted images of god.

Fig. 5-14 Gate at Susan Wenger's Home detail.

Nevertheless, Wenger's work represents an affirmation of the human spirit. As a younger woman, she told Beier that she believed that "what we build in Osun could help people to regain a clearer vision of the world. If the gods can settle again and feel content in the forest, then we can share this contentment because we carry part of the divine being in us."[17]

Wenger worked unassisted on her most recent shrine project as "my work is getting more and more intense and I was getting very nervous about the details (Fig. 5-15). I then realized I had to do it alone." She compares her work to the trees, "coming from the same root. ... When you ask me what or how I am doing it, I don't know how to express myself. ... To ask a tree is difficult ... or rationally to account for what I'm doing ... a fusion of the human and tree spirits." She even compared the mask-like faces

Notes

1. Ulli Beier, *The Return of the Gods: The Sacred Art of Susanne Wenger* (Cambridge, England: Cambridge University, 1975), p. 9.
2. *Ibid.*, p. 9, 10.
3. *Ibid.*, p. 48.
4. *Ibid.*, p. 33.
5. Unless otherwise stated, all quotations are based upon interviews with Susanne Wenger, Oshogbo, Nigeria, August 1986 and August 1987.
6. Beier, *Return of the Gods*, p. 53.
7. Ulli Beier, *Contemporary Art in Africa* (New York: Praeger, 1968), p. 89.
8. Beier, *Return of the Gods*, pp. 48, 33.
9. *Ibid.*, p. 35.
10. *Ibid.*, p. 38.
11. *Ibid.*, p. 94.
12. *Ibid.*
13. *Ibid.*, p. 82.
14. *Ibid.*, p. 94.
15. *Ibid.*, p. 81.
16. Beier, *Contemporary Art in Africa*, p. 92.
17. *Ibid.*, p. 94.

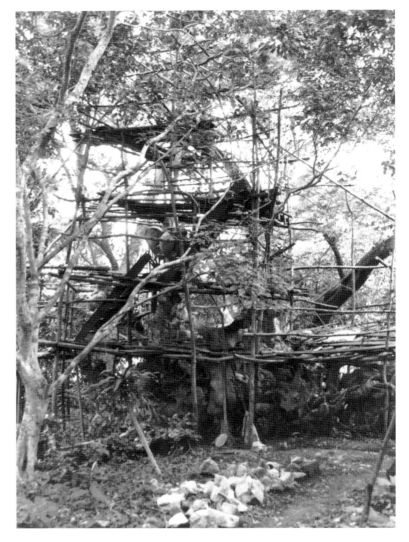

Fig. 5-15 Bamboo scaffolding for shrine construction, 1987.

and bulbous eyes of her figurative sculptures to "the tall trees that lay open their faces to the gods and the angels. The universe is like one eye of the orishas ... the big eyes ... an impression of the sky, very wide, like a universe filled with the complexity of the orishas."

Pama Sinatoa
Malian Mud-Cloth Paintings

PAMA SINATOA has converted the traditional medium of *bokolanfini* or mud-cloth painting for decorating garments into a unique personal expression (Fig. 6-1). Her panoramic scenes reflect her Moslem heritage, as well as the traditions of the Bambara, Dogon, Peulh, Malinke, Tuareg and Fulani peoples of Mali, in West Africa. Bambara is Sinatoa's first language. Some of her compositions are dominated by large figures while others are composed of complex repeat-pattern designs of survival activities, such as women carrying water or firewood, tending gardens or pounding millet, the basic food staple (Fig. 6-2).

Occasionally Sinatoa's historical paintings refer to slavery related to the Moslem conquest of the Bambara who are animists, but she omits Mali's colonization by the French from the 1880s until independence in 1960. She also avoids current social issues that can seem overwhelming to outsiders, such as the recent years of severe drought and famine; the forced migration of thousands of Tuareg nomads into cities as the desert encroaches upon their cattle-grazing land; and the epidemic blindness due to infection from a common river fly. Instead, Sinatoa's strip-cloth canvases, varying from an intimate eight by twenty inch size to five by eight feet, are filled with life-affirming episodes, including those generated by a recently established women's cooperative.

The ancient town of Djenne, where Sinatoa lives, is an important Moslem religious center with a majestic, mud-constructed mosque that for centuries has attracted pilgrims and, more recently, some Western tourists. Djenne is difficult to reach even when the roads are not seasonally inundated by the Bani or Niger Rivers. Its narrow, mud-walled streets are lined with the Islamic architectural features of the many Koranic schools and homes of the *marabouts* or Koranic scholars.

Djenne's rhythm of life seems to have hardly changed through the centuries, though women are no longer confined to the family compound and have access to some education. Transistor radios and the roar of motorbikes compete with the rooster's crowing, the muezzin's call to prayer, and the women's pounding of millet at dawn and late afternoon. There is no electricity. Donkey carts and horses were the means of local transportation.

Though the Bambara people in Mali, the Ivory Coast, and Niger have been painting on cotton cloth with mud solutions for several centuries, the exact origin of this technique is unknown.

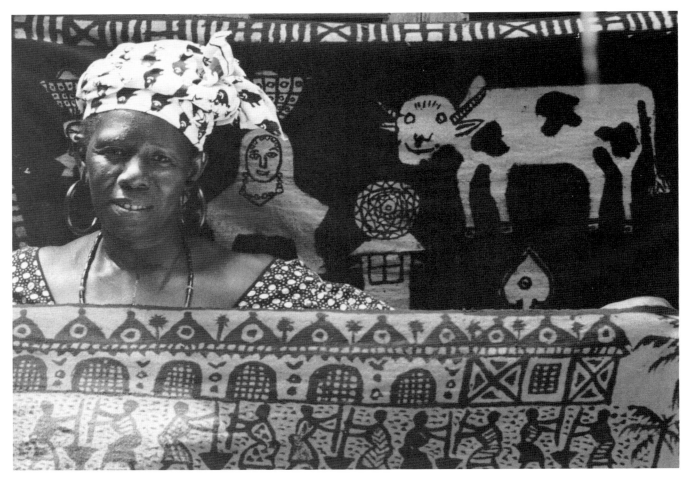

Fig. 6-1 *Pama Sinatoa*, Mali, 1988.

The cotton is locally grown and processed by the women into thread as part of their household activities. Then it is given to male weavers who work collectively on small, portable looms, producing long, coarsely woven strips that are six inches wide and vary in length from seven to forty-two feet.

The strips are purchased according to lengths required for forming basic garments. These are shirts and pants, *panas* or wraparound skirts, and square cloths for securing babies onto the mother's back. Then the garments are given to skilled women for the *bokolanfini* decoration.

Extensive research on the process was conducted by Pascal James Imperator and Marli Shamir from 1966 to 1970. They regret the gradual disappearance of the *bokolanfini* cloth, because

the failure of younger women to learn the art and gradually increasing preference of young people for European styles and factory-made cloth create concern for the survival of this art beyond the next few generations, unless new interest is generated in it and new demands made for it.[1]

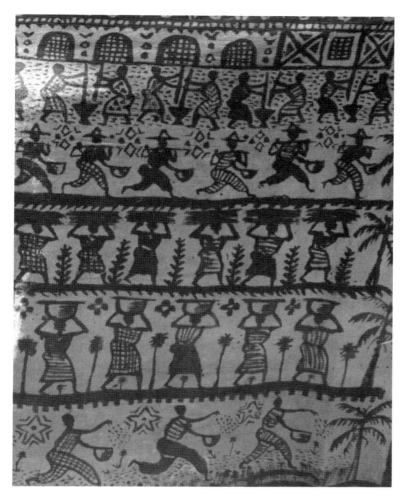

Fig. 6-2 *Pounding Millet*, 4x5', 1989.

In the Djenne region, *bokolanfini* painting remains popular, particularly due to the efforts of two women. Pama Sinatoa creates paintings for wall decoration while Mathini Niare, president of the Cooperative Feminine Multi-fonctionnelle de Djenne, paints traditional designs for garments. Both women sell their work through the Djenne cooperative and are receiving international recognition.

Preparing the sewn cotton strips for *bokolanfini* processing requires a preliminary washing to allow for shrinkage, approximately twenty percent. After drying in the sun, the natural soft white cloth is dipped into a solution prepared from the leaves and branches of the local Wolo bush to achieve a deep ochre or brown background color. The black, oily or viscous mud used for painting is collected during the dry season from the bottom residue of ponds and then left in large clay containers for a year. A small amount of the mud, as needed, is placed in a clay pot, mixed with water, and then applied with a brush made from a bamboo stick frayed at one end.

Sinatoa paints in her courtyard in the midst of family activities such as food preparation and the sharpening of agricultural

tools. Sinatoa is the mother of five children and is married to a merchant, Djeidancy Traore. Her work area is shared by her daughter and several older women who make beaded bracelets and small straw toys.

But Sinatoa, robust in stature, dominates the space as she spreads a large, black plastic tarp and then her Wolo-dyed cloth. She sits upon her cloth or leans over from one side to paint, as she says, "little by little" (Fig. 6-3). Often, if the composition is complex, she will first draw the image in pencil. The completed painting is rinsed in water, and, after drying, the mud solution is reapplied at least once or twice more so that the image will remain a deep, non-fading black. At this time Sinatoa's sons, eleven and twenty-two years of age, assist her, applying the mud paint to larger areas with a toothbrush while she concentrates on the details. During the second and third applications the image appears grey until rinsed in water which removes the excess pigment and permanently restores the pattern to the deep black.

Sinatoa works six to eight hours each day, usually on several images in different stages of processing. A small painting requires four to five days for completion while a larger one requires eight to ten. Small paintings are rinsed in the courtyard in shallow pans filled with water from a nearby well while large ones are rinsed in the Bani River. Sinatoa walks beyond the water's edge where the children scour pots and goats quench their thirst. Almost knee deep in water, she thoroughly rinses each painting.

The Djenne Cooperative Director, Mathini Niare, or Ma as she is affectionately called, works at the back of the Encampment, a small government hotel which she also manages. She sits on a stool with her cloth placed over a low table and begins painting a traditional repeat-pattern geometric design on the bottom right-hand corner, gradually shifting the cloth as she progresses slowly and methodically (Fig. 6-4). Niare's method differs from the traditional technique in which the white color is achieved last of all by removing all of the Wolo-dyed brown background with a solution of *savon de sodani*, a locally produced caustic bleach. The bleach is carefully applied to the negative design areas, and, after the rinsing process, the cloth is restored to its natural white color. Sinatoa uses this solution as a means of highlighting select areas of her large panoramic scenes.

Sinatoa's somewhat nontraditional use of *bokolanfini* may be attributable, in part, to her upbringing. Sinatoa was born approximately forty-five years ago in a small town near the port of Mopti along the Niger River. As a young girl she and her sisters learned home crafts: cotton spinning, embroidery, beadwork, leather processes, and batik. From age eight to fifteen Sinatoa and her sisters were privileged to attend school where, in addition to academic subjects, she proudly says, "My French teacher taught us how to draw." Sinatoa is the only one in her family to have utilized this skill as a means of personal expression.

After Sinatoa's marriage to Traore, becoming his second wife (Moslems are legally permitted four), they first lived in Mopti. About fifteen years later they moved to Traore's birthplace, Djenne, where each wife and her children now have separate homes. It was from Traore's first wife, a Bambara woman, that

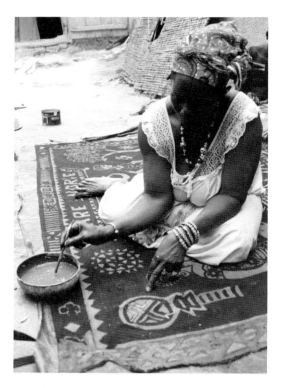

Fig. 6-3 Pama Sinatoa Painting Cloth, 1989.

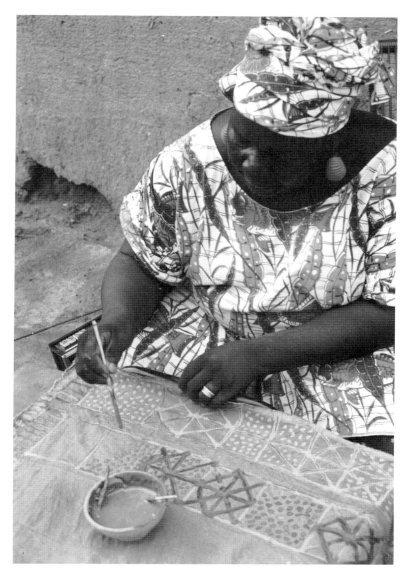

Fig. 6-4 Mathini Niare Painting Cloth, 1989.

Sinatoa learned the *bokolanfini* technique which she in turn has since taught to many other women.

At first, Sinatoa created traditional garments, but gradually she began to compose scenes from Malian history, her own experiences, and her imagination. Recently she has begun to experiment with perspective, as exemplified in her painting of the Djenne Bridge and mosque with small figures in the foreground and the mosque looming large in the distance. Though unsigned, Sinatoa's work is clearly distinguishable as no other *bokolanfini* painter has as yet ventured beyond fulfilling traditional needs. During Djenne's market day a variety of *bokolanfini* garments and baby-carriers are for sale (Fig. 6-5).

Besides developing new images, Sinatoa also recopies some paintings, such as her panoramic scene of *Segu*, in which figures and objects are arranged in two rows, surrounded by a border

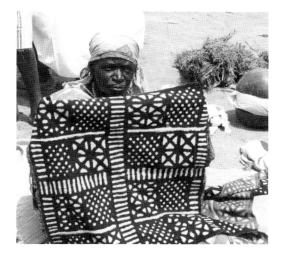

Fig. 6-5 Vendor with *bokolanfini* baby carriers, Mali, 1989.

Fig. 6-6 *Dogon Ceremony*, 4x5', 1989.

pattern. An elaborately dressed Fulani couple dominate the upper row who, according to Sinatoa, are "the king's ambassadors or representatives." A cow stands beside them, and a slave plays the flute. Below, a Bambara woman pounds millet while at the other end of this seven-foot wide composition another slave holds a fetish object in the shape of a bird rattle for enticing rain. There is also a large scorpion, a symbol of power, and two pairs of leather sandals. Lines of calabashes and small grain-storage huts add texture and pattern to this lively composition.

In Sinatoa's intricate repeat-pattern paintings, Dogon life and ceremonies are frequent themes. Space between forms is often textured with dots, which creates a vibrating effect. While in recent years the Dogons have suffered severely from drought, Sinatoa's paintings are joyous as they focus on planting and harvesting activities. She includes long rows of round millet-storage huts with pointed thatch roofs and men wearing elaborate masks performing ceremonial dances. There are caravans of camels, elephants, or an occasional ominous crocodile (Fig. 6-6).

One large painting features the activities of the Djenne Women's Cooperative, which was organized by Sinatoa in 1981. Sinatoa sadly described the severe drought in the Djenne region from 1983 to 1987. "I see it never rains, and all the women are

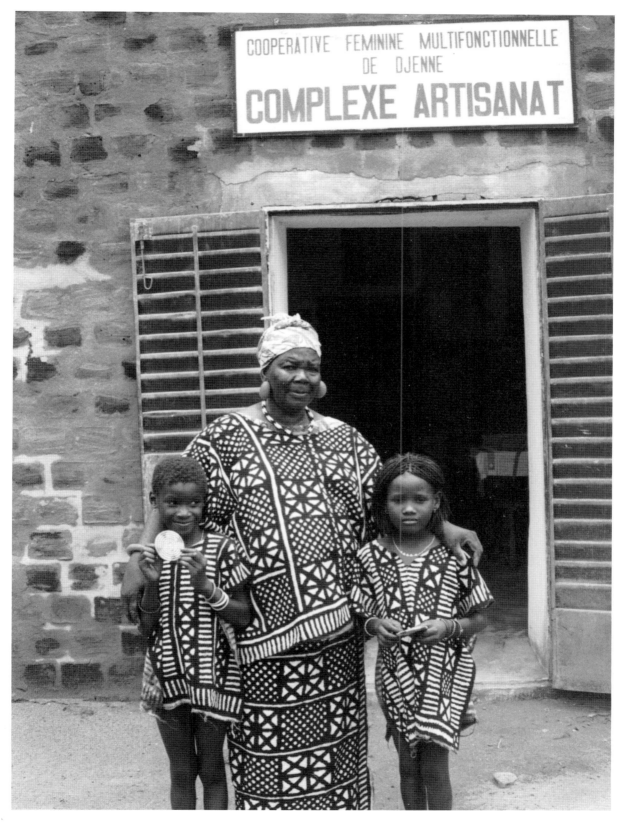

Fig. 6-7 Mathini Niari and grandchildren at the Djenne
Women's Cooperative, Mali, 1989.

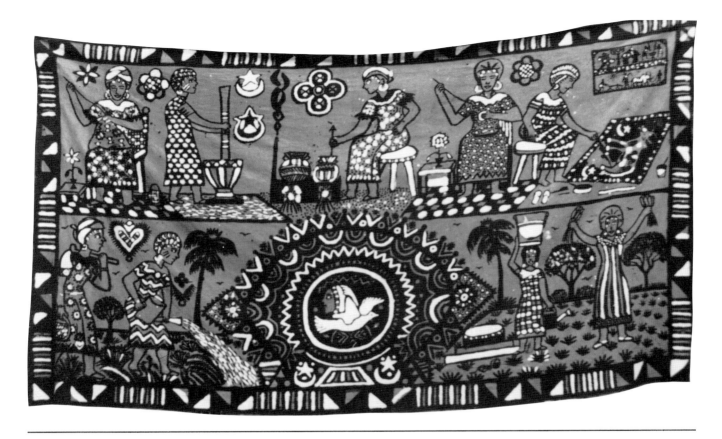

Fig. 6-8 Djenne Women's Cooperative, 4x5', 1989.

tired, and children are dying of hunger. There is nothing to eat."
Then, realizing the desolation of the women as they suffered at
home in isolation, she invited them to a meeting to discuss their
problems. Only seven women came, but "at the meeting I explain
to them the benefit of collaborating and working together to
improve our situation." Subsequently, this group grew to thir-
teen, then forty-five, and soon became the cooperative which now
has 150 members (Fig. 6-7).

Niare points out that Djenne women have always contributed
to their family income by creating crafts which they sold inde-
pendently at the weekly market and to tourists. They could earn
more by collaborating and expanding their sales to Bamako and
eventually by exporting their work. As a cooperative, members
are required to contribute a percentage of their earnings for the
promotion of a health program which she initiated to improve
children's nutrition and to provide inoculation against disease,
and they all agreed. Then, when international representatives
came to Djenne to administer relief projects during the period of
severe drought, Niare was instrumental in gaining their support
for the cooperative.

Soon, with Canadian funds, a modest building was con-
structed, and the members also received several long work tables
with benches and glass display cabinets. Three sewing machines

were donated by Italian women. With a permanent space for meetings, women could work together when time permitted, as well as plan for the future. They began to receive commissions from government representatives impressed with their diverse craft projects varying from *bokolanfini* to beadwork, embroidery, knitted baby garments, leather craft, pottery, and carved gourds.

Two years ago the cooperative initiated another program to improve nutrition by establishing an agricultural project involving ninety women. They were able to claim unused land on the outskirts of Djenne to establish individual garden plots, 1,100 square feet, where each woman could grow peanuts, sweet potatoes, manioc, corn, and other vegetables for family consumption or for sale. Two deep wells were dug to supply water, and the women protected their garden with a fence and planted trees as a windbreak. Holland sent two agricultural advisors to work with them.

In a large, joyful painting, Sinatoa celebrates the Djenne cooperative by featuring the group's symbol, composed of a woman's face and a white dove; also included are portraits of women sewing, pounding millet, and watering, weeding, or har-

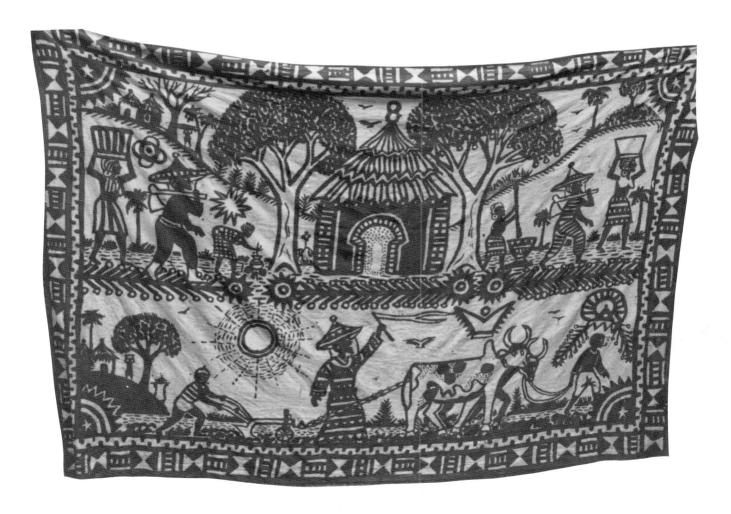

Fig. 6-9 *The Farm*, 4x5', 1989.

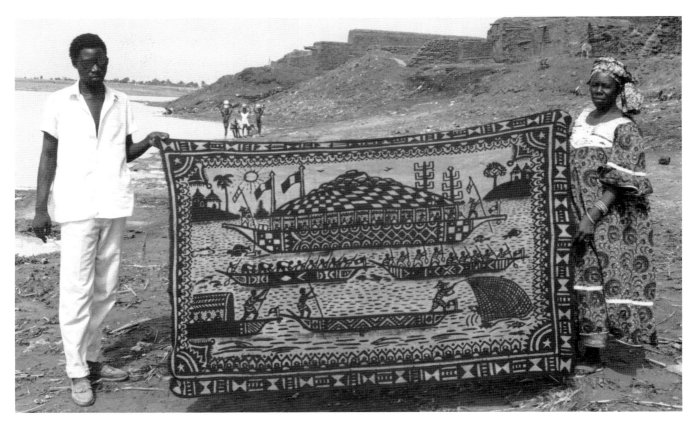

Fig. 6-10 *The Niger River*, 4x6', 1989.

Notes

1. Pascal James Imperator and Marli Shamir. "*Bokolanfini*, Mud Cloth Painting of the Bambara of Mali," *African Arts*, Summer 1970.

vesting their gardens. A woman, perhaps Sinatoa herself, is seated on a stool, painting a picture of a cow (Fig. 6-8).

In another painting inspired by agriculture, a procession of men and women carry baskets and farm implements as others weed and pound millet and below them a farmer plows with oxen (Fig. 6-9).

Sinatoa has also painted a large boat filled with passengers, surrounded by smaller pirogues and boatmen with long oars and fishermen casting nets in the Niger River (Fig. 6-10). During the rainy season there is much activity along the Niger and Bani Rivers, and Sinatoa characterized it as a "happy time of year."

How long will it be before Sinatoa signs her mud-cloth paintings? Will she receive government recognition, or be requested by a gallery in Bamako or abroad to have a one-person exhibition? For the present, she is not concerned with these issues and is content to paint and grow creatively and contribute to her family and the Djenne cooperative. She says, simply, "I am happy when people like my paintings."

Anta Germaine Gaye
The Women of Senegal

DAILY, VISITORS to Gorée Island of Senegal wend their way through the stray goats and chickens to retrace their ancestral roots to the dark Gorée cells where slaves from many West African nations were held captive prior to their ocean passage to Haiti and Louisiana. Gorée is the site of most of the country's art galleries.

Dazed by the memory-echoes of this time-transcending experience, visitors, many of them African American, stroll from the slave pens below to master's rooms above, now converted to art galleries. Pain mingles with pride as they encounter visual interpretations of contemporary African life by African artists. Stylistically diverse, each artist's drawing, painting, or sculpture portrays scenes of rural and urban life, emphasizing the dignity of Africans, the beauty of Africa, all wonderful tourist souvenirs to brighten a difficult pilgrimage.

Even though Leopold Sedar Senghor, Senegal's first president, encouraged support for the arts until he died in 1980, by 1988 national interest in the Senegalese visual arts seemed at a low ebb except among a tiny elite group and the tourists. But Anta Germaine Gaye (Fig. 7-1), one of the country's few women artists, benefitted from her family ties to Gorée and from a home environment that was influenced by Senghor, because her father was Senegal's Minister of Foreign Affairs.

Gaye, tall and slim, still lives and works in her parental home, which is filled with French furniture, antiques, and impressionistic paintings. Gaye's creative endeavors encompass several media. "When I was young I always worked with my hands to make things beautiful, and I designed and decorated clothing," she said. "Many things fascinated me, and I had to learn to focus."[1] But Gaye's professional activities remain varied, as, in addition to designing fashions and jewelry, she has recently begun to challenge herself, to create large-scale ceramic wall murals. For the past eight years, however, most of her energy has been focused on mastering the fixé, a technique of oil painting on glass.

Gaye admits that at first she had no support for her artistic interests. She was told by her family, "Painting is for people who cannot do academic studies." She added, "They were very surprised when they saw that I had the academic ability to study at the university, but stopped everything to paint." When Gaye completed her undergraduate work in literature, her teachers and her father hoped she would continue in the doctoral program, and then in the future pursue her art interests.

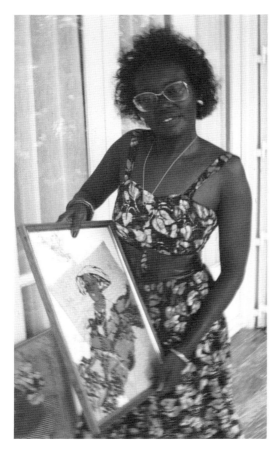

Fig. 7-1 *Anta Germaine Gaye with her Fixé*, Senegal, 1988.

Determined not to delay her creative impulse, she enrolled in 1980 at the National Beaux Arts School. Her beginning class was small, consisting of herself and five male students, though occasionally other women enrolled. Gaye, speaking a mixture of French and English, commented,

> But they soon stopped coming. It was *très difficile* for most women to study seriously, especially academic drawing skills, as mostly they just wanted to do fashion design. ... The men were supportive, but they noticed that my way of expression was different. They were always surprised when they saw how I painted, like I forgot everything my teachers taught me ... but I think they respected my way of creating.

In time, even her father changed his opinion when he realized her intense commitment. Gaye noted, "Now he thinks my art work is good because I have my own style, and he encourages me to continue." She has participated in group shows such as the 1984 American-Senegalese exhibit at the National Gallery of Art, the 1985, 1986, and 1987 National Salons of Visual Art held at the Musee Dynamique, a fixé exhibit at the Italian Cultural Center in 1986, and at the German-Senegalese Conference in 1987. In 1988 she worked at the Almadies Ceramic Studio to complete several large ceramic mural commissions for installation in home environments.

Gaye's stylistic independence is apparent in her 1988 series of fixé portraits, *The Women of Senegal*. This series differs from the more traditional fixé themes and techniques displayed in hotel lobbies and in art galleries and sold by street vendors throughout Dakar. These popular fixés seem uniformly bright in color as if mass produced and frequently portray musicians, dancers, or tropical scenes. In contrast, Gaye's nostalgic personal portraits of upper-class women are posed with typical facial or hand gestures, coordinated with the fashionable dress of the 1940s and 1950s (Figs. 7-2, 7-3, and 7-4). Gaye's portraits are also varied in expression, revealing distinct character traits. But it is in her innovative incorporation of collage, paper, dried plants, fibers, or fabric and her expressive use of line that she has transformed fixé into a contemporary art form.

Oil painting on glass was useful in eighteenth century Europe and North Africa for preserving, reproducing, and popularizing famous pictorial works. In the fixé technique the artist places a thin piece of glass on top of the original art in order to trace or make an exact copy of the image by first outlining it with black ink. At this stage, corrections can be made by scraping ink off and redoing the lines. In fixé painting, the reverse or unpainted side of the glass is the one ultimately exposed to view; therefore, the process of filling in the outlined forms with oil paint is reversed from other painting techniques. Highlights for shading and details, such as fabric patterns, portrait features, landscape foliage, or animals forms, are all painted first. Then the background colors are applied in thin layers over the details. Before the background can dry, a sheet of white paper is pressed over the painted surface of the glass, causing the paint to blister and

crack as it dries. The fixé is then backed with cardboard cut to the glass size, and the outer edges are taped or framed. When finally viewed from the reverse side, the completed image with its crackled paint surface appears like a batik.

The history of fixé is linked to the ancient skill of glassmaking, which reached a high point in sixteenth century Venice, Italy. Fixé was also produced in China and India, but with the spread of Islam it became popular in North Africa and the Middle East. Small souvenir fixés of the portraits of the great Islamic leaders or "marabouts," as well as illustrations of their miracles, were brought to Senegal by Moslem visitors to Mecca. Senegal is eighty-five percent Moslem. In Moslem homes "religious fixés were hung against the wall ... often with amulets ... and constituted an altar."[2]

By the nineteenth century a popular fixé art movement flourished in Senegal, "giving birth to works of a less finished nature, but, at the same time, more moving."[3] Fixé themes of women were based on mythical and societal roles. Mammy Watta, a feminine water spirit, was presented as a siren with thick, black hair, and there were scenes of domestic work, including millet grinding and cooking over charcoal fires. Family portraits were commissioned and reproduced from photographs. There were also moralistic fixés which illustrated people's good and bad deeds.

Gaye's use of the fixé techniques is considerably different from that of the traditional male artisan, as she works spontaneously upon the glass without copying from a photo. Her portrait results are personal, as her character outlines are more fluid when compared with traced lines. Often her portraits appear like vignettes, their outlines varying in thickness and interwoven with textures that range from strands of wheat, dried flowers, and paper doilies to lace and cloth. Gaye has converted a small bedroom in her parental home to a studio which is filled with works in progress. She also paints on paper, exploring a variety of nonrealistic, decorative flower and bird motifs, as well as abstract designs.

Gaye is thirty-seven years of age, and since her recent divorce her energies have been even more focused upon her art. She married at age twenty, meeting her husband while they were university students. While he studied for his doctorate in physics, she accompanied him with their two children twice to the United States where he worked at Georgetown University and at a laboratory in Stillwater, California. During their years of marriage, Gaye's husband did not encourage her art as he was mostly involved with his work. She benefitted, however, by visiting museums in the United States, and later in Europe where they traveled for family holidays. This broad exposure to art has proved beneficial.

Gaye also considers her physical and astrological ancestry significant for "my aesthetic formation." Born in 1953 in the northern town of St. Louis in Senegal of Gorean parents, she is convinced that this heritage was conducive to her "artistic vocation," and in any case honestly admits to "the feeling of belonging to a privileged and eclectic world."

When she is not painting, Gaye creates jewelry in which she integrates "the noble materials of amber, ebony, old gold, glass

Fig. 7-2 *Women of Senegal*, fixé, 12x18", 1988.

Fig. 7-3 *Women of Senegal*, fixé, 12x18", 1988.

Fig. 7-4 *Women of Senegal,* fixé, 12x18", 1988.

Notes

1. All quotes, unless otherwise cited, are based on the author's interview with Anta Germaine Gaye in Dakar, Senegal, August, 1988.
2. Carl Brasseaux, *Senegal: Peintures Narratives* (Lafayette, Louisiana: University of Southwestern Press, 1986), p. 63.
3. *Ibid.*
4. Keorapetse Kgositsile, "Culture and Resistance of South Africa," *The Black Scholar*, July/August 1986, p. 28.

trinkets, and beads." She works consistently, using evenings, weekends, and vacation periods, because since 1983 she has been teaching full time at the C.E.S. Mame Thiernis Birahim School, a secondary school in Dakar.

The medium of fixé has undergone many transformations with its more recent, popular adaptation for tourists. Gaye's fixé innovations sidestep this limited market. In her own way she affirms Keorapetse Kgositsile's position as stated in *Culture and Resistance in South Africa*: "And what is truly creative in art is a reflection and an affirmation of life in moving images."[4]

Gaye demonstrates great honesty as she strives to open doors for herself as a woman and as an artist. Her fixé series, *The Women of Senegal*, affirms pride in her national identity. Just as she defied parental and teacher expectations to continue her studies in art instead of in literature, she has also defied Western influences, evident throughout Africa, to create art that is limited in theme but does contribute to the sustaining of a national consciousness rooted in the Senegalese cultural heritage.

Theresa Musoke
East African Painter

THE AESTHETIC VISION and professional goals of Theresa Musoke (Fig. 8-1) are unique among East African artists. Stylistically, Musoke considers herself a "semi-abstract painter" whose thematic concerns include people as well as nature. Her mixed media images reveal aspects of her Uganda-Kenya heritage, exposure to a broad world view, and awareness of diverse aesthetic systems. Musoke has also explored feminist themes that include: women at market; self portraits that probe her own multifaceted psyche as artist, mother, and teacher; and the controversial theme of family planning.

East Africa's history of tribalism, colonialism, nationalism, and, more recently, women's determination to take charge of their own lives are all components of Musoke's personal story. She is a significant pacesetter and role model, considered by art educator Elsbeth Court "the most significant black woman painter in East Africa."[1] This was confirmed by Elimu Njau, director of the Paa-Ya-Paa Gallery, the only African-owned gallery of contemporary East African art in Nairobi, who said, "Theresa's career was launched in 1965 when she became the first black woman artist in Kenya to receive a show."[2] She was then twenty-one years old. In the twenty-five years since this exhibit, she has assertively continued to develop her professional career and has gained international recognition, competing confidently within the limited East African white-dominated gallery system.

Theresa Musoke was born in 1945 in Kampala, Uganda, the fifth of nineteen children. Musoke's father, Simon Musoke, was a Sasa tribal chief but became converted to Catholicism, so tribal traditions did not continue with his children. Musoke remembers her father as "a very kind, religious man,"[3] proud to have sent his seventeen surviving children to the Catholic Mission School. Education was considered synonymous with progress or advancement as people moved from rural to urban areas.

During colonial rule the goals of formal education were primarily the spread of Christianity and some vocational training for producing semiskilled workers. Most of the Musoke children went beyond these limitations to become university graduates with diverse professional careers in Kenya, England, Germany, and the United States. The family grew apart, but were briefly reunited in Uganda a few years ago for Simon's funeral.

At age five Musoke was sent to the Catholic Mission Boarding School where art was integrated within the curriculum, as saints' day celebrations, holidays, and children's birthdays all

Fig. 8-2 *Giraffes,* mixed media, 30x36", 1982.

Fig. 8-1 *Theresa Musoke,* Mairobe, Kenya, 1987.

necessitated special decorations. The nuns frequently called Musoke from class, saying, "She's so good ... Come draw for me."

At Trinity College, a secondary school which Musoke attended from 1955 until 1960, she recalls, "The nuns didn't mind if academic exams weren't passed. They wanted you to become a good person," which meant to Musoke "consideration for others." She feels that spiritual guidelines are sorely lacking in the world today.

"African schools are full of children who never see an oil painting on canvas, since it is an art form developed in Western culture," Musoke observes. Her experience was different, however. Musoke grew up in a time in Uganda when opportunities for broad artistic exploration and expression were possible. This was largely due to the pioneering efforts of Margaret Trowell, an extraordinary English educator who had respect for cultural diversity. She taught art in Kenya and Uganda from 1929 to 1958. Elsbeth Court, in the journal *Art Education,* recently described Trowell's art program as based on "seeing the visual world through African eyes ... and trying to understand their spiritual and social attitudes towards their own works of art."[4] In 1945 Trowell's efforts to establish a School of Fine Art succeeded, and this school later integrated with the Makerere University at Kampala, Uganda. During the colonial period Makerere was the only university in Uganda, Kenya, and Tanzania.

In teaching art, Trowell believed the "imposition of Western techniques would only promote a derivative style. ... 'The form grows from content. The content is not invented as an exercise in form.' She struggled to 'rethink in light of the African's needs' which methods were most suitable to bring out 'their imaginative faculties and to help keep their strong sense of design and craftsman's skill.' "[5]

Musoke was fortunate to be a recipient of Trowell's progressive art education philosophy when in 1960 she was one of five students to pass the competitive examinations for the Margaret

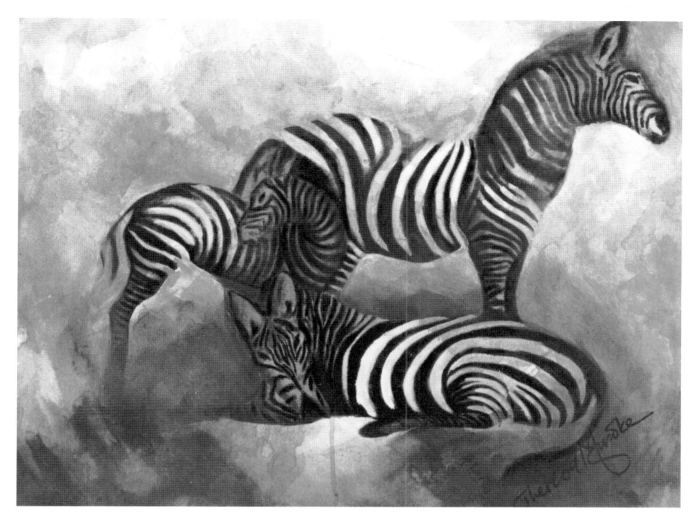

Fig. 8-3 *Zebras #1,* mixed media, 24x30", 1987.

Trowell School of Fine Art. There, all her art teachers but one were English, but Musoke happily recalls, "They 'encouraged art by their own example of creating and experimenting and insisting that we work and work.' They opened the door for me to become a painter."

In 1962, at age seventeen, Musoke won the Uganda Development Corporation Christmas Card Prize. In one of Musoke's early paintings, *Nativity,* her individual style, based on expressionistic brush strokes and symbolic use of color, is apparent.

Musoke's interest in animal themes began as an undergraduate. "I drew lots of cats, animals, skulls and bones," she said. "One of our tutors took us to the zoology department to draw monkeys and then to the slaughterhouse." Musoke firmly drew the line, however, when her instructor, who wanted to further his students' understanding of anatomy and muscle structure, insisted that the class visit a morgue. "I'm not going ... I'll quit school!" she asserted.

Fig. 8-4 *Zebras #2*, mixed media, 24x30", 1987.

Fig. 8-5 *Zebras #3*, mixed media, 24x30", 1987.

Besides winning the Margaret Trowell Painting Prize in 1965, Musoke had a one-person exhibit at the Uganda Museum of Art. Jonathan Kingdon, a Makerere University professor, reviewed Musoke's Uganda Museum exhibit, pointing out some unique qualities of her early work that are apparent even twenty-five years later. Kingdon's comments emphasize the positive contribution of her feminist perspective in portraying African wildlife. She avoids the "vulgarity and cornyness" associated with this theme "through the dreadful paintings of the businessmen who are called 'wildlife artists.'" He writes:

There is a continuous thread of vision that runs throughout all her paintings; an essentially feminine sense of the mystery and of the "presence" of living things ... With Theresa we have perhaps the first East African painter who is sensitive to that wildness, that otherness, that mystery that is outside and beyond us and our affairs. She returns to us that vision that most of us lost at an early age ... before we learned the arrogant he that everything that creeps upon the earth wherever there is life, has been given unto us for meat. ...

If anyone wants proof that a woman can have a special view of life and can do things that men cannot, Theresa's unique sensitivity and vision are here and we may be thankful in a materialistically functional world for a reminder of gentler things.[6]

From 1965 to 1966 Theresa Musoke continued her postgraduate studies at Makerere University in the Department of Education. While a student she also received her first commission to paint a mural on the theme of "Birth" at Makerere University. After graduation Musoke taught briefly at the Tororo Girls School in Uganda, until she received a postgraduate scholarship to

Fig. 8-6 *Wildebeests,* mixed media, 24x30", 1985.

attend the Royal College of Art in London from 1966 to 1968.

Musoke's son Kenneth was born in London in 1968. She then made the decision to raise her son alone, but to return to Uganda where her mother could temporarily help. During this period Musoke taught art at Mount Saint Mary's School. She continued to paint and exhibited at the Alliance Francaise in Kampala, Uganda.

Artistically, Musoke focused upon printmaking, the intaglio, and lithography process—but due to the limitations on supplies and equipment in East Africa, she could not continue working in these media of expression. Musoke successfully competed for a Rockefeller Foundation Fellowship. She attended the Graduate School of Fine Art and Architecture at the University of Pennsylvania from 1969 to 1973. There she focused upon drawing, painting, and graphics while realizing, "When you're away from home, you become more aware of the things you miss. What you like becomes much more important and, therefore, you struggle to retain them," she reminisced, referring to her family and artistic themes related to African life. "You can't take them

for granted as you do when you find them all around you."

Musoke had her own studio and found the interaction among the students, faculty, and guest professional artists and art critics very stimulating. She enjoyed the fact that "they came to you, in your studio, to find out what you were doing," providing positive feedback. Later in Kenya she was to miss this rich exchange.

In the United States Musoke exhibited at the Hampton Institute in Virginia and at Rockefeller Center in New York City. Her work was well received and when she returned to East Africa, her self assurance was strong. Musoke told me how "I came to Kenya, alone, with my paintings, and went to Gallery Watatu and looked around. I liked the gallery. Then I said to the director, 'I want an exhibit.'" After the white woman's initial shock, the gallery officials looked at her work and were impressed. They gave Musoke an exhibit in 1974 and many others in the years following.

Musoke taught for a time at the Margaret Trowell Fine Art School. She also was commissioned to paint a mural at Uganda's Entebbe Airport. The brutality of Idi Amin's regime had penetrated the university system, however, resulting in many "random victims, the killing of a faculty member, and guns all over the place." Therefore, when she went to Kenya in 1976 to exhibit, Musoke made the decision to stay. Having been to Kenya many times before, as well as to London and North America, she said, "it was quite easy to make that change."

In Kenya opportunities began to unfold in both teaching and art. Musoke's work process is innovative and experimental as she develops her mixed media paintings. Working from the abstract to the concrete, Musoke first impregnates the cotton canvas with a random tie-dye stain. She then allows the stain to suggest an image which she pursues with oil or acrylic paint until it becomes a unified composition. She usually defines forms with a suggestive outline and frequently uses white as a highlight. With a minimum amount of oil or acrylic paint her images seem to emerge from the canvas with ease.

Musoke says, "I have to work with more than one painting at a time, or I get impatient and spoil them," and smilingly adds, "Sometimes the back of my painting is better than the front. ..." Occasionally Musoke draws with dye before tying and dipping the cloth into another color of dye which causes a soft bleeding of the image or "kills something." Then she says, "The artist is challenged to bring up something new, which is always a magical part of the process."

Through the years, a recurrent theme for Musoke has been her poetic portrayal of animals. In Kenya, with sketchbook and camera, she visited the extensive and protected animal reserves to observe and record the hundreds of diverse animals that roam the vast plains and migrate seasonally to different locations. For Musoke, this experience represents "the essence of life."

It is shocking at first for people accustomed to viewing animals in zoos to encounter giraffes, ostriches, and gazelles freely walking about on the road just outside Nairobi, a modern capital with many skyscrapers. In addition, one can see the proud nomadic Maasai tribal people, wearing bright-beaded necklaces

Fig. 8-7 *Market Woman Selling Baskets,* mixed media, 24x30", 1986.

Fig. 8-8 *Family Planning: Children With Dolls,* mixed media, 30x36", 1985.

and other body adornments, herd cattle, goats and sheep. At the game park the elephants, monkeys, zebras, wildebeests, antelopes and rhinoceroses appear in massive numbers, all peacefully grazing until stalked by their predators, the leopards or lions. Like the magical vision provided by a kaleidoscope, the varied animals with their subtle colors and body markings are constantly moving and changing.

"At the game park at first you don't see, but then your eyes begin to pick up the animals, just like that," Musoke observes. "Your eyes must focus, because you don't see the animals singularly; they become large shapes of color and movement. You can see them one minute, but the next minute they're not there."

In contrast to most European paintings of wildlife, Musoke's paintings, suggestive rather than realistic, evoke this magical and mysterious essence. In her painting of *Giraffes* (Fig. 8-2), for example, the numerous giraffes appear as a single massive unit of warm brown and orange spotted tones. The negative space between their legs and the long lean necks is left refreshingly white, except for a delicate scattering of brush strokes that suggests tree branches and leaves, a subtle merging of animal and environment.

One of Musoke's most fluid and abstract paintings is *Chains of Flamingoes.* The flamingoes' deep pink forms are linked together like a group of comrades strolling arm-in-arm against the cloud-patterned blue and white sky. In contrast to this generalized treatment of forms, Musoke's *Lions,* a mother with two cubs, is carefully sketched with umber brown paint and superimposed upon a light beige-stained canvas.

In Musoke's three paintings of *Zebras* (Figs. 8-3, 8-4, and 8-5), her method of abstraction and experimentation is evident. Beginning with a group of three striped and carefully detailed

zebras serenely arranged upon a yellow-green, stained background, she then explores in her second painting the cubist fragmentation of form. This style unifies the vibrant zebra movement and their striped patterning with the background. In the third painting an underlayer of bright green stains penetrates through the superimposed black wash that suggestively defines the zebras' fleeting forms. White, ribbon-like stripes playfully, as if blown by a gentle breeze, wrap around or embrace the zebras' prancing forms.

In a March 1977 interview with the magazine *Africa Women*, Musoke elucidates her creative method:

> I like the excitement of the way animals are formed and move. I watch them all the time ... giraffes, flamingoes. I never paint while I watch. I digest the whole thing and form my impression. Then I go and paint from memory. Sometimes I can get up in the middle of the night and work from memory until I get it right. But you know, the artist's choice of his subject is almost incidental. It is what he says about the subject matter, how he interprets it.[7]

In 1980 when she was commissioned by Nairobi's prominent Stanley Hotel to create two large paintings on the theme of the thorn tree, Musoke admitted, "I had never looked at this tree before. When I did, I fell in love with it." Since then the thorn tree appears frequently like strands of long hair, somewhat tangled and windblown above groups of animals such as wildebeests or guinea hens as they feed beneath (Fig. 8-6).

Musoke is also very adept at drawing the human form. She especially enjoys market scenes with rural women wrapped in their bright patterned traditional cloths or *kangas*. Once again, her paintings range from detailed images such as *Market Woman Selling Baskets* (Fig. 8-7) to more abstract renditions in which the women, their patterned cloth, baskets, and produce seem like a dynamic flurry of bright designs and color. Yet even when color and pattern dominate the composition as in *Women Selling Cloth*, her individualized portraits of the women's features form a strong pictorial component.

Perhaps Musoke's most sensitive and dramatic series of paintings in 1986-87 is on the theme of family planning. Kenya's population jumped from 8.5 million in 1963 to over 20 million in 1987. Abel Ndumbu in *Out of My Rib: A View of Women in Development* notes the "failure of family planning activities" and says that

> the group with the largest potential for acceptance of family planning methods is the youth. But in a society where most schools have affiliation to a religious denomination, "issues of morality" play havoc with the programme.[8]

In her personal life Musoke admits: "Women do have a tough time, because there is no system for child support. Always it is the woman who carries the burden." She sarcastically adds:

Fig. 8-9 *Family Planning: Preparing Young People to Avoid Teenage Pregnancy,* mixed media, 30x36", 1987.

Fig. 8-10 *Maasai Women at Market,* mixed media, 24x36", 1987.

"Some women think they have to get married ... and attach themselves to these creatures who are no good. They think their worth can only be recognized if they are recognized as Mrs. So and So!" We also discussed many issues related to women, especially as "women single-handedly run about twenty-five percent of the total households in Kenya ... and do fifty percent of the agricultural work."

For the past three years, funding for an annual calendar on the theme of family planning has come from the Goethe Institute, affiliated with the German Embassy in Nairobi. The large format of the widely distributed calendar, twenty by thirty inches, features the work of East African artists whose paintings are reproduced in color. Each artist was challenged to illustrate a slogan such as "Too heavy a burden to carry? Plan your family"; "Avoid overcrowding and poverty: plan your family"; "For love and peace: plan your family" and "A family needs sufficient food: plan your family." Musoke's slogan was: "Prepare young people to avoid teenage pregnancies: plan your family."

With Musoke's plentiful energy, rather than limiting herself to one image, she developed a series of paintings on the same slogan. In each of her five canvases white is the dominant background color, applied over pale and delicate tie-dye stains. In several of her paintings children are sensitively portrayed as they hold younger siblings or dolls (Fig. 8-8). The painting selected for the 1986 calendar features two teenage girls dressed in school uni-

forms (Fig. 8-9). Their facial expressions reveal their vulnerability, as behind them groups of young boys walk by. In another painting, a child stands before us, holding a large doll in front of her. This stark image, drawn upon an ochre-stained background with a spontaneous black line, captures the emotional link between child and doll, a preferable situation to a child and her own baby.

Popular subjects for many East African artists are the tall, lean, and nomadic Maasai tribal people whose survival depends on their hunting skills and cattle raising. Though missionaries, government policies, and climatic changes such as drought have brought some Maasai closer to settled communities, most have maintained pride in their traditions and refused to be assimilated.

Unfortunately, the bountiful portrayals of the Maasai in the medium of wood carving or painting produced for the tourist trade, a mainstay of the Kenya economy, have frequently been reduced to stylized cliches. Musoke's 1987 painting *Maasai Women at Market* (Fig 8-10) provides a refreshing portrayal of women selecting cloth. The subtle, thin washes of warm brown, red, and yellow tones which envelop the women still permit Musoke's linear drawing of their facial features, body adornments, and hand gestures to remain evident. Musoke also allows the rhythmic linear patterning of the cloth wrapped around the women's shoulders to merge with the cloth they are seriously considering for purchase.

Musoke attended the 1985 Women's International Conference held in Nairobi and during the conference had a one-person exhibit of fifty paintings at Gallery Watatu. Though Musoke was disappointed that she did not sell many paintings her work was well reviewed. In Nairobi's *Sunday Nation* of July 7, 1985, Eva Ndavu stated:

Fig. 8-11 *Self Portrait #1*, mixed media, 18x24", 1985.

> Theresa forges ahead with some fifty oil paintings and metallic gold wildlife sketches. ... She is one of the most productive and industrious artists around. You can seldom find her without a paintbrush in her hand unless she is teaching some of her many students a new techniques introducing them to a new medium.[9]

Simultaneous with Musoke's Gallery Watatu exhibit, the Armory Pre-Selection exhibit also opened in Nairobi, hosted by Mrs. Javier Perez de Cuellar, wife of the United Nations secretary-general. The prestigious *Armory '86* exhibit, featuring the work of nine international women, including Musoke, was seen at the Armory in New York City in 1988.

Musoke's work is now under consideration for purchase by the American Women's Association of Kenya's National Museum, to present as a gift to the National Museum of Women in the Arts in Washington, D.C.

Through Musoke's work sells well at her numerous individual exhibits, primarily to European collectors, teaching has remained a mainstay of her economic freedom. She has taught both at Kenyatta University and at Nairobi University, but found both experiences did not measure up to her standards as an artist and an educator.

Musoke prefers the artistic integrity and intensity of young

children and therefore left the university system to teach at the Kestre Manor School and more recently at the International School where the children range in age from two to eighteen years. She works mornings only and offers Saturday classes at her home studio, which gives her ample time for her own work. Musoke finds children rewarding, especially "when you give them an assignment, they have all the motivation and the time." She exclaims, "They will do it and do it and do it with enthusiasm!" Musoke's son Kenneth, with whom she has an extremely close relationship, is also a subject for her paintings.

Musoke's personal independence is critically important to her, and she expresses her sense of the East African notion of *uhuru*, or freedom, through her individual desire to paint and live as she wishes. "Holding onto my freedom is my greatest accomplishment," Musoke proudly states. "I don't have to depend on anyone; I'm not tied down. With my freedom I can travel and work when and where I want."

This expression of freedom in individual—rather than societal—terms almost seems in contradiction to her acknowledgment that "Women do have a tough time, because there is no system for child support. Always it is the woman who carries the burden." Though Musoke's independent lifestyle shows that she has made many undoubtedly difficult choices in order to press forward with her work—choices that she faced in particular as a black woman artist—she emphatically states, "I don't think of myself as a woman, just as an artist; and I encounter my problems as an artist." This stance is similar to her response to racism during her stay in the United States. "It was the first time

Fig. 8-11 *Self Portrait #2*, mixed media, 18x24", 1985.

Notes

1. Elsbeth Court (English-Kenyan art educator), from 1985 correspondence.
2. Elimu Njau, director, Paa-Ya-Paa Gallery, Nairobi, Kenya, in conversation, 1986.
3. Unless otherwise stated, all quotes are from an interview with Theresa Musoke in Nairobi, Kenya, 1986.
4. Elsbeth Court, "Margaret Trowell and the Development of Art Education in East Africa," *Art Education*, (November 1985), p. 36.
5. *Ibid.*, p. 37.
6. Jonathan Kingdon, "Theresa Musoke," Uganda Museum of Art, exhibit catalog, 1965.
7. "Uganda's Innovative Artist," interview, *Africa Woman*, No. 9 (March/ April 1977), p. 53.
8. Abel Ndumbu, *Out of My Rib: A View of Women in Development*.
9. Eva Ndavu, *Sunday Nation*, Nairobi, Kenya, July 7, 1985.

I thought about being black, but I never experienced any prejudice. I bypassed all that."

During the past fourteen-year period of stability and maturity in Musoke's life and artistic development (1976-90), she has not only raised her son Kenneth alone, but has taught art from the university to kindergarten levels. She has painted incessantly and has reached beyond her studio to exhibit and achieve professional national and international recognition. These accomplishments are indeed enormous for any artist, but even more extraordinary for a black woman in East Africa, where African culture and traditions have been the focus of over 200 years of colonial oppression and attempts at elimination.

Musoke has successfully bridged the gap between her art training in contemporary Western aesthetics and her visual or thematic inspiration rooted in her African heritage. Musoke's success is partially due to her realization that "since art is now a commodity, it is not possible to paint without being reminded of the market. But a good artist will never let it dictate his or her style and purpose."

Occasionally Musoke is personally introspective, as in her self portraits (Figs. 8-11 and 8-12), of which she says, "They're more difficult. I keep on painting while I'm thinking inside." In her multiple self-image of 1987, in which her face seems to rotate in different directions, perhaps a reference to time past, present, and future, or to different stages in her life. It would be wonderful to see these facial images extended as full-length autobiographical studies—a kaleidoscopic version symbolically incorporating aspects of her childhood missionary experience, travel and exposure to a broader world view, and finally the mature woman, taking charge of her life, striving for *uhuru*.

Chaibia

Moroccan Artiste-Peintre

CHAIBIA, A SELF-TAUGHT Moroccan painter, has earned her *houria* or freedom both as woman and as artist (Fig. 9-1). This is an unusual accomplishment since under the Moslem family law practiced in her country, women must submit to the control of father, husband, or brothers and certainly are not professionally encouraged to be painters.

Chaibia's unique professional achievements, her vibrant figurative paintings and drawings, have now been exhibited in Morocco, France, Germany, Denmark, Spain, Tunisia, Iraq, and the United States. Her fairy-tale life story from rags to riches and her freedom to develop a career, to exhibit and to travel have been subjects of extensive television, video, and journalistic review. In Morocco she has become a folk heroine, especially among women of the poor and working classes. Most recently, the King of Morocco bought twenty of her paintings for his private collections, and one of her paintings was selected as the poster for the 1984 Contemporary Women's International Art Exhibition in Vitry-sur-Seine, France.

Chaibia was born in 1929 and spent her brief childhood in the village of Chtouka in the region of Casablanca. Like most peasant women of her generation, she was illiterate, and candidly told Fatima Mernissi in an interview for a 1985 exhibition catalog:

> Listen! Don't forget that I am a peasant ... but that is not all. You must know the rest, otherwise you would not understand my success. You have to know that when I was little I used to do unusual things. I used to make flower crowns and wear them ... no other girl did that ... nobody ever did that in the Chtouka. They treated me as *msettia* (mad). I was crazy for red poppies and daisies. They found me strange. They said: "You are queer, like a *Nasrania* (Christian, occidental, the other, the different, the enemy)." You must understand, it's important, not being afraid to be different.[1]

Chaibia's marriage to an elderly man was arranged by her family when she was thirteen. She was his seventh wife. Their son, Hossein Tallal, the husband's only offspring, was born when Chaibia was fourteen. At age fifteen she was widowed. Though she had many suitors, Chaibia told me, "I refused further offers of marriage because I was scared someone else would not treat my son as I wanted."

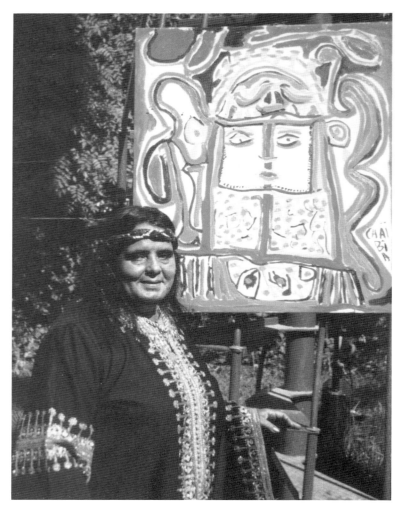

Fig. 9-1 *Chaibia,* Morocco, 1988. Photograph: Oliver Sepulchre.

Fig. 9-2 *The Dancer,* acrylic on canvas, 24x30", 1988.

An older French couple who visited Chtouka for their vacations knew Chaibia's family and offered to employ her. She left with her infant son Tallal to work in Casablanca as their maid. "But," she said, "I always dreamed a great deal and had a feeling my life would change." Chaibia cared for the wife during a long period of ill health. Later, she did the same for the husband. Upon their deaths, some twenty-five years after she went to Casablanca, Chaibia inherited their house and extensive French antique collection. The bronze front door plaque now announces: "Chaibia Tallal, Artiste-Peintre."

During those early years, Chaibia's primary goal was to educate her son. She remembers with pride, "I bought Tallal his first toys, I paid for his school—it cost a fortune—and I bought him his first motor bike." Tallal was always interested in art, and when he was about sixteen she bought him a ticket to Paris. There, Tallal's vision of life and art rapidly expanded; he studied painting in the studios of other Moroccan artists and exhibited in Paris, but then he returned home to Morocco where he has continued to paint and exhibit, never straying too far from Chaibia.

Once again, a most unusual turn of events occurred as Chaibia became stimulated by her son's paintings and flourishing career. She had a dream in which voices told her, "Get up, take your colors, and paint." She then bought bright-colored house paints used for trimming doorways and with her fingers began to dab these colors on paper, cardboard, and pieces of wood.

At this time Tallal had his studio in a Casablanca suburb but asked to bring his paintings to Chaibia's house in preparation for a visit by Ahmed Cherkadh, one of Morocco's leading older generation painters, and Pierre Gaudibert, director of the Museum of Art in Grenoble, France. During their visit Chaibia surprisingly informed them all, "I started to paint too," and she spread a bed sheet on the floor upon which she placed her little paintings. Attracted to these bold bursts of color, Cherkadh and Gaudibert then suggested that Tallal encourage his mother to follow her own inclinations. Two weeks later, Chaibia bought better quality paint and stretched canvas, and two years later in 1966 she had her first series of exhibits at the Goethe Institut in Casablanca, the Galerie Solstice in Paris, and the Salon des Surindependants Modern Art Museum in Paris. This was accomplished with the assistance of Cherkadh who became an enthusiastic supporter and friend until his recent death.

Since the launching of Chaibia's career, she has worked indefatigably, exhibiting annually. In the United States she has shown at the Raleigh Galleries, Raleigh, North Carolina, in 1982, and at Gallery Ana Izay in Beverly Hills, California, 1988. Chaibia is also grateful for the consistent support of Ceres Franko of the Gallerie L'Oeil de Boeuf in Paris, where she has had seven personal shows since 1973.

Chaibia's vigorous strokes and primary colors have often been compared to the artists of the Cobra Movement of Copenhagen, Brussels, and Amsterdam. Alain Flamand in his book *Regard sur la Peinture Contemporaine au Maroc*, considers Chaibia

> not a brute painter like the Cobra, but rather a child with all the virtues of astonishment and wonder. ... Chaibia paints with the spontaneity of a child, without the detour of culture. ... Each picture is an act of rebirth of a world that is a refreshment to the eyes. ...
>
> She often seems to take the colors as they come out of the tube, without altering them or shading them. Between the desire to paint and the act, no detour.[2]

Chaibia says "I paint what I see. I love the sea, the river, the earth, and especially the flowers that bloom in the springtime after the rain," adding, "I still remember the flowers and the people of my village. In the beginning I used to travel more, and saw more poor people, farms, animals." Now Chaibia is mostly in Casablanca except when traveling abroad, as her health is not good.

Among Chaibia's recent paintings is a series of small portraits, approximately twenty-four by thirty inches in size, dominated by vivid red and orange brushstrokes: *The Dancer* (Fig. 9-2), *The Bride* (Fig. 9-3), *The Storyteller* (Fig. 9-4), *Woman from Fez* (Fig. 9-5), and *Girl from Casablanca*. Flamand says,

Fig. 9-3 *The Bride*, acrylic on canvas, 24x30", 1988.

Fig. 9-4 *The Storyteller*, acrylic on canvas, 24x30", 1988. Photograph: Oliver Sepulchre.

Fig. 9-5 *Woman From Fez*, acrylic on canvas, 24x30", 1988.

More than in her large canvases, always a little heavy, it is in her small format that Chaibia gives the best of herself. ... For Chaibia, the world is not used up. ... Chaibia discovers each time with equal spontaneity the pleasure of repetition, the same recurring themes ... as if the painter, carried away by the pleasure, the joy of discovering the first time ... it was given to her by the grace of childhood to find it a second time, then again and again, always the same pleasure, the same joy.[3]

Among the large paintings (approximately forty-eight inches by fifty-six inches), remaining in her home are *The Fisherman* (Fig. 9-6) and *The Football Players* (Fig. 9-7), because most of her major works are in museums, private collections, or packed for exhibition. *The Football Players* is especially exciting as in this complex composition Chaibia captures the players' essence, particularly in their expressive features, disarrayed hair and striped uniforms.

Most extraordinary to behold is her large mural on the outer patio wall (Figs. 9-8) of the two rooms containing her collection of small works. Painted in 1978, the brilliant, dazzling textured portraits that dominate these walls represent Chaibia's childhood memories of Chtouka. The mural is surrounded with low cushioned couches and tables where family and friends eat, talk, and watch television in the midst of this aura of warmth and gaiety.

Chaibia said that in 1982 she painted a big mural in the city of Assila, the site of an annual festival. Tourists began to frequent this area especially to take photographs of her mural. The mural has since been destroyed because, according to Chaibia, other artists were "jealous." She related this without bitterness but laughs when she discusses the archetypical Moroccan painting, *Fantasia*, which depicts a group of men on horseback racing to shoot their rifles. *Fantasia* hangs in Casablanca hotel lobbies and its theme is incorporated into the interior decoration of Royal Air Maroc airplanes.

Chaibia paints consistently and works more in summer than in winter when it is cold, for her studio is located in the outdoor patio at the back of her house. Chaibia's dark eyes twinkle, and she smilingly says, "My paintings make me happy. My colors are life and nature. My life is more easy now, but I stay the same. I'm happy with my paintings, the house, the dogs, [five, of all ages], birds [including a peacock that struts freely about the patio], and tor-

Fig. 9-6 *The Fisherman,* acrylic on canvas, 40x56", 1978.

toises [which are too numerous to count]." Chaibia also feels, "People will have good luck if they have my painting in their house."

Perhaps the most rewarding aspect of Chaibia's work is her capacity to risk, to express her emotions directly. Her mind is uncluttered by self-doubts or the process of formal aesthetic analysis. The results may appear brutish or rough, but her work is always engrossing. She has developed her innate sensitivity to color and composition and refreshingly permits the white surface of her paper or canvas to become an effective part of each image, to balance the intensity of her colors and forms. She seems continually ready for new challenges, but like the poet Emily Dickenson who saw the world as a grain of sand,

Chaibia's world, revolving largely around her childhood memories, remains rich and intriguing.

In contrast to her work, which is considered modern and avant-garde, Chaibia remains traditional in her dress and lifestyle. She wears long caftans, enjoys jewelry, applies Berber makeup or designs to her face. She wears her hair in a bun when very hot, loose or sometimes in a youthful ponytail. She offers visitors many glasses of strong, fresh peppermint tea with sugar. Her art rages forth among all the French antiquities. One room is devoted to her collection of other contemporary artists' work, and the two back rooms where she and Tallal formerly lived are now like a gallery featuring Chaibia's numerous, well-framed, small drawings and paintings.

Significantly, mother and son are both independently famous, their work distinctly different. Though their lives and careers have remained intertwined, they have only exhibited together twice. As Chaibia's manager, Tallal arranges her travel, publicity, and exhibitions. Chaibia shows her work in Tallal's gallery, which he established six years ago in Casablanca. Chaibia says, "He is my best friend, my comrade."

Chaibia says, "I always thank God for what happened to me. When you receive something, you must also share." She admits that during her first exhibits, her prices were very low, and she

Fig. 9-7 *The Football Players,* oil on canvas, 40x54", 1984.

Fig. 9-8 *Women of Chtouka,* mural, acrylic, approximately 9x16', at Chaïbia's home, 1978.

happily sold all her work. Upon returning from Paris, she relates, "I place my pile of money on a carpet. Then I take one-half of this money and go to the suburbs of Marakesh and give it to poor women, some of them poor Jewish women, blind people and children." She continues to share her good fortune as she now supports several employees including a maid and a cook and is interested in their families' welfare and children's education.

Chaïbia believes, "Religion helps you organize your life. I'm doing my prayers, but I'm modern. Women should not let themselves be like donkeys with blinders." Most significant is the fact that Chaïbia's consciousness extends beyond her own success. In her 1985 interview with Mernissi, she stressed the point that

> There must be a joint responsibility between women who were lucky to go to school and those who were not. An educated woman has to help the others; otherwise how could we change society? Morocco will not advance if those who have privileges forget the others.[4]

Chaïbia is not afraid to be different or outspoken. She equates education with freedom and chides some of her Moslem sisters about the current political trend in Morocco and other

Notes

1. Interview with Fatima Mernissi, Exhibit Catalog: *Presences Artistiques au Maroc: Farid Belkahia, Chaibia, and Mohammed Melehi*, Maison de la Culture de Grenoble, France, in collaboration with Le Centre d'Art Contemporain, April 19 - June 15, 1985.
2. Alain Flamand, *Regard sur la Peinture Contemporaine au Maroc* (Casablanca, Morocco: Société d'Edition et de Diffusion al-Madaress, 1983), Introduction, pp. 10-12.
3. Flamand, *op. cit.*
4. Interview with Fatima Mernissi, *op. cit.*
5. *Ibid.*

Arabic countries in which women are returning to wearing the veil. She tells Mernissi that Mohammed V (the father of Morocco's present King Hassan II)

> changed that. The veil and walls made us like donkeys. He gave us education and dignity. You Moslem sisters [referring to organized fundamentalists], you want to take us back to the Dark Ages. Now that Moroccan women are doctors, lawyers, and we begin to be proud of ourselves, you want to give us the *hijab* [veil].[5]

Chaibia's indomitable spirit continues to be manifested in both her life and art. Lack of formal education has not dulled her creative energies, sensitivity to environment, sense of class consciousness, or responsibility to others. Tranquil in her artistic achievement and fame, she has become a significant role model for Moroccan women.

Inji Efflatoun

Art, Feminism, and Politics in Egypt

IN THE EARLY decades of this century, Moslem custom kept upper-class Egyptian women veiled and confined to the family compounds. Change was slow and for many years limited primarily to a small number of exceptionally daring, talented, and privileged women.

Egypt's population of approximately sixty million is predominantly Moslem, with only ten percent adhering to the Coptic or Christian faith. Moslem or Islamic law, recorded in the Koran in the seventh century, regulates social relationships, and until recently women commonly married in their early teens. The customs of veiling in public and restricting women's activities to a harem or series of rooms within the family compound were reflections of social status, as the struggle for subsistence for the Egyptian peasantry has always necessitated women's unhampered and arduous physical labor outside the harem.

Dramatic changes for women were initiated in 1923 when Huda Shaarawi removed her veil in public as a formal protest.[1] She was a founding member of the Egyptian Feminist Union which tried to influence the government to legislate restrictions upon men's easy access to divorce, to regulate certain aspects of polygamy, and to provide equal educational opportunities for women. After the 1952 revolution the British were forced out of Egypt, and King Farouk was replaced by a military government. A few years later, under the presidency of Colonel Gamal Abdel Nassar, some significant changes in women's status were legislated: for example, free public education was established for all, and women gained the right to vote.

The Higher School of Fine Art was founded in Cairo in 1908, but upper-class women were limited to home tutors for art lessons. By the 1940s several significant women artists did emerge and participated in the societies that were then formed for the promotion of modern art. Today among Egypt's estimated three hundred professional artists, eighty are women.

Inji Efflatoun (Fig. 10-1) was a leading member of the older generation of women artists. This generation includes Teheya Halim, who has served on the Supreme Council of the Arts, and Zeinab Abdel-Hamid, known for her "special ability to portray life in the popular suburbs and the crowds at the marketplace."[2] Efflatoun died in 1988.

"Efflatoun has been very close to the heart of society, express-

Fig. 10-1 *Inji* Efflatoun, Egypt, 1987.

ing its griefs, hopes and aspirations," according to the catalog of the 1975 exhibit *Egyption Women Painters Over Half a Century.*[3] Working in a predominantly figurative mode and responsive to both traditional and modernist influences, Efflatoun has courageously risked expressing her views of Egyptian reality from a militant perspective which has not always been well received. Her passionate involvement in art, feminism, and radical politics resulted in a jail stint of over four years, an experience that did nothing to diminish her radicalism and creativity.

Efflatoun was born in Cairo in 1924 into a traditional Moslem family she described as "semifeudal and bourgeois."[4] She appreciatively added, however, that they were "liberal and more open than most because of their frequent travel to Europe." Her father, Hassan Efflatoun, was an entomologist who had studied in England and Switzerland and established the first Department of Entomology at the University of Cairo.

Efflatoun considered her mother, Salha, "a fighter." Salha

was educated by private tutors in the subjects of French (the language spoken at home), English, Arabic, piano, and clothing design. Her marriage to Hassan Efflatoun, a distant cousin, was arranged when she was only fourteen years old. By the time Salha was eighteen, she managed to divorce her husband; as Efflatoun explains it, he was "a good scientist, but a poor father." Alone, her mother raised two daughters, Inji and Gulperie, who is three years older than Inji. Salha took the initiative to open a fashion boutique in conjunction with a business partner, a prime promoter of the Egyptian textile industry. Not only was she the first woman in Cairo to have her own boutique, but in the early years of aviation she was the first woman to fly, unaccompanied, from Egypt to France, where she had gone for inspiration in fashion designing. Her business venture was successful, and she continued to manage a garment production factory employing one hundred workers until her retirement in 1975.

As a liberal-minded Moslem, Efflatoun's mother sent her daughters to Sacred Heart, a Catholic boarding school. Efflatoun considered this "my first prison" as "everything was forbidden." This experience also sensitized Efflatoun to social injustice as "the division between rich and poor was very apparent, with the poor nuns doing all the domestic work." Efflatoun lamented, "There was not even equality before God. We prayed all the time and were very worried that all non-Christians would be tortured in hell." Efflatoun recalled, "I made so much trouble at Sacred Heart that by age fourteen I was transferred to the French Lycee. Here there were French, Jewish, and Moslem students, and I

Fig. 10-2 *Carriers of the White Stone*, oil, 24x32", 1958.

became impassioned with the study of literature and history." She was intrigued with the French Revolution and Napoleon's brief invasion of Egypt, which had such a lasting cultural impact upon Egypt's upper classes. As a result of her studies, Efflatoun said, "I became very militant, and began to question, why is there such a big difference between rich and poor? At first I was an anarchist in my views; then Marxism became my guide for

social solutions." At this time, Efflatoun insists, she was still "ignorant of real Egyptian history."

Parallel with Efflatoun's political development was her growing interest in art: "from very small, I liked to paint, and my parents encouraged me." At first Efflatoun enjoyed illustrating her sister's fairy tales, some of which were published in their uncle's newspaper; however, in school she found her art tutors to be "very academic illustrators." A turning point occurred when the expressionist painter Kamel El Telmissany was hired as her private tutor. He introduced surrealist and cubist aesthetics and encouraged Efflatoun to express what she felt. In 1939 Telmissany and other painters, art critics, and writers had organized an avant-garde group, Art and Liberty, which promoted modern art in Egypt. They held annual exhibits, Salons des Independents, and in 1942 Efflatoun was invited to participate. She was then only eighteen years old. A typical painting of this

Fig. 10-3 *Old Sailor*, oil, 14x18", 1958.

period is *Young Girl and Monster* in dark brown and blue tones. A terrified girl is running while pursued by a powerful vulture. At this time trees became a significant theme as "trees are like people—suffering—and represent our dream spirits."

Efflatoun recalled that people were astonished by her paintings and wondered "why a girl from a rich family was so tor-

Fig. 10-4 *Fourth Wife,* oil, 16x22", 1952.

mented, so unhappy ... and refusing a lot of things." She added, "I was very unsatisfied with the superficial people around me who had no aim in life. ... I attended balls with the royal family, dressed nicely, but I was very bored with men of my generation, and I thought, 'If I marry someone like that, life will be very boring.'" From 1946 to 1948 Efflatoun stopped painting: "What I was doing no longer corresponded to my feelings." She felt a growing contradiction between her personal vision of reality and the social conditions of "the real Egypt, my roots, that I needed to discover."

In 1948, Efflatoun married Muhammed Abdul Elija, also known as Hamdi. A nationalist activist, he was of Moslem heritage from a "common or poor family." Hamdi was educated in law and served first as a "progressive judge" and then as a state counsel. Efflatoun's interest in painting was renewed after she explored ancient towns like Luxor and made trips to the rural areas of Nubia and Barrage that still maintained their folk traditions. She considered these experiences her "best school." Early in their brief marriage, Hamdi encouraged her painting and insisted that she not "lose time" by teaching, arguing that her dedication to art and politics was sufficient contribution. Hamdi was ultimately sentenced to a two-year prison term because of his own political activity. He died in 1956 of a sudden illness,

Fig. 10-5 *Go, Go You Are Divorced Now,* oil, 20x20", 1952.

shortly after his release from prison.

Efflatoun spent one year studying at the studio of the Swiss painter Margot Veillon, developing her drawing and composition skills. She benefitted from a workshop with the painter Hammad Abdullah. Trips to oasis and farming regions gave her more opportunity to "penetrate the houses and sketch men and women at work." During the period 1948 to 1958 her paintings varied from the rhythmic groups of working people joined in a common activity, to individual portraits. Most of these images were done by thick applications of paint with the artist creating deep, dramatic shadows, a reflection of the intense Egyptian sunlight. *Carriers of White Stone* (Fig. 10-2) depicts Egyptian prisoners who were often forced to carry heavy rocks, a common building material, on their heads. In *Old Sailor* (Fig. 10-3) the composition is dominated by the sailor's seated form, one hand resting on a knee and the other holding an oar. The dark red-brown tones of the boat planks blend with his sun-bronzed face and hands.

Fourth Wife (Fig 10-4) depicts a young nursing mother seated beside her much older husband and surrounded by her children. Efflatoun explained that Moslem divorce laws, as interpreted in the past, have permitted a husband to tell his wife, "Go, go, you are divorced now," and she will be forced to leave his home. If the father desires, all their older children will legally remain in his possession. In the painting of this title (Fig. 10-5), the faces of mother and daughter reveal their sense of an uncertain future.

Women's lack of legal rights under Moslem and Egyptian law

Fig. 10-6 *Port Said*, oil, 22x30", 1957.

Fig. 10-7 *The Protest*, oil, 24x36", 1957.

was of major concern to Efflatoun as was the Egyptian feminist movement. In 1945 Efflatoun went to Paris as a delegate to the First Women's International Congress, representing Egypt's Democratic International Federation. The federation supported complete social equality with men, national liberation movements, and work toward world peace. According to Efflatoun, "political activities had to be done secretly, as in Egypt there was no freedom or right to do it."

At this time Efflatoun wrote three popular political pamphlets. In one of these, "Eighty Million Women with Us," she linked Egyptian women's fight for liberation from colonial and male oppression with efforts of women from all over the third world.

In 1949 Efflatoun became a founding member of the First Congress of the First Peace Council of Egypt and in 1956 helped form the Women's Committee for Popular Resistance. Efflatoun related that during her early years of activity her "mother and grandfather were very strict" and not in favor of her attending meetings; therefore, she decided to gain some economic independence by giving private French lessons. She also taught drawing for two years at the French lycee where she had formerly been a student. There drawing was still taught from a rigid, academic perspective limited to copying reality, but, Efflatoun says, "I introduced modern ways to make students' imaginations work."

In hindsight, Efflatoun considered her mother to have been "very perceptive," because she had recognized that "in Egypt, if you're involved in politics, you finish in prison." Her mother tried to convince Efflatoun to finish her fine arts studies in Paris.

Fig. 10-8 *Behind the Bars,* oil, 12x18",
1961.

Fig. 10-9 *Group of Prisoners,* oil, 24x30",
1961.

Efflatoun admitted, "It was very tempting to go to a good academy, but I refused completely. With five or ten years of Parisian study I would be a better artist, but I would know nothing about my country, and then it would be too late. Now I began to understand my roots, to be Egyptianized, which was important for my future. In addition, it also meant learning to speak Arabic rather than French." Efflatoun takes pride in her self-discipline: "I organized myself: mornings for painting, afternoons and evenings for political work. And I worked every day. I did not wait for inspiration."

The results of her dedication were proven by the impressive exhibitions and honors Efflatoun received even during her early years as an artist. Individual exhibits include: *Galerie Adam le Caire,* 1952; *Aladin le Caire et Association des Amitiés Françaises,* Alexandria, 1953; *Le Gallion* and *Le Caire,* 1954; and *L'Atelier du Caire,* 1956. At this time her international group exhibits included the *Venice Biennale* in 1952 and the *São Paolo Biennale* in 1953.

Efflatoun's aesthetic direction was appreciated and influenced by the internationally renowned Mexican painter and muralist, David Alfaro Siqueiros. They became friends during Siqueiros' 1956 visit to Egypt, and his comments about her art were later used as a catalog preface for a 1959 exhibit. He succinctly summarized Efflatoun's aesthetic achievements:

> Her art has the quality of good plastic (aesthetics) as far as structure, form, colour and texture are concerned, while showing no lack of those attributes which make for a realism more eloquent and richer than that of the past. … She is propelled by the powerful individual emotion that she possesses toward a national art of universal impact.[5]

One of Efflatoun's 1951 paintings, *We Cannot Forget,* played a key role in the events ultimately leading to her incarceration. A sea of faces fills the canvas. Cutting diagonally across the faces are five coffins held aloft to commemorate victims of Egypt's nationalist struggle against British control of the Suez Canal. The foreground is dominated by the stern, angry features of mothers, their heads and bodies outlined in black veils as they march with upraised arms and clenched fists. This canvas was included in Efflatoun's first one-woman exhibit at the Galerie Adam Le Caire in 1952, along with other works focusing on the involvement of the population in the nationalist struggle. For the students and intellectuals who came to this exhibit, Efflatoun said, "My painting, *We Cannot Forget,* played its role in expressing the popular sentiment by honoring the victims of anti-British political activity. My exhibit became like a demonstration." After the exhibit, *We Cannot Forget* was displayed at the office of the Director of Cairo's University City where it "became a political instrument." The students made posters of this potent image and used it in their protest campaigns.

Two powerful paintings, *Port Said* (Fig. 10-6) and *The Protest* (Fig. 10-7), painted in 1957 and 1958, were included in Efflatoun's exhibit held just prior to her 1959 arrest. In *Port Said* a horrified child sits beside the fallen body of her mother, whose

Fig. 10-10 *Dormitory of Political Prisoners,* oil, 20x30", 1961.

form is outlined by a pool of her own blood. In *The Protest* a woman dressed in bright red, stands with her feet widespread and arms upraised, expressing her outrage. Behind her some women echo this expression, while others huddle together dejectedly. These two paintings are reminiscent of the passionate images of the European expressionists Edward Munch, Barlach, and Kathe Kollwitz. As in their art, intense colors and exaggerated proportions augment the emotional impact.

In 1952 the Democratic National Movement (DNM) was outlawed and "a period of terror" was initiated, with concentration camps opened "for political prisoners," Efflatoun recalled. "It was easy to put men in political detention, but not women, because in Egypt, an Oriental country, it is scandalous to arrest women. It is against public opinion, and the newspapers, the press, cannot mention it."

Nasser was extremely anti-communist. After a Nasser speech against all political activity, Efflatoun felt the growing pressure of the government's campaign against the Communist Party. "Until 1959," Efflatoun said, "if the police came and searched your home and could not prove you were a member of the Communist Party, they could not arrest you"; however, with the 1959 passing of the Decree of Detention, it was possible to "be arrested without proof if one is considered a danger to society." Her broth-

Fig. 10-11 *Homage to the Fedayans*, oil, 24x32", 1970.

er-in-law, Ismail Sabri Abdullah, an economist, had been arrest-
ed during a massive roundup of political activists. At any time,
Efflatoun sensed, she too could be arrested; therefore, she decid-
ed to go underground and announced to her family that she
would disappear. For over three months Efflatoun dressed as a
peasant, covering herself with a veil. She lived isolated, in a
small room, and described her life as "very difficult, very boring,
more than when I was in prison." She began to paint; one of her
images, *My Illegal Room*, depicted her sparse environment.

Finally, in March 1959, under a republican decree, the police
secretly arrested Efflatoun and twenty-five other politically active
women. They were Egypt's first female political prisoners, and
the media were forbidden to mention their detention. At first only
Efflatoun's sister and those in the women's movement were
aware of what had happened.

Efflatoun described the women's prison as similar to "a small
village where all the vices of society are packed together, the
prostitutes, hashish dealers, thieves, and the condemned."
Efflatoun felt "prison was a fantastic occasion to express the
human situation. People were very nice, but miserable—even
people who murdered."

The most difficult aspect of the imprisonment was the uncer-
tainty. "We were neither condemned to die nor given an official
time sentence. We didn't know how long we would stay ... a whole
lifetime, or to be liberated tomorrow. You live on your nerves. I
said to my comrade prisoners, 'Don't always think about libera-
tion. Instead of being strong, you will be defeated.'" Efflatoun was
emotionally prepared for this experience; as she said, "I knew
from the first day I became militant, I risked prison."

Efflatoun's mother, who has always remained conservative
and politically uninvolved, clearly played a role in steeling her
daughter's resolve. Efflatoun proudly recalled that when the
twenty-five women political prisoners were first incarcerated, the
prison officials "tried to make us write a denial of our beliefs,
telling us we would then be set free. They also questioned, 'Who
made you a communist?' Of course, we told them nothing; how-
ever, some mothers counseled their daughters, 'What is a piece
of paper! Say what they want.'" But, Inji said, "My mother could
never accept that. When she heard about the questioning, she
proudly said, 'Inji wants to get out of jail but will not accept free-
dom at any price, and at the loss of her dignity.'"

Before her incarceration Efflatoun fortuitously participated
in the 1959 Landscape Painting Competition sponsored by the
Ministry of Culture at Cairo's Museum of Modern Art. While in
exile, she read in the newspaper that she had won the first prize.
"I needed the money; it was like 100 pounds today, but as I was
exiled, I couldn't get to it. It was the only prize I had ever won in
my life—and eventually it helped me a great deal."

In order to gain permission to paint, Efflatoun utilized the
publicity generated by the prize to her advantage in jail. At first,
"political prisoners were kept separate from the others, as they
were afraid," she laughed, "we would contaminate the thieves
and prostitutes. They didn't torture us physically, as they didn't
want a scandal ... but oppression took the form of forbidding us
reading, writing, and family visits." Thus began Efflatoun's long

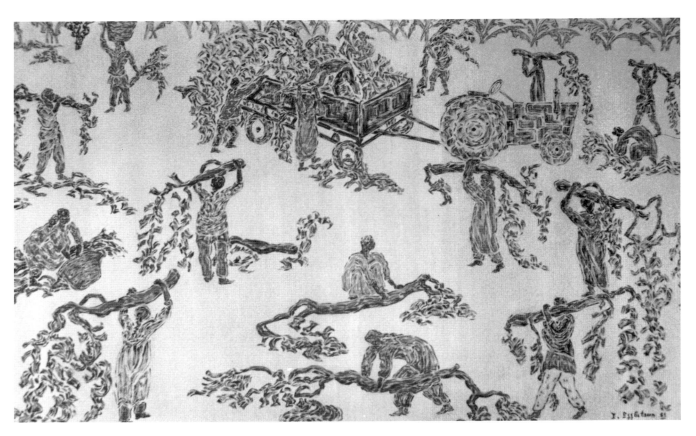

Fig. 10-12 *Carriers of Old Trees,* oil, 30x36", 1981.

battle with the prison director to obtain the right to paint. "In the beginning I tried gently to persuade the director and staff that nothing was written on the books to forbid painting. Eventually the director said, 'I will let you paint, on condition when the paintings are finished, you will send them to the prison administration for censorship.'"

In the beginning, she recalls, "the first three paintings passed censorship, but the eleven that followed were confiscated. One painting was of a condemned woman, dressed in red prior to her execution."

In order to continue painting, Efflatoun boldly told the prison director upon whose good will her fate depended: "I'm a very famous painter. I won a prize for 100 pounds. Let me paint and you can sell my paintings for the benefit of the prison." The director succumbed to her wishes. "In the beginning," Efflatoun said, "he brought me some very bad colors ... and I gave him my paintings. Then the director informed me, 'Nobody wants to buy your paintings. They are very tragic. The prison police officers who can afford to buy them don't like them.'" Efflatoun then suggested that she and her comrades were ready to buy the paintings, and she bargained: "Instead of three pounds for each one, I will buy them for one and one-half pounds." Efflatoun's early prison paintings include both the portraits and group scenes dominated by the inmates' striped prison uniforms and

the vertical bars of the jail cells. *Behind the Bars* (Fig. 10-8) focuses on a single woman whose blue-striped prison dress, outlined with bright orange, contrasts vividly with the thick steel bars through which she desperately peers out. In *Dormitory of the Political Prisoners* (Fig. 10-9) and *Group of Prisoners* (Fig. 10-10), the impact of crowded cell conditions is clearly evident. Efflatoun aesthetically organizes the groups of women as they sit upon the three-tiered dormitory beds or stand behind bars.

In a portrait study, *The Dreams of Lady Bahama*, we see a white-veiled woman stitching a patterned cloth, the garment for a child she would like to conceive. Bold orange brush strokes outline the basic body forms, warmly emphasizing the desperate and tender mood of Lady Bahama as her eyes dreamily focus on her sewing. *Portrait of a Young Prostitute* is also created with orange calligraphy emphasizing face, hair, veil, and intense eyes. Perhaps this woman was one of the dormitory newcomers.

It was not surprising to learn from Efflatoun that after two years she could no longer paint people. So much misery disgusted her. She then developed an interest in nature, trees, and the distant sailboats. She was able to pursue her new interest when "one prison director let me go upstairs to the prison laundry to have a better view of the landscape and the distant sailboats. The prisoners would shout to let me know, 'The boats are coming!' so I could run up and make sketches. Then these prisoners too began to get excited and to realize, though they had seen it for years, that the movement of the boats symbolized freedom." Trees, flowers, the moon, the beautiful sunsets became the new themes of Efflatoun's paintings. From her cell window she could see a singular tree near a barbed wire fence and began to paint the flowing branches like great arms stretching up to the blue sky. This prison tree eventually became known as "Inji's Tree."

Efflatoun was able to continue painting until her release. "My sister, before she too was imprisoned, came to give me good paints. I then secretly bribed the guards who rolled the unstretched canvases (that ranged in size from nine by twelve inches to twenty-four to thirty inches) around their bodies, to take them out on days when there was no body search of the guards." "I was afraid," Efflatoun added, "because if they caught the guard with my painting, they would take away from me the right to paint." After three years of confinement, five political prisoners were suddenly given their freedom, but for Efflatoun imprisonment lasted until July 1963, a total of four and one-half years. Then suddenly the president gave the order for the liberation of all the political prisoners and the dismantling of the women's detention camp. She noted that "the secret police were so furious that I was liberated that they didn't look at my paintings and the hundreds of sketches I took with me."

"When I came out of prison, I became much more human," Efflatoun recalled. "Before, I was militant and a little dogmatic. When I came out of prison, I became more open to people, to life. Before, I didn't compromise. Now if I see someone's weakness, I can accept it," adding, "Nasser, although he put me in prison, was a great patriot. ... Prison was a very enriching experience for my development as a human being and artist. When a crisis or tragedy occurs, one can become more strong, or be destroyed." By

1963 Egypt's Communist Party, of which Efflatoun was a member, had been dissolved, and painting became her dominant activity.

In 1964, less than a year after Efflatoun was freed, she had an exhibit at the Akhenaton Gallery. The French tapestry artist Jean Lurcat stated in the catalog:

> Inji Efflatoun chooses to depict faces and groups, caressing the hands and gestures of men at work, and knowing that to make herself heard she must shun faddishness. The artist listens only to the voice of her origins, or Egypt, the voice of song, of the Nile and of vast horizons glowing with an inner fire.[6]

The next year Efflatoun received a one-year grant, consisting of a monthly financial stipend from the Egyptian Ministry of Culture. In the following years she had both national and international exhibits in Rome and Paris in 1967, and in Dresden, East Berlin, Warsaw, and Moscow in 1970. In 1974 and 1975 she exhibited in Sofia, Bulgaria; Moscow; and Prague. Among her post-liberation paintings are many landscapes and two prominent works from 1973 which feature heroic women role models. Both are composed of a variety of rhythmic and textured brush strokes exposing narrow, irregular pathways of light or unpainted canvas between each stroke. An *Indian Express* review of Efflatoun's 1979 exhibit in New Delhi refers to her painting, *Homage to the Fedayins* (Fig. 10-11):

> Instead of following the dictates of "modernism" and "pure forms," she has wisely chosen the common toiling masses of her country, and has achieved a kind of simplicity which communicates directly. ... Yet, the simplicity is deceptive. The viewer must have noticed the discreet use of the formal elements on the canvas.
>
> Efflatoun's *Fedayin* is, however, different in its arrangement of pictorial space. ... The unpainted areas inside the human figures, the viewer will notice, throw up a pattern of invisible linkages that tie the human forms and the weapons in a noble togetherness.[7]

In *Homage to Angela* Efflatoun portrays the Afro-American activist Angela Davis like a beacon of light rising above masses of chained black forms with upraised hands, a symbol of Afro-American history and liberation struggles. In the 1970s Efflatoun also helped to organize two major exhibitions: *Art in the Service of Peace and National Independence*, held in Cairo in conjunction with the Conference of Solidary with Arab Peoples in 1971; and *Ten Egyptian Women Painters over Half a Century* in 1975 to commemorate International Women's Year.

Courage has always been an implicit aspect of Efflatoun's character in art as well as in politics. Her later work included more and more of the white canvas background between her light brush strokes interacting with the painted surface. This aesthetic development involved considerable risk. "Since 1974," she said, "I took courage in my two hands to enter a new adventure. I used to leave some white between brush strokes for vibra-

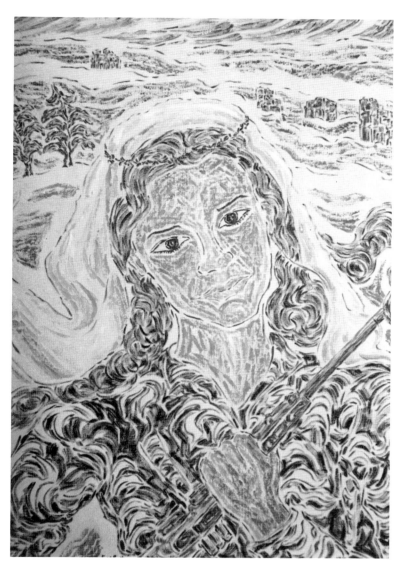

Fig. 10-13 *Bride of the South,* oil, 30x36", 1985.

tion. Little by little I discovered if I leave more white, it helps." In a 1986 interview in *Cairo Today,* Efflatoun further analyzed the increasing use of large white spaces around her forms:

> Prison was very gloomy and devoid of color and light effects. When I was released in 1964, my eyes were dazzled by the outside world. I began to fill my canvases with color and to leave white stripes. ... I had always been interested in expressing the specific quality of Egyptian light. ... The period of white light proper started in 1974. When I went to the village of Garagoz near Luxor, I found the palm-filled landscape very inspirational. I became more daring and started to leave bigger spaces free of color. ... This allows the painting to breathe in addition to detailing movement.[8]

Notes

1. See Fatima Mernissi, *Beyond the Veil* (Bloomington: Indiana University Press, 1987); and Huda Shaarawi, *Harem Years: The Memoirs of an Egyptian Feminist, 1879-1924*, trans. Margot Badran (New York:Feminist Press, 1987) on Egyptian women and Egyptian feminism.

2. Badr El-Din Abou Ghazi. *Egyptian Women Painters Over Half a Century* (Cairo, 1975).

3. *Ibid.*

4. Unless otherwise stated, all quotations are from the author's August 1987 interviews with Inji Efflatoun in Cairo.

5. David Alfaro Siqueiros, "Preface," in *Inji Efflatoun Retrospective, 1942-1985* (Cairo: Galerie Akhenaton, 1964).

6. Jean Lurcat, *Efflatoun Retrospective, ibid.*

7. "A Deceptive Simplicity," *Indian Express*, 21 April 1979.

8. Heba Saleh, "From Surrealism to Socialism," *Cairo Today* (August 1986), 18.

9. *Ibid.*

From 1959 until her death, apart from the years of her imprisonment, Efflatoun shared a light, spacious duplex apartment with her mother. Interspersed with their antique Oriental furnishings, Efflatoun's paintings covered the walls and filled many studio storage bins. It was obvious that she had been a prolific artist, undeterred by adverse circumstances.

Each day Inji Efflatoun continued to paint and plan for her complicated schedule of national and international exhibits. She was concerned about establishing a more permanent public location to house a representative body of her work. She was supportive of other artists, especially the younger generation, and was very actively involved with Cairo's Association of Artists and Writers. Indeed, Efflatoun's work continued to grow and challenge us by revealing new aspects of the Egyptian character as well as her own:

At present there is less emotional charge and more contemplation in my work. I am still politically involved, but art is my priority. I think that white light is one step on the road to expressing another of the special attributes of Egypt.[9]

The shock of so much white canvas, almost dancing between her lively brush strokes, as well as behind each form, is truly dazzling—like the Egyptian sunlight. Her late career landscape paintings, depicting scenes of rural life offer much joy, lightness of spirit, and delight to the spectator—though occasionally they seem too thin or fleeting.

In contrast to her prison paintings of trees, densely painted with opaque layers of intense color, Efflatoun's more recent canvases, such as *Carriers of Old Trees* (Fig. 10-12) and *Bride of the South* (Fig. 10-13), make it apparent that the shape and pattern of the white space behind each form is as important as the form itself. In her treatments of Egyptian palm trees, their slim towering forms seem to sway with sensual outreach into the vastness of undefined space. Each brush stroke is charged with life and emotion. Efflatoun has learned to relax with her paints and express a sensual enjoyment of life and nature, a stage of inner freedom not everyone can reach or share.

Sue Williamson

Art and the Struggle for South African Liberation

SUE WILLIAMSON'S development as an artist-activist is linked with her identity as a white South African struggling against apartheid (Fig. 11-1). Her vision of a just society, based upon the free movement and interaction of all peoples within a nation and their right to equal representation, evolved during the five years she spent in the United States in the 1960s. When she returned to South Africa she found it hard to accept how separate the races were.

What is most extraordinary about Williamson is that she forged her vision and subsequent political experiences into an artistic statement that has had a significant impact upon black and white South Africans and now within the international community. "Art," Williamson believes, "can certainly create a kind of awareness in people that is a necessary precondition to change. That is why artists are a critical part of any society, particularly one like South Africa."[1] In addition to her individual work, Sue also contributes to many collective or group art projects.

Using faces of women to tell the story of the history of the struggle for liberation in South Africa, Williamson has created an ongoing series of poster-size portraits titled *A Few South Africans*. These portraits are the faces of women who married, raised children, and carried on the struggle for freedom in obscurity, or occasionally in the international spotlight as has Winnie Mandela (Fig. 11-2).

A Few South Africans exhibited at On the Wall Gallery in Medford, Oregon, in 1985 as part of a tour of Northwest U.S. galleries and museums. The Oregon-based artist and writer Tee Corrine commented in *Women Artist News* that "the words that came to mind looking at these prints are: inspiring, superb, accomplished, mature, fully realized. Williamson, in her seamless blending of appropriate form and heart-wrenching content, has created an art that is both informing as well as enforming, meaning an art that can form (change) people's lives."[2]

Williamson is a risk-taker not only aesthetically, but also in her outspoken personal commitment to justice, even when, as she notes, "you must face very freely that you can be jailed at any time." She was born in England in 1941 and, in 1948, her family moved to South Africa where her father worked for a construction company in Johannesburg. Throughout high school her professional goal was to be a newspaper reporter. After high

school graduation Williamson took a secretarial course and then obtained a job as an assistant secretary to a news editor at a major newspaper. At that time women were generally hired only as social event reporters and, though Williamson's job included verification of the news reporters' stories, the newspaper management would not let her advance.

"I was always interested in art, but it was not until 1964 when I married and came to New York City with my husband that I pursued this interest," Williamson said. "He was a management consultant while I worked for an advertising agency. Then one day," Williamson relates, "after a friend took me to an exhibit of Sumi style watercolor paintings, my study of art began." She first enrolled in a Sumi class. "At that stage my ambition was no more complicated than doing Christmas cards." But soon Williamson began to study seriously at the Art Student's League—figure drawing with John Groth, life painting with Thomas Fogarty, and etching with Seong Moy. From that time one she began to carry a sketchbook with her wherever she went.

In 1969 when Williamson, her husband, and her daughter (born the year before) returned to South Africa, she continued her studies in a Cape Town art school; in 1973 she had her first gallery exhibit of etchings, mostly landscapes. By this time, however, Williamson had joined the Women's Movement for Peace (WMP), and her life and art were soon to merge and undergo dramatic changes.

The WMP was "based on the simple idea that if women refused to be bound by apartheid, they could form friendships across color lines. I came to know the black townships as well as I know the white suburbs." The focus of the WMP, an interracial group, was not only to witness the government's genocidal policies toward blacks but to try to stop these destructive activities peacefully and to educate the South African public, as well as the world.

Williamson describes a typical incident that took place in 1986 at Modderdam, a squatter camp three miles out of CapeTown. "The government claimed the people had no right to be on the land and they must move as the government was going to knock the camp down. The day the demolition was supposed to start, we went out there to try to stop the bulldozers. We stood in the road waiting for them to come, while we formed a human chain across the road. They were there, but they did not start up. But by three o'clock in the afternoon most of the mothers had to leave to pick up their kids from school and then the bulldozers promptly moved into action." It was disappointing to realize, Williamson continued, "that we couldn't organize on a scale to stop them. It was too much of a last minute effort on our part."

Williamson remained at Modderdam with her sketchbook and over the next seven days she recorded "the police tear gassing, homes being demolished and furniture smashed down. In seven days, 2,000 homes were demolished." She created a series of etchings in which underneath each image of destruction were phrases, sarcastically representative of the government's point of view, that stated, "They shouldn't be there anyway" and that praised the government for "cleaning it all up."

One etching was reproduced on a postcard and printed com-

Fig. 11-1 Sue Williamson, New York, 1986.

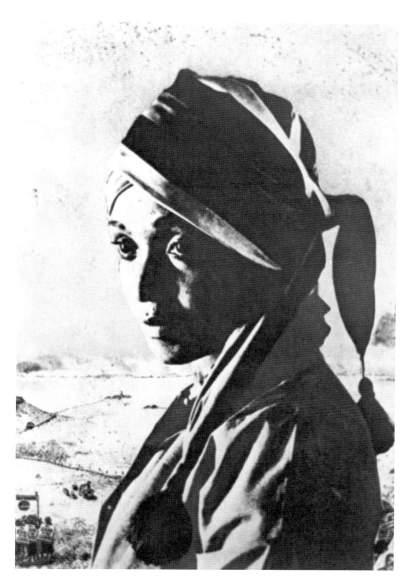

Fig. 11-2 *Winnie Mandela, A Few South Africans*, detail.

mercially (Fig. 11-3). In an attempt to focus world attention on these events, several hundred were sent all over the country and overseas, but within a week the card had been banned. The Publications Control Board said, "While the postcard is not without artistic merit, it must be pointed out that it does not give an accurate image of the situation. Your postcard is a tool in the hands of the enemies of South Africa."

Williamson believes her postcard was banned because the government was embarrassed by it. Her card was not illegal since government policy states that "you may criticize but not incite or make plans for illegal action."

"With Modderdam down," Williamson relates, "the government turned its attention to Crossroads, another, and far larger, banned squatter community that existed a short distance from the Cape Town Airport. Crossroads was well established, many

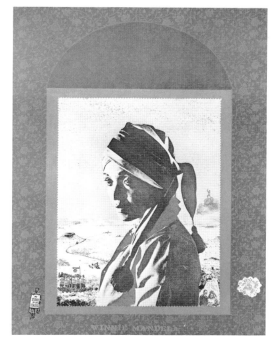

Fig. 11-2 *Winnie Mandela, A Few South Africans,* photo etching and silk screen, 22x33", 1985. Photograph: Rob Jaffe.

Fig. 11-3 *Modderdam*, etching and postcard, 4x6", 1986.

times the size of Modderdam, and was a teeming, vital place whose residents were determined not to be moved. The WMP was one of a number of organizations which launched an intensive campaign to save Crossroads. There were slide shows, photo exhibitions, public meetings, petitions, and events staged in the community to white influential people would be invited. In the end, Crossroads was being written about in papers across the world and for the South African government the political cost of knocking Crossroads down had become too high. The people of Crossroads and their supporters had won."

During this intense period of political activity Williamson did almost no artwork but she gained an incredible first-hand knowledge of the women and the issues for *A Few South Africans*, which she started developing in 1983. As a result of her

activities, however, Williamson began to receive nightly phone calls and death threats: "You'll get a petrol bomb through your window, you dirty commie bitch!" Williamson says, matter-of-factly, "Unpleasant phone calls are a feature of South African life but they can't always be considered jokes, as the ex-husband of the previous WMP chairperson had been gunned down by unknown assailants before the eyes of his children. This woman could no longer take it and for her children's sake she left the country." When a Cape Town city councilor confronted the police about the threatening phone calls, these calls finally ceased.

At first Williamson was not inwardly satisfied with her early attempts to express her feelings through her art during this difficult period. She admits, "My images were just not strong enough." She felt the need for further study. She enrolled at the Michaelis School of Fine Art at the University of Cape Town and completed an Advanced Diploma in Fine Art. "I had a wonderful tutor, Jules van der Vyfer, and he gave me the confidence to attempt larger, more technically complex prints than I had ever done before," says Williamson. The work produced for the advanced diploma (for which she received a distinction) were the first nine prints of the series A Few South Africans. These prints are twenty-two by thirty inches in size and combine the techniques of photo-etching and silkscreen printing.

This ongoing project represents a synthesis of Williamson's skills as an artist and a writer. Accompanying these images are her personal interviews with the women, condensed to a concisely written statement and placed beside each of the portraits. The photo-etched portraits in the center of each print are amplified by a larger, symbolically decorated, designed border, inspired by pictures that Williamson frequently saw in black homes. They consisted of "family snapshots, any kind of certificate or award, religious mottos or reliquiae and were framed elaborately to amplify their importance. Sometimes gift wrap cut into bright patterns was collaged onto the frames."

Sometimes while Williamson was working on an image, she would receive a call to go to Crossroads because the police were teargassing or shooting. "There I am, working on an image, and the real thing is happening!" Williamson also recalls the occasions when she had gone to Crossroads to observe a police action and it began to rain. "A woman, whose own house was under threat, went inside and brought out a blue pillowcase for me, the only thing she had to offer me to put on my head to protect me from the rain. You can't imagine how kind these people are!"

Williamson speaks in a soft voice that reflects pride in both her art and political activities.

> Working on A Few South Africans has been a very moving experience for me. The strength of these women in the face of oppression gives one real hope for the future of South Africa. ... The feeling of the women is that I've taken their history out of the closet and put it on the walls for everyone to see. It was so touching for me to see the response of black women who feel that their story has been told.

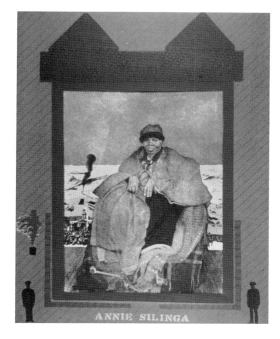

Fig. 11-4 *Annie Silinga,* photo etching and silk screen, 22x30", 1983.

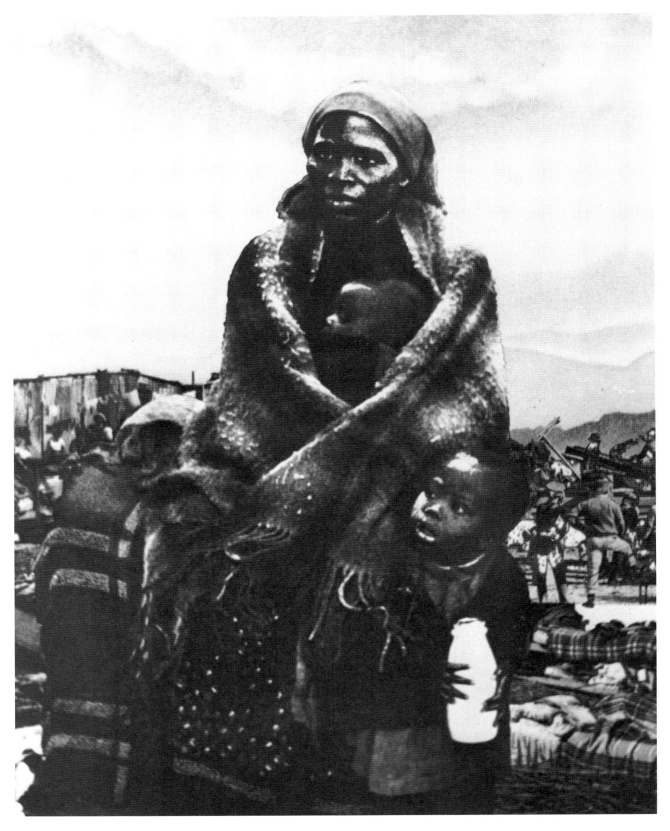

Fig. 11-5 *Case No. 6831/21*, detail, photo etching and silk screen, 22x30", 1983–1985.

Williamson also described the responses of white women who "sometimes stood there, literally crying. They were feeling deprived, that this whole thing had been going on in South Africa and they hadn't been aware of it—because that's what apartheid does, it cuts people off from each other."

The print of Annie Silinga (Fig. 11-4), who took a lifelong decision never to carry an identification pass, shows her seated and enclosed by a narrow red frame and then by a wider, purple-striped border that contains two South African policemen standing guard on either side of her. The accompany statement reads in part:

> "I will carry a pass the day the prime minister's wife carries a pass," Annie Silinga declared publicly during the Defiance Campaign in 1952. And to the day she died in June 1984, she never did.
>
> For her steadfast refusal to submit to the indignity of a pass, Annie was constantly harassed and arrested and was one of the accused in the 1956 Treason Trial. But even when old and poor and carrying a pass would have enabled her to receive pension, she refused.
>
> Her steadfastness in the face of oppression directed her life.

In another print, a tall, pyramidal figure of a mother with a child in her arms and another beside her as she surveys the devastation is titled Case No. 6831/21 "from Crossroads Squatter Camp (Fig. 11-5). To the left of this mother are smaller collaged images of the clustered camp shacks with women and their laundry, while the right side shows the backs of the police as they destroy the shacks, smashing and scattering the few belongings of the people. The warm tones of this brown photo portrait are bordered with a pale orange edge forming a center arch. The wider beige border extending around the portrait contains brown linear drawings of the adobe and thatch huts of Transkei or their distant tribal lands.

Williamson's statement reads:

> Nameless, for she is but one of thousands like her, "Case No. 6381/31" has appeared several times in the Langa Courts for being illegally in the area.
>
> Born in Transkei, she came to Cape Town some eleven years ago to be with her husband, a contract worker on a construction site.
>
> In those years she has lived in many places, but in 1977 came to Crossroads, where she and her family lodged.
>
> Her landlord moved, the shack was demolished and for most of this year she has been a "bed person" living with her family in the open. Flimsy shelters of sticks and plastic erected over the beds against the bitter Cape winter have been continually destroyed and confiscated by officials in regular raids.
>
> Twice this year she has been arrested and had to appear in the Langa courts ... "Case No. 6331/21," on charges of being illegally in the area. But returning to

Fig. 11-6 *Helen Joseph,* detail.

Fig. 11-6 *Helen Joseph,* photo etching and silk screen, 22x30", 1983–1985. Photograph: Rob Jaffe.

Transkei is not an option. There is no work there. No medical attention for the children. And she would see her husband only once a year, when he is between contracts. So she remains in Cape Town, strong and determined. Her will to survive is matched only by her capacity for endurance.

Some of Williamson's portraits are of white women like Helen Joseph, "the mother of the struggle," shown sitting in her home with her hands folded and with a determined facial expression (Fig. 11-6).

Now over eighty, Helen Joseph still travels the country, attracting huge audiences to hear her speak out against apartheid.

Over forty years ago she became secretary of the newly formed Federation of South African Women and was one of the leaders of the 20,000 women who marched to Pretoria, protesting against the carrying of passes by African women. In 1962 she became the first

person to be put under house arrest in South Africa—a restriction which lasted ten years.

Perhaps the only woman from *A Few South Africans* who is known internationally is Winnie Mandela, "the symbol of resistance." She is shown in three-quarter view with a scarf-covered head and calm eyes. In a brief quotation from the biographical statement, Williamson says:

> Since 1977 she has been banished to the small, dusty Afrikaner dorp of Brandfort in the Orange Free State, where she lives in House No. 802 in the treeless location outside town. Perpetual harassment has extended even to the confiscation of a bedspread in the colours of the African National Congress, and a conviction on a charge of contravening her banning orders, when she called at a neighbour's house regarding a chicken.
>
> But nothing has been able to crush the indomitable Winnie Mandela or prevent her from speaking out fearlessly when she has been able to.

Williamson's studio consists of an old Cape Town house that was cooperatively bought with two other people. "We have an etching and litho press and facilities for silk screening. Approximately eight other artists can rent this space and equipment." She is also a frequent exhibitor at the Gallery International.

She is proud that *A Few South Africans* has been purchased for the Oppenheimer Library in Johannesburg and the Durban Art Gallery. Three of the prints from this series are also part of *Tributories*, an exhibit of South African art in West Germany.

Some of her current work includes silkscreen projects such as *Freedom Charter T-Shirts, A Pillow for the President* and a section of a very long *Protest Banner*.

"Gallery art is important, but I also like making art in more accessible forms," says Williamson. Thus, she has had postcards made of eight of her prints, posters of three, and last year designed a T-shirt which featured the historic Freedom Charter of South Africa, a document recently unbanned after thirty years of being banned (Fig. 11-6). This famous document, drawn up at the Kliptown gathering of the Congress of the People in 1955, lists the basic human rights that should be guaranteed to all regardless of race:

The People Shall Govern; All National Groups Shall Have Equal Rights; The Land Shall Be Shared Among Those Who Work It; All Shall Be Equal Before the Law; All Shall Enjoy Human Rights; There Shall Be Work and Security; There Shall Be Houses, Security and Comfort; The Doors of Learning and Culture Shall Be Opened; and There Shall Be Peace and Friendship.

In addition to continuing with her series *A Few South Africans*, Williamson works on collective projects such as the *Protest Banner*. This project was initiated by an anti-apartheid group in

Fig. 11-7 *Freedom Charder* tee-shirt.

Notes

1. All quotes not otherwise documented are from an interview with Sue Williamson or from her presentations at the Women's Caucus for Art (College Art Association), Cooper Union, New York City, on February 11 and 12, 1986.
2. Tee Corine, "Sue Williamson, a Few South Africans," *Women Artists News*, Spring 1986.
3. Ernest Fischer, *The Necessity of Art* (New York: Penguin Books, 1959).

Johannesburg and was coordinated by the prestigious Goodman Gallery. Artists from all over South Africa were asked to portray visually their deepest feelings of what they would like to see for South Africa. The banner is a strip, twenty-four inches wide, the individual artists making their sections as long as they desired.

Using the silk screens Williamson had used earlier for her *Freedom Charter T-Shirts*, she printed a four-foot section with the words "Freedom Charter" and all its clauses in many different colors. "I wanted to produce the effect of a brilliantly colored, happy South Africa, which we might have if the provisions of the Freedom Charter could be realized," Williamson says.

During her 1986 presentation for the New York Women's Caucus for Art, Williamson questioned the dilemma and motives of the white artist working in an oppressed society:

> And for the white artist, may one be sure that if one does produce sociopolitical art, one's motives are pure? Steve Biko, the great Black Consciousness leader who died in detention, said: "How many white people fighting for their version of change in South Africa are really motivated by a genuine concern and not by guilt?"

Williamson also raised other, more significant issues:

> And what of the black artist from his disadvantaged position in our society? He has had no art training in school, and in fact the white-directed school curriculum has discredited his culture. For him to choose art as a way of life requires an especially loving commitment to this craft. If the white artists cannot survive by art alone in a philistine society, how much harder is it for the black artist?

Williamson's personal experiences which reflect the art historian Ernst Fischer's position are sometimes shocking to Americans, Fischer asserted in 1986: "The artist has the responsibility to arouse and stimulate understanding, to emphasize social responsibility."[3] Williamson adds: "And if he or she takes this position, a position critical of the ugly face of apartheid, may he or she expect the security police at his or her door at 5 a.m. one morning? Please rest assured, the security police monitor cultural activities in the broadest sense."

She concluded: "Though it would be naive to believe that artistic protest in itself, no matter how effective the art, will bring about immediate social change, the artist does and will always have a crucial and indispensable role to play in any society. This is the vision that can bring about new perceptions and the climate of awareness that is a necessary precondition for change."

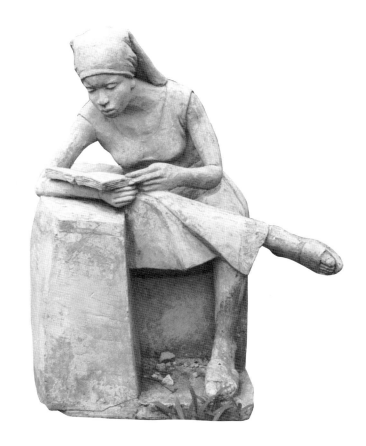

Artists of the Diaspora

Lois Mailou Jones

The Grande Dame of African American Art

HER CREATIVITY undiminished in her eighty-fifth year, Lois Mailou Jones continues to produce powerful paintings that are a bold blend of Western and non-Western aesthetic traditions (Fig. 12-1). In paintings like *Ubi Girl from the Tai Region* (1972) (Fig. 12-2) and *Deux Coiffeurs d'Afrique* (1982), for example, the flat geometric patterns of color juxtaposed with masks and human forms reflect a multiplicity of influences—North American, French, Caribbean, and African.

In Jones' three-story, Washington, D.C., home and studio, Kente cloth of Ghana and checkered strip-loom weavings from Mali covering sofas, chairs and beds seem to merge with Jones' paintings clustered upon the walls or stacked against furniture. In the dining room hangs her 1938 *Self-Portrait* (Fig. 12-3) in which Jones portrayed herself with vibrant brushstrokes as cheerful and self-confident, standing before her easel. This youthful expression has scarcely diminished with time.

On a table in her small and compact studio, clustered among tubes of paints and brushes, are a pair of wood-carvedfigures, a representation of twins, which are a significant component of African mythology. Jones says that for many years these small sculptures served as a source of inspiration. In her 1982 painting *Les Jumeaux* (Fig. 12-4) these twins appear as sisters with arms around each other while each also had one arm upraised. Behind them were a series of cosmic circular shapes culminating with the round, warm orange tones symbolic of the sun.

These recent images have come full circle: Jones first used masks in Boston in the 1920s when she worked as a prop designer for the Ted Shawn Dancers and a Boston repertory theater. She also, during this period, designed fabrics for F.A. Foster and Schumacher in New York City. Jones soon realized, however, that designers remained anonymous. This made her all the more determined to become a successful painter.

She achieved not only this goal, but also became an inspiring and legendary educator during forty-seven years of teaching drawing, design, and water-color painting at Howard University in Washington, D.C., where she was awarded an honorary doctorate in May 1987. Among her students were Elizabeth Catlett and Alma Thomas.[1]

Petite in stature, Jones's warm smile dominates her expressive features. Whether formally dressed in furs, velvets, and

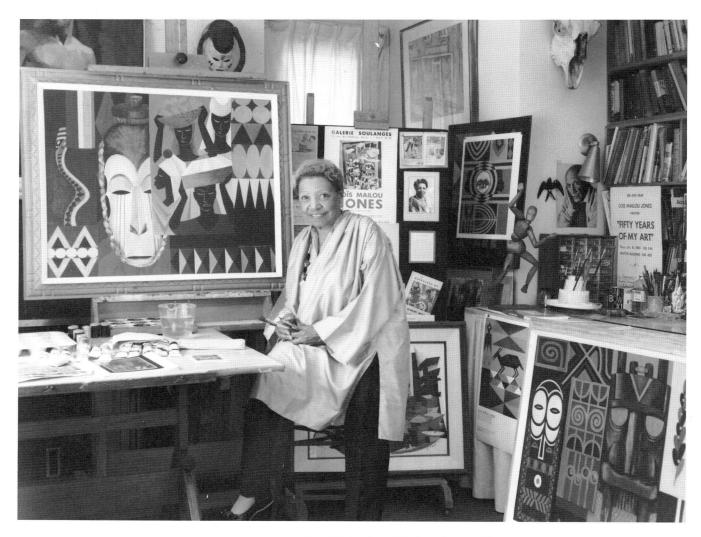

Fig. 12-1 Lois Mailou Jones, Washington, D.C., 1981, photo courtesy of Jones.

silks, or covered by a cotton smock behind her easel, she wears a large, copper pendant from Haiti: the voodoo god of the forest, a symbol of her ongoing link with Haitian life and culture.

Born in Boston in 1905, Jones remembers that as "a little tot I was always drawing."[2] Her mother, Carolyn Jones, worked in a beauty shop and designed hats. Her father, Thomas Vreeland Jones, superintendent of a large office building, went to law classes in the evening and became a lawyer at forty. Each summer, Lois, her older brother John, and their mother escaped the "smoke and tar of Boston to the ocean, daisies, and buttercups of Martha's Vineyard," where, Jones claims, her "life in art really began." This was partly due to the influence of the African American sculptor Meta Warrick Fuller (1877-1968),[3] who also spent summers there.Fuller, who had studied with Rodin in Paris, utilized her African and African American heritage in her work. She advised Jones, "If you want a success in your career, you have to go to Paris."

Jones began studying art at Boston's High School of Practical Arts and attended Saturday drawing classes at the Boston Museum School of Fine Arts. After her high school graduation in 1923 she won a four-year scholarship to the Boston Museum School, where she was the only African American student. Although she majored in design, she admired the watercolor paintings of Winslow Homer and John Singer Sargent and began her lifelong habit of carrying watercolor paints outdoors to depict the various moods of nature. Jones still considers watercolors "a happy medium to relax with, as within four hours of concentrated work I can capture the essence of a scenic view."

After completing her studies at the Museum School, Jones applied for an assistantship there. She was turned down and advised to go south and help her "own people."[4] Jones ignored this advice and continued her studies at the Boston Designer's Art School, and then at Howard, Harvard, and Columbia Universities. Her first teaching job in 1928 was indeed in the South, at Palmer Memorial Institute in North Carolina, but two years later she was recruited to teach at Howard University, where she received an A.B. degree in Art Education in 1945 and remained on the faculty until 1977.

During her first sabbatical leave in 1937 Jones went to Paris and enrolled at the Academie Julian. She was fond of painting portraits of local inhabitants and views of the Left Bank, such as *Rue St. Michel* (Fig. 12-5) and *Rue Norvin, Montmartre*, both from 1938. These paintings look somewhat like Utrillo's street scenes, but are more volumetric. They begin to reveal the artist's commitment to the organizing principles of Cézanne, who, along with the Cubists, she discovered on this first trip to Paris. James Porter Early recognized the Cézanne influence. He wrote in 1943:

> Thus far her painting has been in the tradition, but not in imitation, of Cézanne. ... Miss Jones wishes to confirm Cézanne but at the same time to add an original note of her own. ... She has a commanding brush that does not allow a nuance of the poetry to escape. Sensuous color delicately adjusted to mood indicates the artistic perceptiveness of this young woman.[5]

Elsa Honig Fine confirmed Porter's view: "There is a highly personal quality to Jones's work ... that distinguishes her art from the products of hackneyed French street painters."[6]

At the Academie Julian, Jones developed a significant and enduring friendship with another student, Celine Tabary. "She became like a sister; I forgot I was black." Tabary and her family introduced Jones to "the life of the people, and therefore I have a great love for France." These were productive years for Jones as, she poignantly recalls, "I was shackle-free and I forgot I was a person of color. I was accepted as an artist." She exhibited at the Galerie Charpentier and Le Salon des Artistes Français.

Jones's discovery of African masks in the Parisian art galleries inspired *Les Fetishes* (1938) (Fig. 12-6). "My French professors couldn't understand this painting," she said. "and I had to remind them that Cubism is influenced by African art, which is my heritage." According to Faith Ringgold,

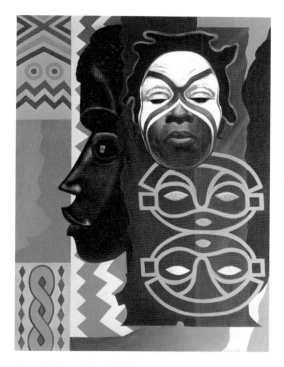

Fig. 12-2 *Ubi Girl from the Tai Region,* acrylic, 44x60", courtesy Museum of Fine Arts, Boston, 1972.

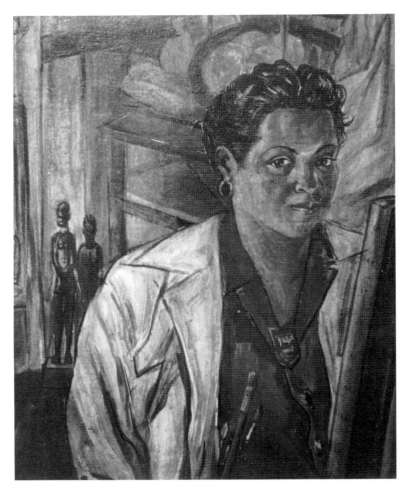

Fig. 12-3 *Self-Portrait*, oil, 1938.

Les Fetishes forecasts the important role of the mask in Lois' art. It is a hollow-eyed mask face in muted tones and warm greys, a strongly singular piece of a type that would find its full force in Lois' African period of the late sixties and early seventies.[7] Sweeping arcs dominate the painting. It continues her concern with volume—the later African-inspired paintings are flatter, more geometric and decorative.

When Jones returned to Boston, she showed her Parisian street scenes and portraits at the Vose Gallery. This first solo show was well received by Boston's art critics, an unusual success for a black artist in those years. Dorothy Adlow of the *Christian Science Monitor* described the work as "imbued with the qualities the impressionists sought to achieve through painting with broad strokes of summary patches of colors which catch the effect of sunlight upon surfaces."[8]

In 1940, Jones invited Tabary to come to the United States

for a brief visit, which, because of the war, lasted for seven years. They lived and painted together in Washington, D.C., where their studio-home was referred to as "Petite Paris." Tabary frequently took Jones's work to competitive exhibitions at the Corcoran and other institutions where Jones subsequently won many prizes, which, she felt, would have been denied her had it been known the artist was black. At the Corcoran, Jones won the Robert Wood Bliss Landscape Award for Painting for the sun-filled 1940 New England beach scene *Indian Shops, Joy Head* (submitted by Tabary). At the Philadelphia Academy, Jones relates, "I received the first prize in a competitive exhibit, but when they found out I was 'colored,' they took it away." In spite of such experiences, Jones says, "I never let it affect me to the place where I became hateful, where I was not going to go on. I lived above it. I knew I was good. I kept saying to myself, 'I am going to make it on my strength as a painter.'"

During the 1940s Jones made frequent trips to New York City where she met many of the key participants of the Harlem Renaissance, or "New Negro Movement," among them painter Aaron Douglas, poets Countee Cullen and Langston Hughes, and the philosopher of the movement Alain Locke. They encouraged her to use her African heritage as the theme for her work. Locke had been an early advocate of black consciousness and hoped

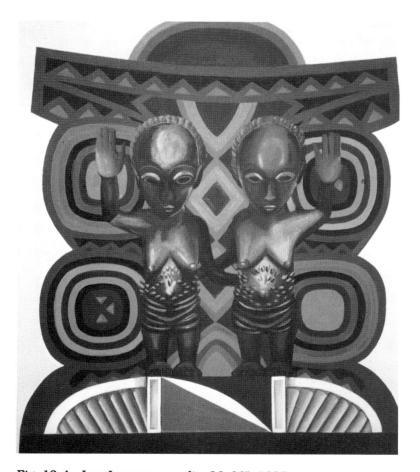

Fig. 12-4 *Les Jumeaux*, acrylic, 26x36", 1982.

for the development of an Afro-American art idiom based on the discovery of African forms. "For the Black American artist," wrote Locke, "this discovery should act with all the force of a rediscovered folk-art, and give clues for the repression of a half-submerged race-soul."[9]

A pivotal oil painting for Jones was the 1944 *Meditation Mob Victim* (Fig. 12-7), inspired by a "tall bearded man, with a torn overcoat and two guitars on his back" whom she saw walking along U Street in Washington, D.C. When he came to her studio to pose, Jones learned he had witnessed a lynching. As he sat describing the experience, his eyes turned upward. Jones, using thick paint applied with swift brushstrokes, deftly captured his anguished expression. Painted in muted greys, browns and blacks, with dark green foliage in the background, *Meditation* is an image of both power and resignation and was included in *New Names in American Art*, a show that toured the United States in 1944. (In 1966 it received an honorable mention for oil painting at the Salon des Artistes Français in Paris.)

Painted with the same broad brushstrokes and monumentality of *Meditation* and related to it in spirit is *Jennie* (1943). Ringgold described the painting:

> *Jennie* shows a young black girl, a domestic at work, cleaning fish. She is set against a warm background of kitchen colors, eyes cast downward, focused on the fish, a look of resignation on her youthful face. Not quite the lyncher's noose, but a noose nonetheless.[10]

Both paintings show the artist's continued fascination with Cézanne—in this case his portraits.

From 1946 until 1953, Jones returned each summer to paint panoramic views of the southern Mediterranean regions. In *Petite Ville-Haute Pyrenées*, a Cézanne-like village encroaches upon a mountain reminiscent of Mt. Sainte-Victoire, while *Spercedes* has cube-like house forms, seen from above, with terraced plantings in the background. They are panoramic views, the bright orange rooftops contrasting with the verdant surroundings.

In 1953 Jones married Haitian graphic designer Louis Vergniaud Pierre Noel. Shortly after their marriage, Noel brought Jones to Haiti. This first visit began a long and productive love affair with the Haitian people and culture. President Magloire of Haiti commissioned Jones to do a series of paintings of Haitian life, thirty of which were exhibited in 1954 at the Pan American Union in Washington, D.C.

In Haiti, Jones's palette became brighter, and she incorporated many of the *veve* or voodoo symbols in her paintings. Voodoo religious beliefs dominate Haitian life. They represent a merging of Catholicism and African cosmic views and practices. *Veve*, or a white linear symbolic pattern, is created by sprinkling flour on the earthen floor by a voodoo priest during ceremonial rituals. *Veve* designs were integrated into many of Jones's oil and rice paper collages from the 1960s, such as *Veve Voudou II*, with geometric, overlapping planes, and the more decorative *Veve Voudou III*, which also incorporates voodoo doll-like images. The colors are bright: oranges, reds, yellows, and greens set off by blues and blue-blacks.

Fig. 12-5 *Rue St. Michel*, oil, 28x33", courtesy of Museum of Fine Arts, Boston, 1938.

Two of Jones's paintings on Haitian themes offer contrasting views of the island's life and culture. *Peasant Girl* (1954) (Fig. 12-8) is an intimate expression of Haitian poverty. Somber earth tones portray a solitary vendor, seated, with head downcast, a basket of produce held between her legs. Yet the girl is lovely and the forms monumental, the paintings still showing the Cézanne influence. *Vendeuses de Tissu de Haiti* (1961) (Fig. 12-9), a frieze-like panel, represents a bright, joyful panorama of cloth vendors—tall, proud women, each with a parcel perched on her head. The painting represents a transition from the earlier, volumetric geometry of Cézanne to the planar geometry of African art, an influence that began to emerge during the early years in Haiti. The eye is quickly led, left to right, following the various positioning of the women's heads, feet, and the cloth they examine. The dark figures contrast with the bright yellows, reds, and pinks of the cloth.

Jones and Noel moved each year between Washington, D.C., where Jones continued to teach at Howard University; the Jones family vacation home at Martha's Vineyard, and Haiti. At each location they maintained their separate studios. Jones taught Saturday classes at the Port-au-Prince Art Center, a germinal institution for promoting the popular Haitian painting movement She has actively promoted Haitian painters' work in the United States, Europe, and Africa.

Noel worked in Haiti for the visual aids section of the Ministry of Education and Agriculture and the Postal Administration in Haiti, and later in Washington, D.C., for the World Health Organization. Several of his postage stamp designs, including the United Nations' twentieth birthday stamp and its Relief Stamp for War Victims, won international prizes. Noel also received a National Association of Industrial Artists Award of Excellence for his "Tribute to President John F. Kennedy." Noel supported Jones's work "almost to the sacrifice of his own." The couple could not have children, and Noel reassuringly told Jones, "Your paintings will be our children." He died in 1982.

Jones felt the sting of sexual discrimination during her tenure at the historically African American Howard University. The art department chairman wanted her to stay with the more "lady-like" watercolor painting, since oil was the preserve of men, and the university already had an oil painter on the faculty—James Porter. Jones stayed with the media of her choice; however, she continued to receive the assignment of teaching watercolor.

In 1972 Howard University honored its beloved teacher with a retrospective exhibition, *Forty Years of Painting, 1932-1972*. Many former students, themselves now respected artists and educators, paid tribute to the woman who Jeff Donaldson, then Art Department chairman, called the "grande dame of Afro-American art." Lloyd McNeill recalled, "it was in your class when I began to understand the commitment of an artist to his/her work and to the community with which he/she chooses to identify." David Driskell stated, "I shall always remember her as a great teacher ... with a strength of character and a personal interpretation of form which made me love and respect her beyond the classroom walls."[11]

With the exception of a few collages and posters created dur-

Fig. 12-6 *Les Fetishes,* oil, 21x25", 1938.

Fig. 12-7 *Meditation (Mob Victim)*, oil, 25x41", 1944.

ing the turmoil years 1968-69, Jones's work has remained free of political themes. Those she did were as provocative as the day's newspaper headlines. The silk screen poster organized like collaged newspaper columns, *Homage to Martin Luther King, Jr.* (1968) (Fig. 12-10), shows the civil rights leader delivering his "I Have a Dream" speech at the Washington Monument, leading a crowd of marchers, and pensively sitting in jail behind bars.

In 1972 Jones expressed her views about art and the "black experience":

I feel it is the duty of every black artist to participate in the current movement which aims to establish recognition of the works by "Black Artists." I am and will continue to exhibit in "Black Art Shows" and others, the works which express my sincere creative feelings. That these works portray the "black experience" or heritage or are abstract is immaterial, so long as they meet the highest standards of the modern art world. The major focus is to achieve for Black Artists their just and rightful place as American Artists.[12]

The latest stage in the evolution of Jones' art began in 1970, when she was sixty-five years old, after her first trip to Africa. She then returned to Africa in 1972, visiting fourteen countries. "Each time," she said, "I made a study of African designs and motifs and found them so inspiring that I've had to use them in part or in combination to create a work." Complex compositions, such as *Ubi Girl from the Tai Region* (1972) (Fig. 12-2) first appear, says Jones, as "an idea or a dream" that she jots down and then develops as a color sketch. A precise sketch is transferred to canvas, and colors and forms are adjusted while she paints. "I work fast when I'm keyed up, and I stay with it." Her large canvases seldom take more than a week to complete.

Ringgold wrote of *Ubi Girl*:

Ubi Girl of Tai Region combines the old with the new; Africa with Black America; painting with design; realism with symbolism. It reveals a new woman. ... *Ubi Girl of Tai Region* has the face of determination. She is painted realistically, a portrait of us: Africa and black America. Her partially masked face is strong but sweet as the flower of black expression. Alain Locke would be proud. This same face of resolution and power appears in several recent works, including *Deux Coiffeurs d'Afrique* and *Petite Ballerina*, both painted in 1982.[13]

Another striking image from this African period is *Sulandesia* (1979) (Fig. 12-11). More so than *Ubi Girl*, it seems to mark the final evolution from volumetric form through Cubist plane to flat, geometric patterning. Both paintings recall her early interest in masks and the flat areas of color she used for fabric designs and reveal her search for meaning in African objects and images. African mask forms and shield patterns dominate the boldly colored *Moon Masque*. PeterMark, writing of African influences on African American painting, referred to *Moon Masque* as

two-dimensional as any Senegalese tapestry designs. Flat patterns ripple across the composition in alternating light and dark bands. These oscillations give a sense of positive and negative space; they also create a steady beat which is the pulsing life of the printing.[14]

In *Sudanesia* (collection, National Museum of Women in the Arts, 1979) (Fig. 12-1) masks, shield and fabric design are integrated into a vibrant pattern in which the dominant colors are

Fig. 12-8 *Peasant Girl*, oil, 31½x21", 1954.

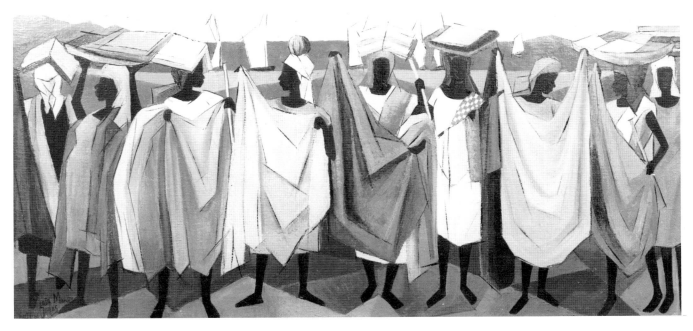

Fig. 12-9 *Vendeuses de Tissus de Haiti,* acrylic, 19x39", cour-
tesy Johnson Publishing Co., Chicago, Illinois, 1961.

red, blue, black, and white. Striped, subtly curved animals'
horns and a crescent moon are prominent. In *Deux Coiffeurs
d'Afrique* (1982), Jones juxtaposes a realistic portrait of a child,
her face expressing "resolution and power," her hair braided in
halo form, with a flatly painted stylized female figure. Both figu-
rative forms are surrounded with geometric designs within an
intense cerulean blue background.

This work was exhibited in 1983 along with Noel's at the
Museum of the National Center of Afro-American Artists in "Lois
and Pierre: Two Master Artists." Displayed chronologically, "It
was," says Jones, "like walking through my life history."

Edward Strickland, museum director, summarized Jones's
latest work in his catalog notes.

> Sometimes the African masks are realistically rendered
> and placed among stylized symbols and abstracted pat-
> terns, as in *Symboles d'Afrique, I* and *Les Jumeaux* (Fig.
> 12-4). At other times, African symbols and design motifs
> are flatly rendered portraits of women and children. The
> juxtaposition of Ashanti fertility symbols and pregnant
> women seems to make a statement about fruitfulness.
> These are perhaps Jones's most successful explorations.[15]

Jones has, in the last two decades, taken on the monu-
mental task of documenting with more than one thousand slides
the historical and contemporary arts and crafts work of Africa.
This documentation, including biographical material on the
artists whose work she has collected, was exhibited in 1977 at
Howard University. Her documentation of the work of Haitian
and African American artists continues. Recently the Budek

Fig. 12-10 *Homage to Martin Luther King,* water color and collage (poster), 20x26", 1968.

Slide Corporation published her commentary for *Caribbean and Afro-American Women Artists*.

The most recent decade has been filled with honors and awards for Jones. Her work is now in the collections of major museums, among them the Metropolitan Museum of Art and the Brooklyn Museum in New York City, the Hirshhorn Museum and Sculpture Garden, the National Collection of American Art, the Corcoran Gallery of Art, and the Phillips Collection in Washington, D.C., and the Palais National in Haiti. In 1980 she was honored at the White House by President Jimmy Carter for her outstanding achievements in the arts, and in 1986 she received the Women's Caucus for Art (College Art Association), Honors Award. Family members of her lifelong friend Celine Tabary came from Paris to witness this occasion. Since 1983 she has received three honorary doctorates, the latest in 1986 from the Massachusetts School of Art. Though pleased to be recognized, she finds it "worrisome" to spend so much time away from her studio and work.

Fig. 12-11 *Sulandesia,* acrylic and collage, 29x41", 1979.

Notes

1. For Catlett see Thalia Gouma-Peterson, "Elizabeth Catlett: The Power of Human Feeling and of Art," *WAJ* (s/s 1983), 48-56. For Thomas see Elsa Honig Fine, *The Afro-American Artist* (New York: Holt Rinehart & Winston, 1973), 151-53.
2. All quotes not otherwise documented are from an interview with Lois Mailou Jones, New York City, February 8, 1986.
3. For Fuller see Fine, *Afro-American Artist*, 75-76.
4. Charlotte Streiffer Rubinstein, *American Women Artists* (New York: Avon, 1982), 226.
5. James A. Porter, *The American Negro* (1943; reprint New York: Arno, 1969), 125.
6. Fine, *Afro-American Artist*, 136.
7. Faith Ringgold, in "Lois Mailou Jones," Women's Caucus for Art Conference Honor Awards (February 10 e 14, 1986), 7-8.
8. Quoted in "Reflective Moments: Lois Mailou Jones" (The Museum of the National Center of Afro-American Artists, March 11 - April 15, 1973), n.p. Essay by Edmund Barry Gaither.
9. Locke, quoted in Fine, *Afro-American Artist*, 4.
10. Ringgold, "Lois Mailou Jones," 7. For color plates of *Jennie*, see Fine, *Afro-American Artist*, 127.
11. Lloyd McNeill and David Driskell, "David Driskell, 'Tributes,' 'Lois Mailou Jones Retrospective Exhibition,'" (Howard University Gallery of Art, Washington, D.C., March 31 - April 21, 1972), n.p.
12. Quoted from *ibid.*
13. Ringgold, "Lois Mailou Jones," 8.
14. Peter Mark, "African Influences on Black American Painting, 1920-1980," *Art Voices* (January/February, 1981), 15. For reproduction, see Fine, *Afro-American Artist*, 138.
15. Edward Strickland, "Director's Notes," in "Lois and Pierre: Two Master Artists" (The Museum of the National Center of Afro-American Artists, 1983), n.p.
16. Jo Ann Lewis, "The Transformations of Lois Mailou Jones," *Washington Post*, February 2, 1990.
17. Tritolia H. Benjamin, "The World of Lois Mailou Jones," Meridian House International, Washington, D.C., 1990.
18. Marguerite M. Striar, "Artist in Transition," *Essence* (Nov. 1972), 72.

Unfortunately, on November 3, 1989, on Jones' eighty-fourth birthday, she suffered a heart attack, but recovered in time to attend the opening of her major retrospective at Washington, D.C.'s Meridian House International. She arrived early and remained

standing for hours wrapped in hugs, thanks and remembrances—her pistons all pumping away like new after triple-bypass surgery. "The doctors told me I had the body of a 67-year-old," she beamed.[16]

In *The World of Lois Mailou Jones*, an extensive catalog produced in conjunction with the Meridian House Exhibit, Tritolia H. Benjamin notes,

Hers is a great talent, carefully nurtured through hard work and enhanced by her sheer love of art. She is also an artist who has devoted her life and career to seeking out what she considers artistic and beautiful. From the most banal scenes to the most exotic subjects, Lois Jones has been able to extract something of beauty and through her skills as an artist to express this beauty to others.[17]

In 1989, Jones happily confided that the National Museum of American Art had just arranged to purchase her landmark 1938 painting *Les Fetishes* for their collection. "Better later than never," she said.

Though Jones is concerned about a permanent repository for her extensive collection of work, she also wants people to know, "I didn't just pass out of the picture with my heart attack. I'm still working." Jones, sensitive and self-critical, remains a remarkable artist and role model, transcending social prejudice and integrating her multiple aesthetic roots to continue expressing her passion for life.

As Marguerite Striar noted in 1972,

It was never enough for [Jones] to revel in her own joy and solid accomplishment as an artist. She also had to educate, to bring together, to sponsor and encourage, to act as an artist-ambassador between her people and the white majority; between Americans and people of other countries; between artists and viewers. This has been her goal and her life-style.[18]

Indeed, Lois Mailou Jones has played many roles in her long, productive life, the primary one always being that of artist. Beginning as a student of Post-impressionism, she evolved through Cubist form, to the flat, abstract patterns of African art, a natural progression of many twentieth century artists, but most especially appropriate for an African American artist.

Edna Manley

The Mother of Modern Jamaican Art

ONE CANNOT visit the art galleries of Jamaica without becoming aware of the powerful presence of Edna Manley, the mother of Jamaican art (Fig. 13-1).[1] Collected primarily at the National Art Gallery and the Olympia International Art Center, with significant pieces in the private collection of A.D. Scott. Manley's work—monumental wood carvings, bronze and fiber glass castings, and large pencil drawings—spans six decades. Her work is uniquely Jamaican, from early figurative sculptural images that symbolically portray the struggle of the Jamaican people to free themselves from English colonial rule, to later work exemplifying the need to maintain cultural pride and identity as a nation of predominantly black people, originally brought from Africa in the seventeenth century to work as plantation slaves.

Jamaican sociologist Rex Nettleford has described Jamaica as an "island of two million souls, a deeply segmented aggregation of descendants of European masters, African slaves and in-between offspring of both."[2] Manley understood how Jamaica's historic past had created many self-doubts and split-identities between Euro-centric and Afro-centric cultural values, and much of her work proudly reflects the latter.

For most Americans, awareness (let alone appreciation) of Jamaican visual arts did not begin until 1983, through a Smithsonian-sponsored traveling exhibit, "Jamaican Art, 1922–1982." Manley was a major figure in this exhibit. Her long life and artistic career have been at the very foundation of the Jamaican art movement.

Edna Swithenbank Manley was born in 1900, in Bournemouth, England. Her mother, Ellie, was a fair-skinned Jamaican while her father, Harvey Swithenbank, was an English Methodist minister. He died when Edna was nine, leaving Ellie to raise a family of nine children. Edna is the middle child. Her early behavior has been described as turning inward to "daydreams" or outward with "tantrums."[3] It was not until secondary school that Edna's interests turned to art and literature. During her rural childhood and adolescence, she developed a love for animals, especially horses, a lifelong interest that later manifested itself in her art.

Her adolescent fantasy was to escape the restrictions of her provincial family. When Edna was seventeen her mother permitted her to go to London to work in the Pensions Branch of the

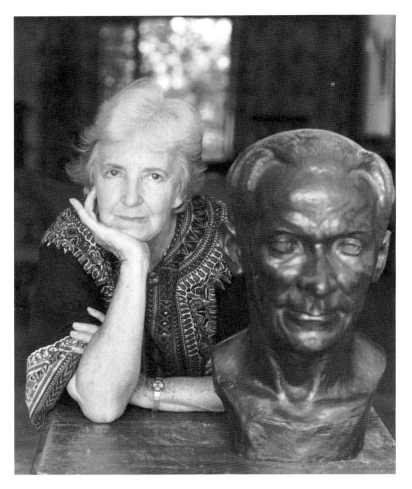

Fig. 13-1 Edna Manley with her portrait of Michael Manley, 1960, Kingston, Jamaica. Photograph courtesy of Maria La Yacona.

War Office—this was to be her contribution to the war effort. After the war she enrolled in an art-teacher training program at the Regent Street Polytechnic Art School, but found it to be "a very dead place. I mean, you come in, you are full of life, but you are not put into a life class." Plaster casts were used as models, and, she says, "I think it's the worst way to start an education. It took me years to throw off the inhibitions that I learned there as a draftsman."[4]

Edna Swithenbank first met her cousin Norman Manley, eight years her senior, when, as a Rhodes Scholar, he came to England from Jamaica in 1914 to study law. Norman and his brother, who was also studying in England, soon enlisted in the service: Norman survived, but his brother did not.

At war's end, Edna and Norman renewed their friendship. He encouraged her to become a professional artist, and she saw in him a way to separate from her family. While he was in Oxford, she worked at the Pensions Office during the day, took classes at night, and began to model in clay on the weekends. It was during this period that the extensive Manley correspondence began. Norman had proposed marriage, but, as she wrote, "I can't com-

promise, life won't have compromises. If I married you I would forget art, you are the only person living who can absolutely make me forget art,"[5] and later, "Love meant marriage and marriage meant children and that was a trap."[6]

In 1920, "to complete an exhaustive apprenticeship in her craft before leaving England," Edna enrolled in the St. Martin's School of Art by day, where she modeled in clay and plaster of Paris, and the Royal Academy at night, where she studied anatomy. Her earlier studies had been mostly of animals, and now she began modeling the female nude.

When Norman completed his studies in 1921, they married. In 1922, shortly after the birth of their first son, Douglas, the family sailed to Jamaica. Norman promised to find opportunities for Edna to work and exhibit in his homeland, and to maintain "their ideal of what a good marriage is—absolute freedom, and fullness of life; and yet also absolute—union—absolute comradeship."[7]

When the Manleys first arrived, Edna, who had grown up with "the most nostalgic stories of Jamaica," felt she had "come home."[8] She soon discovered, however, that in 1922 the Jamaican middle class expected their women to be shadows of their husbands. Undeterred, she became a keen observer of Jamaican life, constantly recording in her sketchbook the gestures and expressions of the people, in the market place, at religious meetings, or at work in the fields. According to Rosalie Smith McCrae, a curator at Jamaica's National Gallery, "She was the first artist to express Jamaican themes and the physical qualities of the people." But, insists McCrae, "if it had been the work of a Black Jamaican artist it would have been totally rejected."[9]

Manley's first truly Jamaican work was the bronze *Beadseller* (1923), created during her first months on the island. "Clearly, her arrival in Jamaica had been a stimulating experience, artistically speaking, for there is a remarkable leap in imagination that separates the conventional animal studies and portraits of her art school days from this early masterpiece with its elegantly Cubist structure."[10] wrote David Boxer in his catalog essay to a 1963 exhibit of Jamaican art. The only curve that breaks the sharp rhythms of the beadseller's lean, angular body is a necklace suspended from her forward thrusting hands. *Beadseller* is the symbolic personification of the pain and suffering of an impoverished people.

Manley's figurative images from the 1920s and 1930s are symbolic portrayals of the Jamaican people struggling to break free from English colonial rule. With works such as *The Beadseller, Negro Aroused* (1935, Fig. 13-2), and *The Prophet* (1935, Fig. 13-3), Manley urged the people to develop national pride and free themselves from European cultural values. (Independence was achieved in 1962.)

The Manleys' second son, Michael, was born in 1924, and as Norman's reputation as a lawyer increased, so did the family's income. During the 1920s Edna continued to work in total professional isolation, returning periodically to England for stimulation, at the same time seeking opportunities to exhibit her work. Her first show in London was in 1929 at the Goupil Gallery; she also exhibited with the London Group, along with

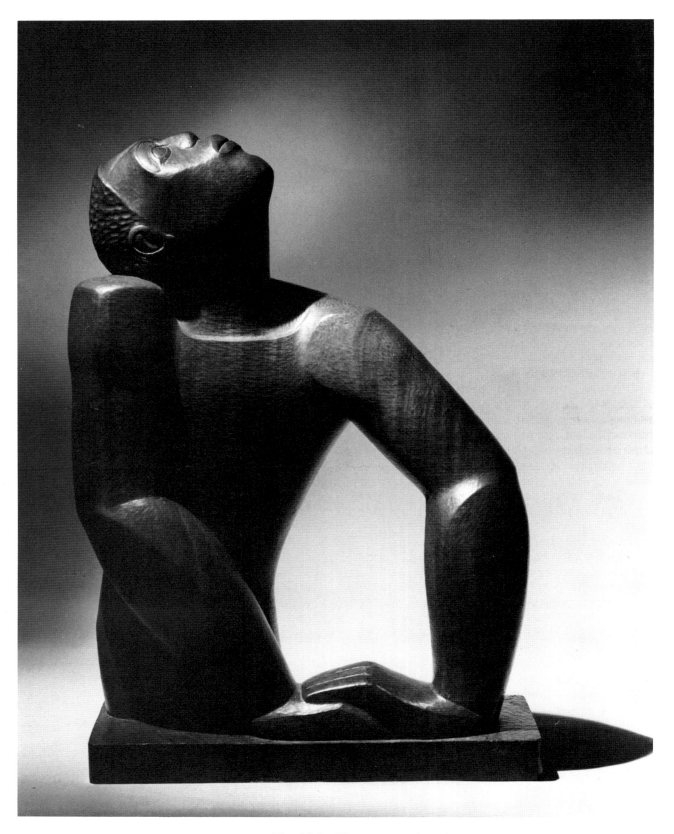

Fig. 13-2 *Negro Aroused*, mahogany, 40". Photograph courtesy of Maria La Yacona, 1935.

Henry Moore and Barbara Hepworth. Manley was a member of the Society of Women Artists and participated in the Women's International Art Club Exhibition of 1930. During the years of struggle against English colonial rule, however, she stopped showing her work in England.

One piece from this period, the 79-inch dark mahogany carving *Eve* (1928), with its rounded, sensual body forms, received much critical acclaim. In *The Art of Carved Sculpture* (1931), Kineton Parker called *Eve* "her most important work so far" and commented that "Edna Manley's especial value to the art of the present day is her adherence to nature and her new interpretation of it."[11] The *East Anglian Times* art critic considered Manley "a champion of human rights" and *Eve* a "realization of an ideal of the mother of mankind (which) departs from those of masculine imagination by the complete absence of any indication of feminine weakness."[12]

While appreciated abroad, in Jamaica Manley's work was still greeted by "puzzled indifference" or "hostility."[13] In 1929, however, she received the Institute of Jamaica Silver Musgrave Medal for her sculpture. And as other European-trained artists began to arrive and Jamaica began to train its own artists, the cultural climate and the attitude toward Manley's art began to change.

Two works from 1935—*Negro Aroused* (Fig. 13-2) and *The Prophet* (Fig. 13-3)—have become her signature pieces. They are "nothing less than the icons of that period of our history, a period when the Black Jamaican was indeed aroused, ready for a new social order, demanding his place in the sun,"[14] wrote David Boxer. The simple lines of *Negro Aroused*, a carved-mahogany, half-length figure, invoke an expression of elegant defiance: the head is turned upward, as if in search of a vision, and contrasts with the firm, straight lines of the figure's back. One arm angles away from the body, while the other is carved close to the torso; the hands are folded, one upon the other, in a gesture that seems to support the will of the figure.

Manley later commented on *Negro Aroused*: "[I] was trying to create a national vision ... trying to put something into being that was bigger than myself and almost other than myself. It took me weeks to stop—being the *Negro Aroused*."[15]

When it was exhibited in her first one-person show in Jamaica in 1937, the Kingston *Gleaner* reviewer Esther Chapan wrote of Manley's work, giving some insights into the evolving state of Jamaican culture:

> In Jamaica I have heard her work described as "grotesque," "distorted." I have known people violently angry at her work and at her temerity as a woman in daring to produce it. I have heard this work into which all her ardour and emotion and creative talent have been poured dismissed as a "hobby." And I have come back to Jamaica to see this attitude changed.[16]

After the exhibit, *Negro Aroused* was purchased by public subscription for the Institute of Jamaica, which is now the National Gallery of Jamaica.

With *The Prophet*, a three-quarter length mahogany figure,

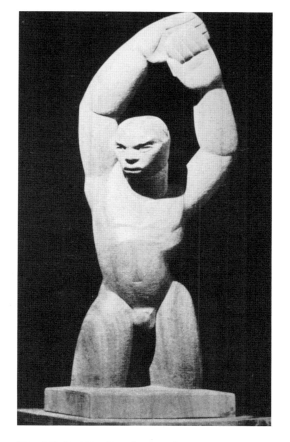

Fig. 13-3 *The Prophet*, mahogany, 40", 1935.

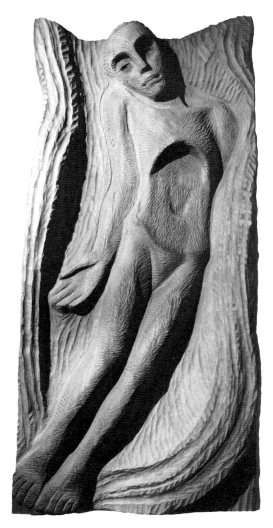

Fig. 13-4 *Journey*, mahogany, 61½", courtesy Maria La Yacona, 1974.

Manley sought to symbolize the Jamaican people's aspiration for political reform. *The Prophet*'s arms are upraised, the hands joined high above the head to form a powerful arc. Here the figure looks not to the heavens, but to the viewers, the people.

> We believe that the people must consciously believe in themselves and their own destiny and must do so with pride and with confidence and with the determination to win equality with the rest of mankind—an equality in terms of humanity which, irrespective of power and wealth, can be measured by the growing values of civilization and culture.[17]

In 1938 began a series of riots and strikes which led ultimately to the politicization of the working class and to the formation of two political parties: the People's National Party led by Norman Manley and the Jamaican National Party headed by his cousin Alexander Bustamante. For much of the next twenty years, Edna actively supported her husband's political career. She became Jamaica's first lady and, according to E. G. Smith, "When Norman finally took office as chief minister in 1955, Edna Manley set aside her own work as an artist and teacher to help her great husband as best she could to bear the burden of his office."[18] Years later, her son, Michael, would also become prime minister.

Edna Manley's influence upon the cultural life of Jamaica extended in many directions and was not always well received. For example, during her visits to Europe in the 1930s, she purchased a small number of African carvings, which she brought to Jamaica and "displayed with the air of someone landing a prize. They were ridiculed."[19]

In the 1940s Manley, along with several other artists, organized art classes. From this activity, interest in the visual arts began to grow, and eventually in 1950 the Jamaica School of Art was established. "These artists together," according to Boxer, "laid the foundation for an indigenous iconography: Jamaican life, Jamaican landscape, Jamaican faces became the means to convey the nationalist sentiments."[20] An art market began to develop, and with it various cultural journals, including *Public Opinion* (founded 1937) and *Focus* (founded 1943), both of which had Edna Manley among their founding editors.

By 1950 Manley's early political work gave way to more private concerns. Boxer claims Manley retreated "into a very private world spawned by a newfound interest in the writings and drawings of Williams Blake."[21] Many of her works during this period are anthropomorphic as she looked to the shapes of the nearby hills and mountains for inspiration. In the mahogany carving *The Hills of Papine* (1950), for example, the mother is like a protective mountain as she embraces the small child asleep in her arms. In fact, the piece was created in the woods, in an open studio shed at the retreat she and Norman had built. This work has a richer texture than many of the earlier works; the chisel strokes remain and enhance the rhythm of the forms.

Her output during the period of Norman's greatest political power was "defocused," according to Boxer, but after Norman's death in 1969, "she resumed her career with a vengeance, and in the 1970s produced a remarkable body of work which re-estab-

Fig. 13-5 *The Message,* bronze, 45". Photograph courtesy of Maria La Yacona, 1977.

Fig. 13-6 *The Ancestor*, bronze, 44". Photograph courtesy of Maria La Yacona, 1978.

lished her as one of the most profound practicing artists in the country."[22]

Manley is also concerned in her work with the eternal verities: the life cycle, joy and grief, love, sensuality, religious faith, motherhood, and death. In sculptures such as *Market Woman* (1975), *Man-Child* (1976), and *Ghetto Mother* (1983), Manley transcends cultural boundaries and offers strong, universal statements concerning the role of women, and especially older women, in society.

In the first several years after Norman's death, Edna created a series of wood carvings—*The Angel, Adios, The Phoenix, The Faun, Journey*, and *Mountain Woman*—in which she expressed the grief, despair, and finally the acceptance of her loss. In *The Angel*, the smaller symbolic form of Norman is held within the protective embrace of a winged female; *Adios* represents the couple's final embrace; *The Phoenix* symbolizes Christ's resurrection; and *The Faun* refers to her inner terrors.

In the 61 ½-inch wall piece *Journey* (1974; Fig. 13-4), the rising figure of Norman contains recessed concave areas around the eyes and rib cage. The curve of the head pushes past the top edge of the wood, while his toes cling to the bottom-right corner of the womb-like shape. Norman, here, is Christ-like.

Another sculpture, *Mountain Woman*, according to Boxer, is the "triumphant carving of a 70-year-old woman who has at last accepted the fact of her husband's death, and who is ready to enter her eighth decade with a determined purpose."[23] These were her final woodcarvings.

A number of her works explore the theme of older women and their role in society. This theme is seen in *The Message* (1977, Fig. 13-5), *The Ancestor* (1974, Fig. 13-6), and *Man-Child* (1974, Fig. 13-7). Manley once described the impetus for *The Message*, a 45-inch bronze, in these words:

> I saw them in the market, two women sitting, lost to the hubbub around them. I watched them and drew them on the back of my check book. ... They were probably sharing some earthy secret. I never knew what it was, but it was a secret an older woman tells a younger woman.[24]

In *The Ancestor*, a 44-inch bronze, a tall, lean grandmother reaches downward to embrace the smaller male figure, while his arms reach upward, paralleling hers. Boxer explains, "The [smaller] figure is not a child, but a man,"[25] and the grandmother figure is the mythical ancestor.

The three seated figures of the life-size *Man-Child* are set in the courtyard of Kingston's Olympia International Art Center. A child clings to his mother and is embraced by both his mother and grandmother. Approaching the figures, one feels as if coming

Fig. 13-7 *Man-Child*, bronze, 40", 1974.

upon an intimate family scene. Manley described how the work reflected the Jamaican family structure:

> It is a matriarchal society—I am speaking about the masses—it is only recently that the father is making his presence felt—this is one of the positive things about the Rastafarian culture—but the grandmother is usually the person who rears the children; the mother is usually out making a living. The father has for centuries been absent.[26]

Attesting to her continued strength in the 1980s is *Ghetto Mother* (Fig. 13-7), a pyramid-shaped group from 1983. Like the mothers in Kathe Kollwitz's post-World War I protective-mother series, Manley's anguished mother forms a nest to protect her many children from the world's evils.

I met and interviewed Edna Manley in 1985. Looking younger than her 85 years, she is tall and lean, looking more like a graceful dancer than a woman who has spent 60 years moving, cutting and shaping heavy mahogany logs and tons of clay.

"I am up to my eyebrows making drawings,"[27] she told me. As we became comfortable with one another (I had brought along

some of my own work to share with her), she began to relate some of her early experiences. One story, in particular, illustrates the social segregation present in Jamaica early in her career.

She and Norman were "delighted," she said, "when one of the impoverished artists would receive a much-needed commission for a portrait painting. However, occasionally when the artist arrived at the designated upper-class home of a light-complexioned or white patron and knocked at the door, the patron would be shocked at finding a black artists! The artist would then turn to me for help, and I had to be the go-between to straighten things out."

Edna Manley mentioned that she has visited Mexico several times, and in 1978 she was invited to China as a guest of the government. She considers the Mexican and Chinese artists as the surest and the best designers. "Their sense of line is always right." Several pre-Columbian sculptures from Mexico are now part of her large international art collection.

She also told me that she has the "highest admiration for the American people and U.S. technology," which "gets things done." However, she lamented over current U.S. policies in Latin America, saying, "You would think that the United States would have learned from England's mistakes, and not repeat them." Then Manley firmly added, "No more politics for me now. In the years that are remaining for me, I just want the time to do my own work."

My meeting with Edna Manley was brief but inspiring. One of the last things she said to me suggests the faith, strength and dedication of her long career: "One must always look forward to the future with hope."

In 1980 Manley was awarded the Order of Merit and elected a Fellow of the Institute of Jamaica for her contribution as "Jamaica's foremost sculptor and inspirer of other artists." She was honored by Hunter College, City University of New York, in 1984, and in Jamaica she was presented the Woman of Distinction Award by the Bureau of Women's Affairs in 1985.

Manley died in her sleep on February 11, 1987, a few days before her eighty-seventh birthday. She was buried beside her husband in National Heroes' Park, Kingston, Jamaica. In a tribute to Edna Manley, Rex Nettleford states, "For lest we forget, Edna Manley was a formidable fighter as only our women can be, now in the barricades identifying with striking workers, now on the party campaign trail with a will to win—above all she was a great and courageous artist who took risks investing in the talents of the youths from all walks of life."[28]

Fig. 13-8 *Ghetto Mother*, bronze, 48". Photograph courtesy of Edna Manley, 1983.

Notes

1. Wayne Brown, *Edna Manley: The Private Years, 1900-1938* (London: Andre Deutsch, 1975), 91. This book is based upon an extensive interchange of letters between Edna and Norman Manley and was invaluable in helping me structure the facts of her life.
2. Quoted in Prologue, Rex Nettleford, *Caribbean Cultural Identity* (Institute of Jamaica, 1978), xiii.
3. Brown, *Ibid.*, 46.
4. *Ibid.*, 58.
5. *Ibid.*, 79. Letter dated April 8, c. 1919, Edna to Norman.
6. *Ibid.*, 80. Letter dated November 25, 1919, Edna to Norman.
7. *Ibid.*, 90. Letter dated November 25, 1919, Norman to Edna.
8. Davis Boxer, in "Jamaican Art 1932-1982" (Smithsonian Institute, 1983), 13.
9. Conversation with Rosalie Smith McCrae, Jamaica, September 1985.
10. Boxer, "Jamaican Art," 13.
11. Quoted in Brown, *Edna Manley*, 182.
12. Quoted in *ibid.*, 183.
13. E.G. Smith, "Edna Manley," (National Gallery of Jamaica, Kingston, 1977), 4.
14. Boxer, "Jamaican Art," 15.
15. Brown, *Edna Manley*, 226. From letter to Norman written during 1937 visit to Amsterdam.
16. Quoted in *ibid.*, 211.
17. Quoted in Prologue, Rex Nettleford, *Caribbean Cultural Identity* (Institute of Jamaica, 1978), xiii.
18. Smith, "Edna Manley," 4.
19. Brown, *Edna Manley*, 131.
20. Boxer, "Jamaican Art," 17.
21. *Ibid.*, 18.
22. *Ibid.*, 19.
23. David Boxer, "Edna Manley, the Seventies," (National Gallery of Jamaica, Kingston, 1980), 13.
24. Quoted in *ibid.*, 19.
25. *Ibid.*, 19.
26. Quoted in *ibid.*, 20.
27. This and the following quotes are from an interview with Edna Manley at her home, August 10, 1985.
28. Rex Nettleford, "Tribute to Edna Manley," Kingston, Jamaica, *The Sunday Gleaner*, February 22, 1987, 9A.

June Beer
An Artist of New Nicaragua

AT FIRST GLANCE, June Beer's apartment could have been in New York City's Greenwich Village instead of in the remote tropical town of Bluefields on Nicaragua's Atlantic Coast. In the main room where Beer ate, painted, and entertained, the white walls were covered with an international collection of paintings and drawings. Beside her easel and a table containing oil paints and brushes was a group of canvases awaiting her impressions. An eclectic collection of books, both Spanish and English, ranging from poetry to politics and history, were neatly arranged on shelves throughout the apartment.

June Beer's life and paintings reflect five decades of Nicaragua's history from a unique black and feminist perspective. Born in 1933, Beer (Fig. 14-1) dedicated herself from 1956 until her death in 1986 to documenting her black heritage in the daily life of her people. They were first brought as slaves from Africa to Jamaica and Haiti, and then to Nicaragua's Atlantic Coast region in the 1600s. Nicaragua's black, English-speaking population is centered mostly in the port town of Bluefields, the main town of the Atlantic Coast. The Rama, Suma, and Miskito Indians, each speaking their own dialect, are another component of the coastal population. The region stretches from the Honduran border to Costa Rica.

In contrast, Nicaragua's dominant Pacific region consists of people who are Spanish-speaking and mestizo of Spanish and Indian heritage. Their colonial history, customs and traditions are distinct from those of the Atlantic Coast peoples. Of the total national population of approximately three million, only ten percent are located on the isolated Atlantic Coast.

Beer is the only painter who has emerged from Bluefields, a town of 40,000 people, to receive national and international recognition. Self-taught, she has forged her own artistic pathway, emulating neither the abstract tendencies of most Nicaraguan professional artists nor the detailed landscape style of the popular "primitive," self-taught Solentiname artists. (Solentiname, a group of islands on Lake Nicaragua, is the name given to the painting, sculpture, and poetry that emanates from the islands' cooperative Christian community, Nuestra Señora de Solentiname.)

Beer was an attractive woman who filled a wide rocking chair to capacity. From the apartment balcony overlooking a bustling market, she described to a 1985 visitor the development of her art and her political perspectives, punctuating her stories with warm laughter.

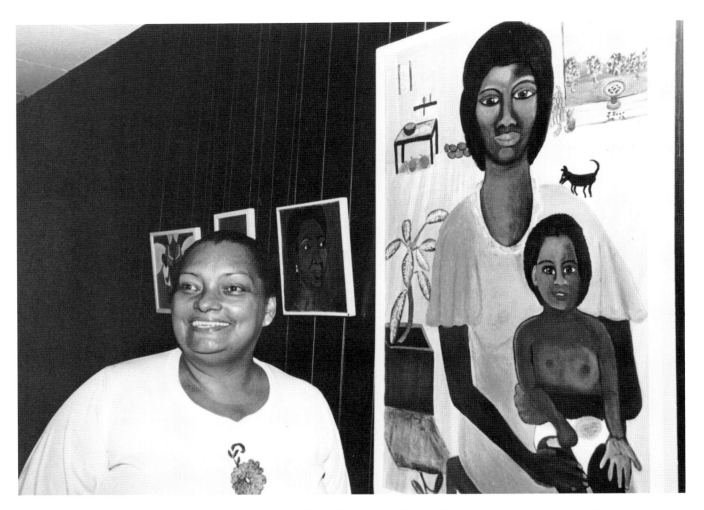

Fig. 14-1 June Beer, Nicaragua, photo courtesy Margaret Randall, 1983.

During the period before the 1979 revolution, when Nicaragua was ruled by the family of Anastasio Somoza, Bluefields, according to Beer, "was a region that was forgotten and ignored. No one was encouraged to dream, to think of the future, or of art, but only to make a little money for subsistence." The message that schools gave people was "not to make a better society for everyone, but only to work for self-improvement."

The youngest in a family of eleven siblings, Beer recalled "as a child I suffered from severe asthma, and I was terribly bored because I couldn't play with other children. I began to read everything and soon my imagination soared sky high."

In 1954, at twenty-one years of age, Beer traveled to Los Angeles where her aunt lived. Her two-year visit there was filled with a series of significant formative ventures encompassing exposure to various religions, jobs, politics, and eventually art. Beer's feisty and expressive character led her away from mundane work and eventually helped her to open doors that led toward her artistic development, a goal that would have been impossible to visualize or achieve had she been a less assertive

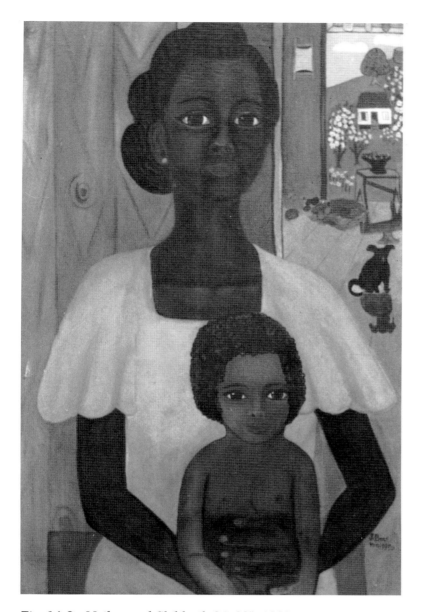

Fig. 14-2 *Mother and Child,* oil, 24x32", 1982.

woman. Beer smilingly suggested, "You'll never believe me, how I began to paint."

Her first job in Los Angeles was at a dry cleaning establishment. "I couldn't get accustomed to working in factories and to people talking to me in four-letter words, especially because I was very careful how I did my work," Beer stated. Soon after resigning from this job, she worked as a character model for artists. In her new career June found herself very much in demand at the various art schools. She also posed privately for artists and one day after posing for the film actress Ruby Ossier, June confided to her, "Ruby, I have a strong feeling I want to paint." Ossier then generously provided her with some watercolors, brushes, and paper. "That night in my room," Beer recalled, "I got naked and painted myself by looking in the mirror, but

painted my body only without my head. I didn't want to let anyone know it was me, but my friends and family guessed anyway. From then on I kept on painting. That's how my career began."

Beer remembered that "there were many marriage proposals and other opportunities to stay in the States, but I felt compelled to return to Bluefields in 1956" because she had left her first child there in her mother's care when she was only two years old. Shortly after returning to Bluefields, Beer married an old friend, and then had her second child with him, followed soon by two more. Unfortunately, Beer lamented, "My husband was not only a poor provider, but also he drank too much." Furthermore, he "never encouraged me to paint," although she persisted.

During years of struggling to provide economic support for her children, Beer resorted to her childhood work experience of collecting empty whiskey bottles and plastic containers, which she would sell in the capital city, Managua. There she used the money to buy fresh vegetables to resell in Bluefields.

"I used to paint pictures of people coming from the marketplace, carrying baskets on their heads; men working on the docks or planting in the fields; women grinding corn, washing clothes or cooking. Sometimes I just painted pictures of flowers." At this time Beer gave away most of her work. "I never dreamed," she said, "that I could make a living from my painting."

The encouragement to pursue her career came in 1968 from another painter, a Dutch ship captain. "I told him, 'When my children are out of school, I will dedicate myself full time to painting.' He said to me, 'Why wait? Why not paint now?'"

"So in 1969," Beer said, "I went to Managua to make myself a name. Fortunately, in Managua I was constantly making paintings and selling them, and then there were orders for more."

At the end of the year, Beer returned to Bluefields. Occasionally art collectors came to buy her work. However, she lamented, "I was not well organized. I was subjected to many people who were like alligators and they often took a big bite out of me. They were so greedy."

"I used to paint on the porch of my house [in the Beholden district], where anyone could see my work as they passed by. I'd make a whole batch of paintings and then take them to Managua. I couldn't stay away very long. I had my kids in Bluefields, so I practically gave my paintings away. ... Bluefields residents would never buy my work. They would rather buy a plastic ornament for their walls."

Beer returned to Managua for two more years, 1971 and 1972, working with professional artists—Roger Perez de la Rocha, Orlando Sobalvarro, Leonsico Saens, Leonel Vanegas, and others. But she didn't exhibit with them at the Praxis Cooperative Gallery in Managua. She was often criticized because her paintings weren't like the detailed primitive paintings from Solentiname. She told them that "my reality and the Solentiname reality are two different things. In Bluefields we have space and my paintings reflect this."

Open space is apparent in Beer's painting *Mother and Child* (Fig. 14-2), a theme she has repeated throughout the years. A proud mother calmly sits with her contented child upon her lap before the open window which reveals hillsides with flowering trees and wood frame homes. In contrast to the formal elegance

Fig. 14-3 *The Dancers*, oil, 24x32", 1983.

of the *Mother and Child*, the *Dancers* (Fig. 14-3), within a more confined space, is composed of the rhythmic interaction of a number of couples enjoying their dancing.

A theme expressed in Beer's paintings of the latter part of the decade is her feminist consciousness. One series she completed during this period includes a painting entitled *The Funeral of Machismo*. While the form of a proud, beautiful rooster dominates the canvas, painted above it is a horizon line upon which a child, a young woman, a pregnant woman, and a grandmother are standing, all shaking their fists at the rooster. "Even if you're a doctor, lawyer, or teacher, when you come home from your job, you work at home while your husband sits down. He sits and watches you work," Beer commented.

Beer's paintings also reflect her patriotic spirit and commitment to social change. She read books about the Nicaraguan revolutionary leader of the 1920s, Cesar Sandino, who inspired the contemporary revolutionary Sandinista National Liberation Front (FSLN). She also read the poetry of Pablo Neruda and of Ernest Cardenal, a leading FSLN member who later became Nicaragua's Minister of Culture. In 1978, Beer painted an unusual portrait of Sandino in which he is compared to a fallen eagle. A series of blood-red feathers are drifting downward along one side of Sandino, toward the head of a wounded eagle which is near his feet.

While Beer was working on this painting, a young neighbor girl saw it and told Beer, "You're going to get yourself in trouble and land yourself in jail." Beer painted the portrait clandestinely and for inspiration listened to revolutionary songs or poems by Cardenal. "If someone was approaching the house that I didn't know, I would turn off the cassette," she recalled, adding, "My blood pressure sank down to my ankles while I was painting Sandino an official of the pro-Somoza military force, the Guardia stepped out of his car, came over to my house and said to me, 'I have a telegram for you.' The message was from the Italian Embassy confirming an exhibit of my paintings that was to take place there soon. After I heard this good message, my blood pressure rose again."

Many Nicaraguan artists had been jailed during Somoza's epoch for their revolutionary activities. In 1971, Beer recalled, five or six of the professional artists were working together in one of their studios, making the final arrangements for Sobalvarro's exhibit at the Praxis Gallery. That evening, the Somoza Guardia broke into the studio, "tearing the place apart, on the pretext that they were looking for drugs." But, Beer said, "they really suspected us artists of anti-Somoza political activities. ... Sure enough, no drugs were found, but the artists were all taken to jail." Beer was released the next day. The others were kept in jail for three days, with hoods over their heads. Protests were held by university students to demand the artists' release.

Beer still had nightmares about an earlier, more traumatic incident with the Somoza Guardia of Bluefields. She would not describe the exact details of the incident, saying only that she had been targeted "for standing up for my rights." Her refusal to be terrorized had provoked the authorities to dehumanizing acts.

"Since I'm outspoken, everybody in Bluefields knew that I was against Somoza," Beer said. She described the Guardia as

Fig. 14-4 *Black Sandino*, oil, 24x38", 1983.

Fig. 14-5 *Fruit Vendors,* oil, 24x32", 1984.

"old thieves that scrape out the last drop of blood from the country before they leave. The only thing they can't take away from us is our revolutionary fervor!"

At the beginning of the eventful year 1979, Beer's son Camilio, then about sixteen years old, frequently wrote and read his papers at the student assemblies. These statements told of various protest activities that the students then joined. Eventually the Somoza Guardia came to Beer's house to pick up her son, she said, but they let him go. Soon afterwards, Camilio went to the mountains where he joined the Sandinista guerrillas and fought against Somoza. Beer proudly says, "My son was politically convinced and knew it was the right thing to do. I encouraged him in his political development."

Shortly before the "triumph," her youngest daughter, then fifteen, also wanted to join the guerrillas. Beer packed a small bag for her and told her "to look out for ... male opportunists who, instead of leading you to the guerrillas, take girls into the bush and take advantage of them. Check ... to smell if your guide has been drinking." Sure enough, her daughter returned